Definition of Rewilding

Rewilding is a contested idea, and people have different views on what exactly it should aim to achieve. For me, two elements of rewilding are crucial. The first is that natural ecological processes should be allowed to run their course, whereby new species can colonise an area, or a new habitat develop – which may, then, be replaced by a subsequent habitat. The second aspect is just as important, and this is that rewilding is something enacted by people, even where the intention is to leave nature to it. These people benefit from rewilding: this benefit might be spiritual, health-related or, indeed, economic. The overall goal is to kindle a more thoughtful approach to living on the Earth, and to support a move to more sustainable living.

This way of thinking has been around a long time. For example, in a book called *Sharing the Work, Sparing the Planet* by Anders Hayden, published in 1999, the author sets out a vision to enable us to achieve both greater sustainability and an enhanced quality of life. He argues that a lifestyle that is less rushed, more thoughtful and community-orientated could both enrich peoples' lives at the same time as stopping

Sheep on snowscape, Conwy, Wales.

us from degrading the life support which our planet now struggles to provide. This reflects my two themes: enriching nature and enriching people's lives in the process.

The aim of this book is to show the many ways of being engaged in rewilding, and the great range of people who are helping to achieve it. I have visited a wide variety of places and spoken to many people, alone and in groups and within organisations, in the UK and Ireland. When I started out I had little idea how many people were actively rewilding. I recorded my impressions through photography – photographs that trace the changing landscape across thousands of years, and the human timeline from stone beehive huts to contemporary homelessness. The significance of rewilding is illuminated in essays written by professionals in the fields of wildlife conservation, recreation, education, agriculture and forestry, and by the people actively involved in making rewilding successful. I hope the book will contribute to our understanding of the potential opportunities and benefits that rewilding offers, and to provide a practical guide for new communities to strive for better connected, satisfying and sustainable lives.

FOR TESNI AND HELEN WITH LOVE

Contents

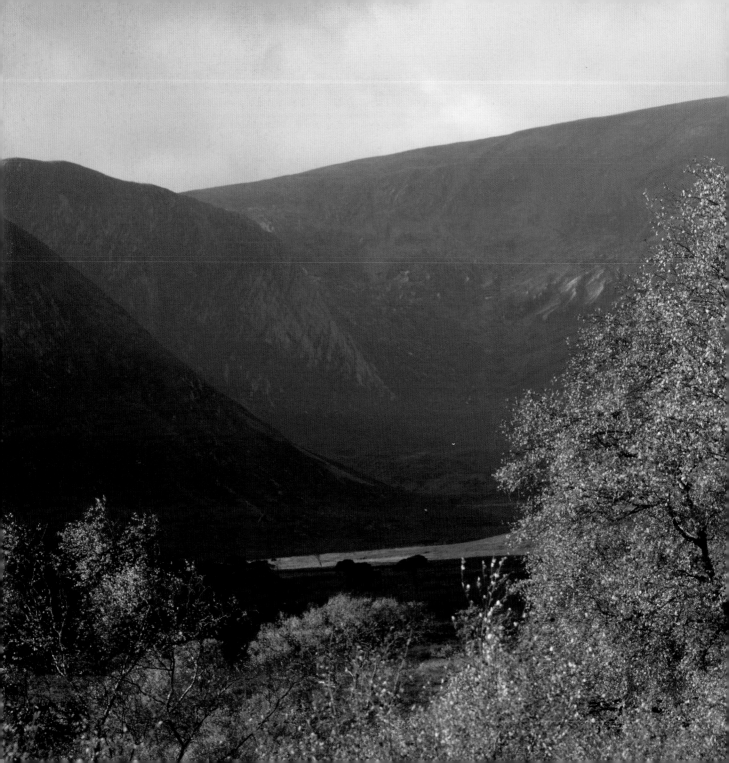

Introduction
David Woodfall

Following the end of the last Ice Age 10,000 years ago, Britain and Ireland began to colonise with birch and oak which, apart from mountain tops, became established in all of our islands. Rewilding, essentially a new concept, is the return to allowing nature to take its own course and carpet our islands once more in natural vegetation and its associated fauna. During the Mesolithic period (15,000–5,000 BCE) this native forest was considerably modified by burning and felling. By the Middle Ages (500 CE onwards) the wildwood had been replaced by a mosaic of cultural landscapes, created by an ever-increasing population. The Enclosure Acts of the eighteenth century were swiftly followed by the Industrial Revolution, with its increasing demands on mineral and timber resources, and further modified our landscapes. Landscapes became empty of all of our major predators, such as wolves, and

Colonising silver birch in glaciated valley, Alladale.

landscape modifiers such as the beaver. While our cultural landscapes contained wonderful chalk grassland grazed by huge flocks of sheep, numerous heathlands grazed by cattle and diminishing peat bogs harvested by crofters in the north and west, these landscapes were unrecognisable from their native state, much of their diversity and richness gradually stripped away. During the Industrial Revolution there was a rapid reduction in the number of people employed on the land and a consequent decline of rural communities. There were changes, too, affecting limestone pavements, peatbogs – a reduction of sheep farming led to the depletion of chalk grassland. The last time our islands possessed any degree of biological richness was the 1930s, a richness that disappeared swiftly during the 1940s when World War II interrupted food imports, leading to a massive increase in lands given over to arable crops.

By the 1960s only a handful of intensively managed nature reserves contained a fraction

Dinosaur footprint, Severn Estuary.

of our previous flora and fauna, often isolated islands in an extensive agricultural prairie, where food production was continually supported by pesticides and chemical fertilisers, further diminishing our wildlife – the future of peregrine falcons were threatened by the build-up of toxins in the food chain. In the US, scientists such as Rachel Carson began to draw the public's attention to such concerns and the environmental movement was born. This has subsequently led to the evolution of the rewilding movement, which I would define as allowing the natural succession from open ground to forest to take place, much in the way

it happened 10,000 years ago. Essentially, to allow the landscape to develop in an organic way, opening up the full range of available niches for local species. However, much of the landscape of the UK and Ireland has been so severely modified that in many cases it is a challenge to allow rewilding to take place, as this process can lead to a short-term reduction in the existing diversity. In effect, the decision on the part of conservation organisations to cease management is a form of management in itself. Many of the priorities in conservation previously seen as set in stone will have to be carefully reconsidered. Further complications emerge from the significant changes being wrought on our landscapes, ecology and ourselves by climate change.

By the modern age, most of the significant apex, 'game changers' within our flora and fauna, were now absent – in parallel with a naturally developing climax vegetation, it was deemed necessary to reintroduce many of the key animals which significantly affect the ecology of our landscapes. These include beavers, lynx, sea eagles, and red kites: species that will help stimulate and revive ecological processes that have been absent from our lands for thousands of years. The introduction of beavers could have a significant effect on reducing the flooding of agriculture areas and towns, something that appears to have increased in both intensity and frequency. Species such as sea eagle and red kite have already demonstrated that their increased presence can have a significant beneficial effect on tourism at both a local and national level.

This work has been carried out by inspired individuals, scientists and a growing number of NGO organisations, who are working with the government conservation agencies to help negotiate with landowners, carry out research and conduct trials with reintroduced species to ensure that such populations are sustainable and equitable among our highly managed islands. In addition, rewilding calls for a greatly reduced grazing regime in our uplands by both deer and sheep, and a general reduction in the grazing of our grassland ecosystems where appropriate to increase both plant and invertebrate populations, which in turn will greatly increase our mammal and bird populations. Due notice will have to be given to our 'cultural habitats', e.g. downland, which have evolved through our grazing regimes. Also both the significance and value of our post-industrial sites will have to be given greater recognition as we are blessed with large numbers of places that are great examples of the beneficial effect of rewilding, without us doing anything active at all. The reduction in fishing through a system of quotas, during the last ten years, has

once again made the North Sea a place in which to fish sustainably, and the introduction of many wind turbines has had the effect of creating 'artificial reefs' which have further increased marine diversity. This is nowhere better demonstrated than the huge growth in cetacean and grey seal populations throughout Britain and Ireland. In turn this has attracted significant populations of killer whale. The changing sea temperatures around our coasts, due to changes in the jet stream, are also enhancing our whale and dolphin populations. Tuna weighing up to 230 kg (500 lb) have been caught off the Hebridean island of St Kilda, demonstrating that our seas, too, can be rewilded.

Our agricultural landscapes, even more so than the native habitats, have the potential for great change through rewilding. Our agriculture has been heavily subsidised through the European Economic Union (via Common Agricultural Payments), since the 1970s, and this has had a profound effect on both the landscapes themselves and their biodiversity. We are about to leave Europe and at the very least this is going to produce uncertainty for our agricultural landscapes. The most likely outcome of this will be that large areas of land will not be cultivated as intensively as previously. On the other hand, financial conglomerates, pension funds and extremely rich individuals may well buy up aggregations of small farms and produce 'super farms', leading to even greater insensitive management of our landscapes. The first of these outcomes ought to give the opportunity for a theory like rewilding to really flourish, allowing for many natural processes to take hold once more, rather than the more manicured effects of conservation that have been attempted so far. We have reached a point in our islands' evolution where our growing understanding of rewilding has the realistic prospect of gaining both political and popular support. This has been achieved, in part, by the rapid growth of environmental education, and the popularity of TV and radio programmes by such people as David Attenborough – informing and enthralling the public with the 'natural world'. This in turn has inspired countless individuals, paid and voluntary, to get involved in disparate conservation projects employing both species introduction and the development of more naturally developing climax vegetation communities. Rewilding has arrived and I feel that now is the right time to publish a book highlighting all the wonderful organisations and inspired individuals who are making the UK and Ireland such a biologically rich series of islands once again.

Mawddach Estuary, Snowdonia NP, Gwynedd.

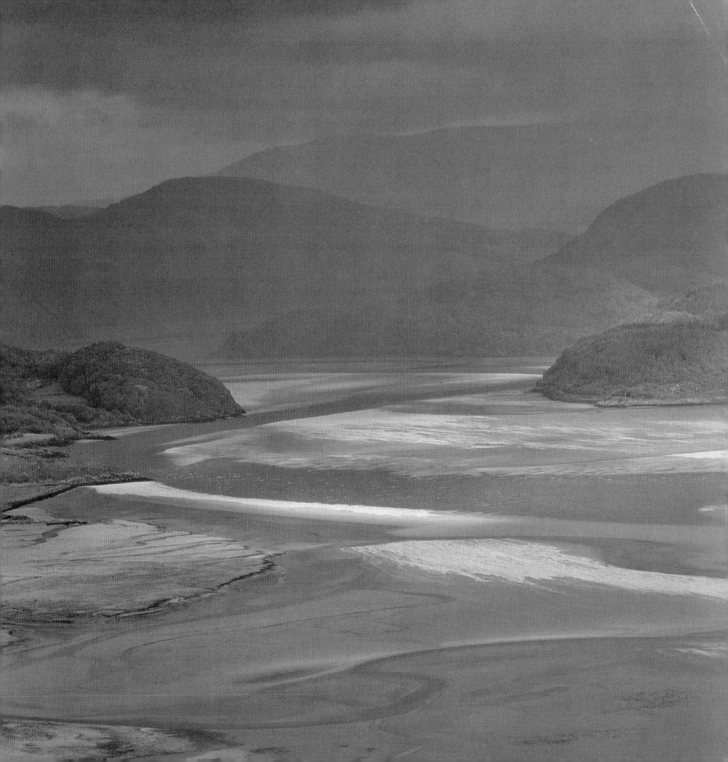

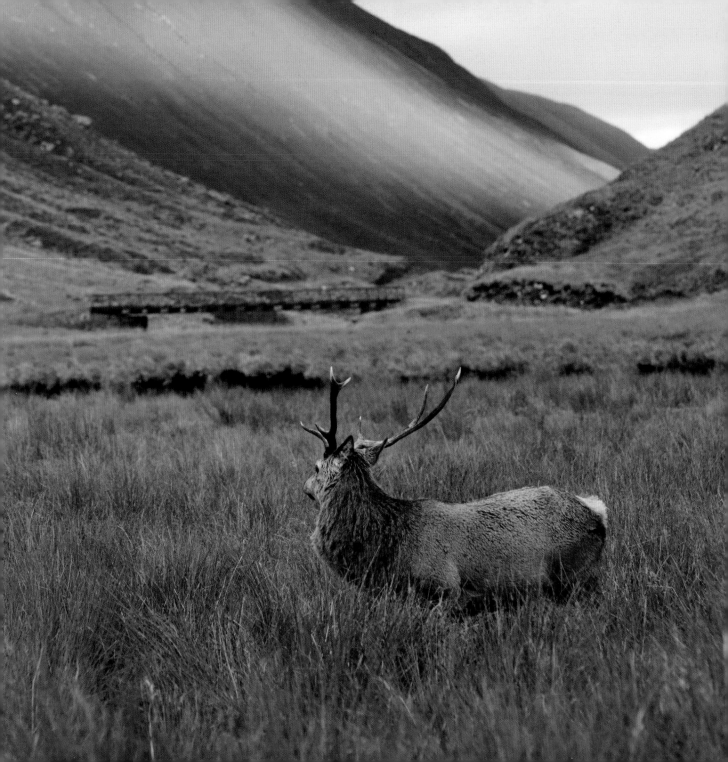

Rewilding in Alladale
Paul Lister

I spent my childhood growing up in north London and at a West Country boarding school, with simply no family connection to Scotland. My first trip north of the boarder was at the age of 23 in 1982 when my father, Noel, decided to take Mum and me on a trip to Argyll and Perthshire to look at some commercial forestry opportunities, on a cold, bleak and wet day. We were shown around by Fenning Welstead of the land agents John Clegg, and Des Dougan, a local deer stalker working for the Forestry Commission. After the decision was taken to invest, Des and I struck a chord and he invited me hind stalking.

For the following ten or so years, I met up with Des once or twice a year in a number of locations to help (or hinder) in the culling of red deer hinds and the odd invasive sika.

Red deer stag at Alladale.

When I first pulled the trigger all those years ago, I wondered what the sport was all about – why was it necessary to shoot so many deer? In my usually inquisitive way, I asked many questions and began to better understand the sorry state of the UK's environment and especially the negative effects on wildlife. Most noticeably, the missing carnivores whose task, until driven to extinction, was to keep browsing deer numbers in check, which allowed native forests to regenerate and create a natural balance. Sadly, for a multitude of reasons, the vast majority the UK's native woodland has been felled or burned over the last millennia; with trees gone, sheep and deer took over. Landowners/managers had little tolerance for large carnivores and their threat to livestock and they all soon vanished.

In the mid-1990s Roy Dennis introduced me to Christoph Promberger, a German ecologist

who as working for the, now defunct, Munich Wildlife Society in 'post-communist' Romania. Two weeks later I set off to meet Christoph and his two socialised wolves, rescued from a fur farm about to close. In the middle of the wild and pristine snowy Carpathian mountains, I learned about a unique and unspoilt corner of Europe; a place lost in time and that had never suffered from mass industrialisation, like so many other countries in Europe. The incredible biodiverse nature of Romania blew my mind and made me realise just how much we had lost in Western Europe, and even more so in the Scottish Highlands. It's really not difficult to imagine why the UK's future King has chosen to spend his annual spring holidays in rural Romania, where he owns a home in a remote village, three hours from the nearest airport.

In my mid-forties, and with over twenty years in the furniture business, my mentor and father suffered a severe stroke, which shook our family and left me reflecting on what my life was all about. After some months of reflection and soul searching, I decided that, rather than be a part of the growing environmental problem, I wanted to be part of the solution. After decades of thinking about Britain's bleak and desert-like environment, I decided to look for a Highland estate to rewild, whilst also establishing The European Nature Trust (TENT), a charity which now supports conservation and wildlife initiatives in Romania, Italy, Spain and Scotland.

After a couple of years and a stringent 'must-have' list, Alladale, a sleepy, stunning and remote deer-stalking estate, was purchased with the sole intention of rewilding. Some 15 years on, as the custodians of Alladale Wilderness Reserve (AWR) we have planted almost a million native trees, mainly in the riparian areas, to help mitigate flooding, prevent river bank erosion, provide food and shade for the salmon and trout, while also acting as a significant carbon sequester! Around 50 years ago the Scottish government naively believed landowners should be incentivised to drain peatlands, which would increase the amount of land available for livestock grazing. The resulting consequence was a huge release of carbon into the atmosphere. To counter this, and in partnership with the finance firm ICAP, we pioneered the restoration of our peatlands by blocking 20 km of hill drains. Our restorative actions have now led to newly moistened peat with live sphagnum moss, which once more acts as a massive carbon sequester.

While much of the discussion centred around Alladale has been about large carnivores, we have been busy with other less controversial species. In 2013, with support of TENT and in partnership with Highland Foundation for

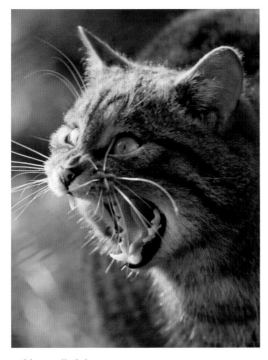

Wild cat, Alladale.

Wildlife, we released 36 red squirrels on Alladale and three neighbouring estates. The project has been a huge success, with hundreds of squirrels now spread far and wide, bringing smiles to neighbours and visitors alike. In addition we have a small collection of breeding wildcats which will be used to stock a larger-scale breed and release centre, now being planned by the Royal Zoological Society of Scotland (RZSS).

We also keep a small herd of Highland cattle whose grazing, trampling and excrement play a significant role in improving the biodiversity of the ground while enriching our newly planted native forests. Over the last 15 years we have reduced deer numbers to around 6–7/km², which is still above European norms where large carnivores exist. This action has already led to a significant increase in natural tree regeneration! In 2018 we stopped guest stalking with the aim of further reducing total deer numbers down to between 300 and 400 (3–4/km²).

AWR's Highland Outdoor Wilderness Learning (HOWL) programme has been operational since 2008. Each year we host over 150 teenagers, from multiple regional schools and colleges, who come up for five days at a time to wild-camp and undertake a variety of nature-based activities. This transformational experience has led to two past attendees becoming AWR rangers!

Finally, guest numbers staying at one of Alladale's four lodges has increased exponentially, which is a clear indicator that, with an environmental focus, it's possible to attract more visitors and create greater job opportunities than would be the case operating an upland stalking estate. All in all a better plan, while also greatly enhancing the reserve's biodiversity. That's what I call a legacy.

Rewilding in the Cairngorms National Park
Will Boyd-Wallis

Rewilding is as simple as planting wildflower seeds in a window-box, as complex as landscape-scale restoration of habitats – it's also everything in between. All forms of rewilding lead to more people connecting with nature and this is happening by the bucket-load in the Cairngorms National Park.

The largest National Park in the UK contains a quarter of Scotland's native woodland and an incredible 1,200 species of regional, national and international importance. The central mountain core, towering over northeast Scotland, is a broad plateau with thin soils and vegetation more akin to the Arctic. Yet even in the wildest, most remote and most extreme uplands, the vegetation hints at a long and complex history of landscape and land-use change.

Loch Morlich, Badenoch and Strathspey.

In the core of the Park there is evidence of hunter-gatherer camps estimated to be nearly 10,000 years old. Ruined shielings (stone and turf shelters) remind us that our vast open landscapes have been altered for many centuries. Gaelic place names litter the maps, hinting at a more wooded landscape where our ancestors had an intimate knowledge and close connection with every wood, crag, hill and cave. The landscape is more cultural than natural, but now more than ever before, we have the potential to give back more to the land than we take.

If you have a head for heights, you may be lucky enough to find very rare plants like the woolly willow or the alpine sow thistle hidden on a ledge. The ledges keep them safe from fire and herbivores, but they cannot cling on for ever. The chances of pollen passing from one isolated plant to another and the delicate

seeds finding a safe place to germinate are slim, but that is set to change. Thankfully rare plants, like the montane willows, are subject to a lot more attention now that there are prominent goals to restore woodland, wetland and peatland habitats – but we still have a long way to go.

The Cairngorms National Park Authority (CNPA) is pushing hard to inspire and encourage nature conservation throughout the National Park. The top three conservation goals set out in our National Park Partnership Plan are all to do with landscape-scale collaboration, deer management and moorland management. We aim to see real meaningful change over the next few decades that will lead to bigger, healthier and better connected habitats. With forest cover at only 15% of the Park area, there is vast scope to expand and connect our native woodlands. Guided by our new Forest Strategy, the health and species diversity of our existing forests will be enhanced and native woodlands expanded by willing landowners.

Many estates already incorporate conservation management of woodlands, wetlands and peatlands alongside their other management objectives, for the greater good of nature and for us all. Four 'Cairngorms Connect' landowners already manage 9,800 ha of forest and 10,000 ha of wetlands with an ambitious 200-year vision to expand them further through deer management and peatland restoration. Six 'East Cairngorms Moorland Partnership' landowners aim to integrate habitat enhancement and species recovery alongside moorland management. Three other partnerships work with landowners in the Spey, Dee and South Esk catchments to restore wetlands, plant riparian woodland, re-meander rivers and encourage natural flood management.

The Cairngorms Nature Action Plan has helped to focus attention on the habitats and species most in need of help. Over 1,000 ha of peatland restoration and well over 3,000 ha of native woodland creation has been achieved by landowners supporting these goals over the last five years alone. There has been a strong emphasis in involving people in conservation through volunteering and events to celebrate Cairngorms Nature. Major complex projects to care for the capercaillie and the Scottish wildcat have received millions of pounds of investment from the Heritage Lottery Fund. These charismatic species deserve all the help they can get, but we haven't forgotten the 'little guys': the Rare Invertebrates and Rare Plants projects are doing great work to involve more and more people in helping these crucial threads in the web of life.

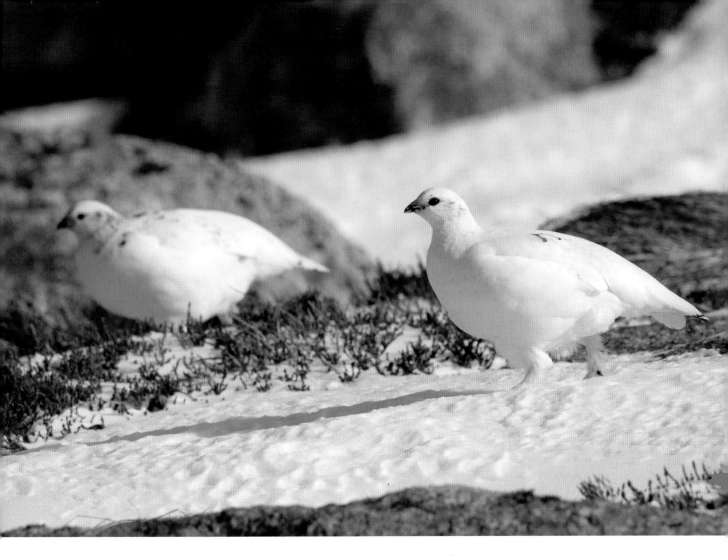

Ptarmigan.

We are at a time of great change. Opinions on the future of our uplands are often polarised and yet, if our recent 'Europarc' conference is anything to go by, there is an overwhelming force of commitment across Europe to rewild, repeople and reconnect us all with nature in our National Parks.

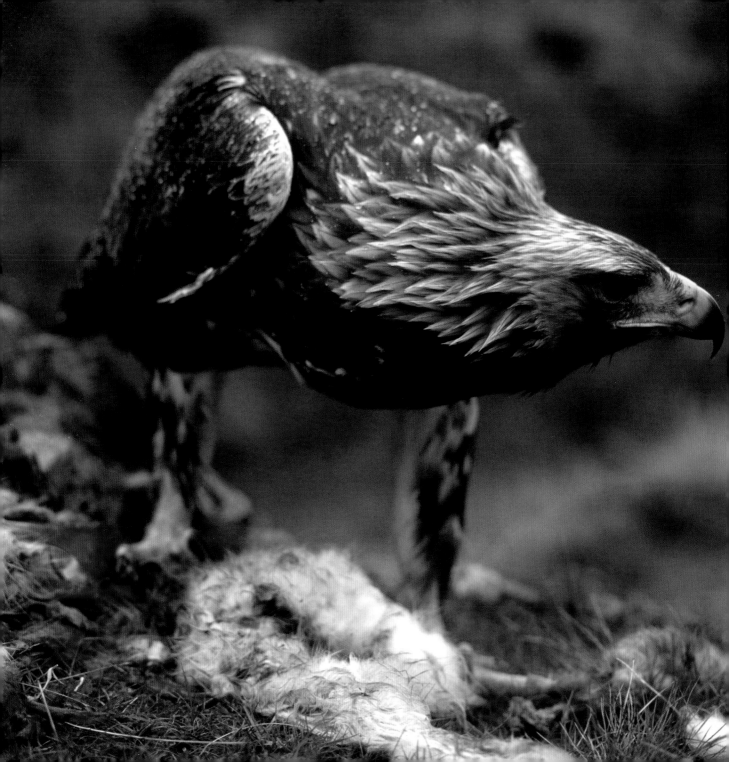

Restoring the Caledonian Forest
Doug Gilbert

I'm setting off today to monitor the progress of natural regeneration in the woodlands at Dundreggan. As I climb through the birch woods, I notice some of the smaller creatures that abound – wood ants scurrying busily about, a woolly caterpillar crossing the track in front of me, the green flash of a tiger beetle as it drones away from my step. As I pass a grove of old Scots pine trees, I notice a few seedlings poking out of the heather at the side of the pathway. A feeling of excitement – *it's happening!* – enters my thoughts. In the quiet thrum of a summer morning, I start to tune in to the natural world around me. A young buzzard mews; a woodpecker chacks in annoyance at me and I stoop down to examine a pine cone dropped by a red squirrel some time ago. They're on their way back too, I muse. Reaching the upper edge of the wood, I emerge from the dappled green shadow

Golden eagle on a decimated mountain hare.

of the birches and squint in the full sun on the moorland. The wood ends abruptly – tall mature birch trees give way suddenly to a treeless moorland, which now stretches ahead as far as I can see above me. I find my monitoring point among some tall heather on the slope of a small, steep hill and start counting and measuring all the young seedling trees I can find – lots of tiny downy and silver birch, a few young juniper bushes and several rowan. A few of these are beginning to emerge above the general level of the heather vegetation – poking their heads above the parapet – and I see that one of the rowans has not been browsed for at least two years. All good signs. As I get my eye in, I can see a few birches in the vicinity also poking above the heather and bog myrtle. If we continue like this for the next few years, it will really begin to look like a young forest!

Dundreggan is a small island of hope for the future of the Caledonian Forest, a wild

woodland that once stretched across much of Highland Scotland but which is now reduced to a shadow of itself. Only 4% of Scotland's land area is currently covered by native woodland, and over half of that is in poor condition, mainly because of high browsing pressure from herbivores – mainly sheep and deer.

I joined Trees for Life in 2014, inspired by the vision for a big native forest in the north-central Highlands of Scotland. There is something fundamentally exciting about the prospect of a big forest, inhabited by all the things that should be there, and one where natural processes are in charge. We live in a highly managed landscape: urban cityscapes, straight-edged agricultural monocultures, commercial forests of regimented conifers and checker-board treeless moorlands. Where are those places where we can experience the full power of natural growth – the sheer exuberance of plant and animal diversity that develops in more natural systems?

At Dundeggan, a 4,000+ ha estate in Glen Moriston, just west of Loch Ness, Trees for Life are building habitats for the future. Our treeless uplands are accepted by most people as 'they way things are', almost unable to imagine a landscape of wooded hills and mountains. Treeless uplands have landed Scotland with a triple whammy of reduced biodiversity and resilience to climate change; increased risk of flooding, as water cascades rapidly off the hillsides into spate rivers; and degradation of peatlands, leading to pollution of drinking water sources and more greenhouse gas emissions. Trees for Life's vision of naturally wooded hills and mountains is an antidote, not only to these ecological problems, but also to the feeling of hopelessness that often pervades people's thinking about environmental issues. At Dundreggan volunteers take part in practical action which addresses these issues at a fundamental level – we plant trees and encourage natural regeneration of native woodlands, building the beginnings of a new, hopeful future for the uplands of Scotland.

At the heart of these issues is the red deer population, particularly the stags so beloved of Visit Scotland as the poster boy of the Highlands. The original painting, *The Monarch of the Glen*, by Sir Edwin Landseer recently toured the public spaces of Scotland and the picture of a huge, wild, noble animal still resonates with people as an icon of wild Scotland. However, the development of a commercial industry around sport shooting of red deer stags has meant more and more management of the deer population of the highlands – selective culling, translocations of stags across the country in an attempt to

'improve stock', habitat manipulations and more recently winter feeding with silage and turnips have reduced the wild red deer herds of the past to semi-ranched livestock. For decades now, public bodies such as the Red Deer Commission and its successors, Scottish Natural Heritage and now the Scottish government have been encouraging, cajoling and more recently threatening the deer sector in Scotland to take action to reduce the over-population of the uplands with red deer (along with other deer species), but the industry seems entrenched in the view that a high red deer population is required to produce a sporting stag 'surplus'. As this impasse grinds on, Scotland's upland habitats become more and more degraded.

The rewilding of red deer is arguably now the most urgent conservation challenge in Scotland. By reducing the deer population and expanding their natural woodland habitat, we can begin to address all these problems. Biodiversity, flooding, pollution, greenhouse gas emission and, importantly, the welfare of the deer themselves can all improve under a reduced deer population. Even the sport stalking experience can be enhanced. The need to fence establishing woodland would reduce – or even disappear – if natural process were truly allowed to establish. Imagine a Scotland where unstoppable native woodland expansion was happening across large areas of the Highlands – new habitat areas for our native woodland flora and fauna; a more natural patchwork of wooded and unwooded habitats fundamentally based on natural processes; where hunting wild red deer was truly a challenging activity in a wonderful varied natural landscape of woods, bogs, mountain tops and meadows.

These are all big issues and big visions, but we have to start in the here and now. As the old adage goes – 'the best time to plant a tree is twenty years ago; the next best time is now'. Trees for Life's Dundreggan rewilding project beckons us towards a new future for the uplands of Scotland – not a return to some past idyll, but forward to a more sustainable, more diverse and more entrancing natural landscape.

Carrifran Wildwood

Philip Ashmole

The vision of a restored wildwood in the Southern Uplands of Scotland, conceived by Philip and Myrtle Ashmole in 1993, was based on the conviction that a grassroots community group could purchase an entire valley and – by a science-led process of ecological restoration – recreate an area of upland wilderness. This had to be large enough to establish plant and animal communities comparable to those flourishing there 6,000 years ago – long after the loss of the ice sheets, but while the sparse human inhabitants had relatively small impact on their environment. That date was easy to choose, since it was the age of the oldest longbow known from Britain, found in peat high on Carrifran in 1990.

Central to the wildwood concept was the idea that after planting and protecting missing species of trees and shrubs, we could gradually hand over management to nature,

Carrifran on a cold February day.

so that the wildwood would develop as a naturally functioning ecosystem, with a wide variety of beautiful habitats and a rich diversity of species.

Establishment of the Millennium Forest for Scotland Trust (MFST), an inspired offshoot of the National Lottery, triggered formation of the Wildwood Group in 1995. Members came from a wide range of backgrounds and occupations, united by a clear vision and a willingness to work for free. With other activists, we helped to form and become part of Borders Forest Trust (BFT) in 1996. However, a suitable site for the wildwood was hard to find, and lottery deadlines had passed by the time we had made a deal for the purchase of Carrifran, so the group decided to raise the funds themselves. A link with the John Muir Trust gave weight to our appeals, and there was an extraordinary response from members of the public, so that BFT was able to purchase Carrifran on Millennium Day.

Carrifran is a spectacular ice-carved glen extending some 650 ha, and rising from 160 m by the road to 821 m at the summit of White Coomb, the fourth-highest peak in southern Scotland. In 2000 the entire site had been grazed and browsed for centuries by sheep and feral goats. However, because some rare mountain flowers remained, it formed part of the Moffat Hills SSSI and is now also a Special Area of Conservation.

For a grassroots group with an ambitious vision, gaining the confidence of relevant authorities is crucial. Planning the transformation of Carrifran began with a major conference in Edinburgh under the title 'Native Woodland Restoration in Southern Scotland: Principles and Practice'. This was followed in 1998 by monthly meetings in a local pub of a diverse and lively planning group convened by our local volunteer Adrian Newton, a forest ecologist at Edinburgh University. The group developed a restoration plan for Carrifran which gained the necessary approval of Scottish Natural Heritage (SNH) and the Forestry Commission late in 1999. Within BFT, we agreed that management decisions for Carrifran should be made by a Wildwood Steering Group and a small Site Operations Team, maintaining the grassroots character of the project. Ultimate responsibility, however, rests with the BFT Trustees, some of whom are also members of the Steering Group as volunteers.

On Millennium Day more than a hundred supporters were piped onto the site to plant the first trees, raised in back garden nurseries. By the end of that month our Woodland Grant Scheme application had been approved, an extraordinary benefactor had agreed to pay for half a million trees (all of them to be propagated from seed collected locally by volunteers) and Hugh Chalmers had been appointed as Project Officer with funding from SNH. In the summer an 11-km perimeter stock fence and some temporary internal fences were erected with windfall funding from MFST, and that autumn most of the goats were rounded up and taken to sites in England found for them by Hugh.

Over the next seven years 300 ha of broadleaved woodland were established in the lower parts of the valley, using contracts with individual planters and small groups. The rules of the grant scheme left us deficient in shrubs such as hazel, hawthorn, blackthorn, juniper, roses and all the scrubby willow species that would be expected in and around ancient woodland, so tens of thousands more shrubs had to be added later. This planting has been the main role of a dedicated band of 'Tuesday volunteers' who have come to work at Carrifran each week, some of them for more than ten years. In addition, hill-walker volunteers have inspected and made running repairs to the perimeter fence almost every month since 2001.

The great altitudinal range of Carrifran offered an unusual opportunity to establish treeline woodland and 'montane scrub', low-growing, wind-pruned shrubs growing in such exposed conditions that upright trees could not survive. This habitat is almost lost from Britain but widespread in Scandinavia and elsewhere. In the last decade about 30,000 willows and junipers have been planted high up at Carrifran, mainly during a series of 15 High Planting Camps in spring.

In the main valley some of the trees are now 4 to 5 m high and in some places the canopy is closed, favouring shade-tolerant flowering plants, such as ferns and bryophytes, and causing the retreat of bracken. Bluebells are rapidly colonising the woodland from a few places where they have survived for centuries, and some of the special mountain flowers have escaped from their prisons on the crags and spread down the burns, providing a wonderful floral display in summer.

Other changes following removal of grazers and planting of trees have been revealed by formal studies at Carrifran and the adjacent valley of Black Hope, still grazed and functioning as a 'control' site. Vegetation surveys carried out in 2000/01 and 2013 showed extensive replacement of anthropogenic grassland by heathland and recovery of tall herb communities (especially along watercourses). Annual surveys of breeding birds show woodland species flooding in to reclaim habitats lost many centuries ago. Data of this kind are rare, and their publication generated a marked increase in visits by student groups and professional environmental managers. Furthermore, feedback from members of the public shows that Carrifran has now become truly inspirational, as we had always hoped.

In the meantime, Borders Forest Trust has been developing a more extensive vision, 'Reviving the Wild Heart of Southern Scotland'. In 2009 the Trust purchased the 640-ha farm of Corehead and Devil's Beeftub, which now features both low-intensity sheep farming and 200 ha of developing native woodland. Four years later BFT purchased Talla and Gameshope, meeting the northern boundary of Carrifran and extending to 1,830 ha, more than half of which is above 600 m. Grant-aided planting on this site already covers 40 ha, and volunteers have planted thousands of trees, as well as starting to establish montane scrub on the 750 m summit of Talla Craigs.

Of the 3,000 ha of hill land owned by BFT, a large proportion falls within one of only two 'wild land areas' identified in southern Scotland in a recent SNH project. BFT hopes that in the years to come, restoration work by the Trust and nearby landowners will ensure that the whole of the area becomes a truly wild and naturally functioning ecosystem.

Rewilding and Nature Agencies

Robbie Bridson

Between 1969 and 2007 I was privileged to work on nature conservation and land management as a Nature Conservancy Council warden, afterwards chief warden, and ultimately regional manager. Over this period my responsibilities involved working in Wiltshire, the Highlands and coast of Scotland, and North West England. During those 38 years, there was plenty of opportunity to be involved in species research and management on most major habitats. As chairman of the wardening staff association in Britain I had a unique opportunity to be involved throughout the country. After retirement in Cumbria my appointment to the Lake District National Park Authority gave an insight into planning, recreation and tourism.

Having been 'out of the loop' for some time my memories and assumptions might

Ulpha Common, Lake District National Park.

not be accurate, but I am aware that changes have affected the management of nature conservation over the past 50 years.

It seems improbable now, but I recall that in 1974 there were only two of us (a warden and a scientific officer) working on the ground in Scotland south of the Clyde and Forth. The RSPB had wardens on sites in Britain but many fewer in number than now. The Wildlife Trusts were not widely known and had few site managers.

The National Trust was involved in its country house management, landscape, and recreation, with just a small number of staff dedicated to nature conservation. The Forestry Commission was focused on timber production.

All that has changed. I am always pleased to see Wildlife Trust staff featuring regularly on *Countryfile* and the RSPB has become the most well-known and influential organisation for nature conservation in the UK with many links

to the rest of the world. The National Trust employs dedicated ecologists and staff who are knowledgeable and effective in safeguarding the natural environment on their properties. The same commitment to nature conservation with well-informed staff has occurred in the Forestry Commission along with their emphasis on recreation. Throughout Britain local authorities now have officers working in all aspects of managing the environment and involving people.

When I became a warden there was no training to equip anyone becoming involved in nature conservation. Working as a volunteer was a way to become part of the system but there were no academic or technical opportunities. Today there are myriad colleges and agricultural establishments offering degrees in a range of land and wildlife management. Perhaps there are already courses in rewilding?

Governments have also made some major changes that improve the safeguarding of biodiversity, with the Wildlife and Countryside Act 1981, the European Habitat and Species Directives, and the creation of the Environment Agencies perhaps being the most significant.

It might seem that wildlife is now safeguarded in Britain, but it all remains vulnerable. The long-term consequences of climate change, agricultural intensification, pollution, and development will always be major threats.

Looking back over the years, I feel there are some aspects of the changes to the Scottish, Welsh and English wildlife agencies that have diminished their ability to protect the environment. They are directly linked but there are three elements that I feel are significant.

- *The break-up of the Nature Conservancy Council* The government set up the former Nature Conservancy (later Nature Conservancy Council) with very focussed policies based on science and research. The agency was filled with dedicated, and inspirational, ecologists and developed into a national network. I remember that if there was a question, for example about entomology, ornithology, or geology, an expert was at the end of a phone and could arrange a visit. That national network and the focus on science and research has gone.

- *The clumping together of the environmental responsibilities* This would seem a positive move, as all the impacts on our environment are linked and should be coordinated, but it relies on sufficient qualified staff and management. My occasional

discussions with former colleagues in the three national agencies reveal that their nature conservation responsibilities are being overwhelmed because recreation, development and agriculture have a higher profile.

- *The diminished power of the national agencies* Would the problems faced by the efforts in safeguarding scheduled coastal sites from golf development in Scotland, or fracking in England, have had a different outcome with a national and powerful nature conservation agency? Long-serving staff I knew in the RSPB and the Wildlife Trusts have negative views about the power and effectiveness of the agencies, which saddens and worries me.

Clump of ash trees, Snowdonia National Park.

Yes, there is so much to celebrate in the work of the non-governmental organisations and individuals in safeguarding our dwindling wildlife. The contributors to this book show the range and diversity of rewilding projects making a positive difference to benefit our wildlife.

The work never ends. National and local governments have policies and commitments to safeguard and improve our natural environments. They must, however, be constantly held to account and balance the pressures from so many other powerful interests.

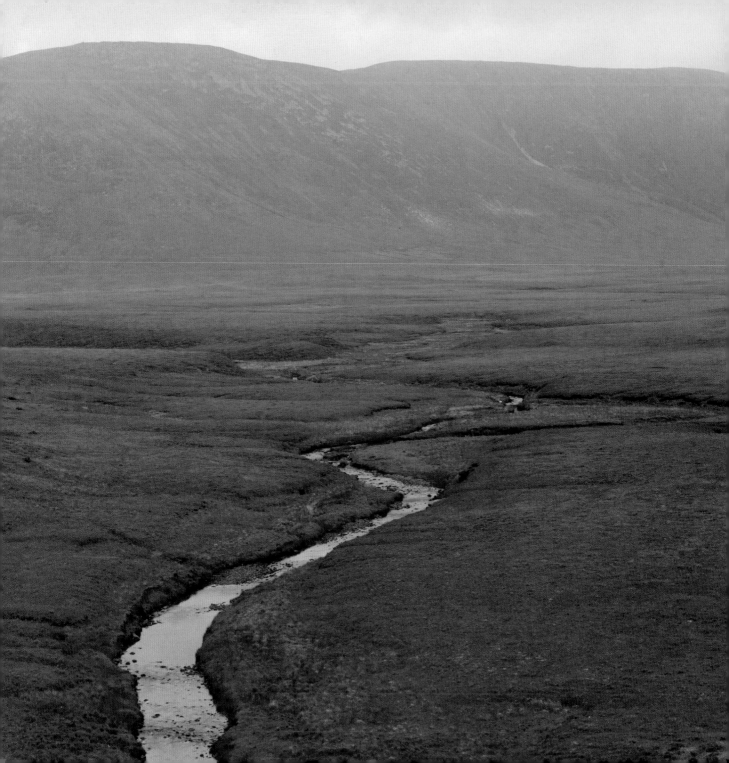

Wild Nephin National Park

Susan Callaghan

The Bangor Trail is an ancient cattle drovers trail that meanders along the western slopes of the Nephin Beg mountain range through the heart of Wild Nephin (Ballycroy) National Park – it leads you to a timeless place. Rainbows are often your welcome banner and a gentle reminder that this can be a 'soft' place where the mist and drizzle is only a rainbow away.

Stunning views immerse you in its enormity – but it can be a bit unsettling in its remoteness. It is not just a simple 'walk in the park'. A few kilometres along the trail a lone, gnarled oak tree (*crann darach*) is a welcoming site in the vast expanse of heath and bog. It gives you comfort, like an oasis in the desert. This oak is a survivor, a gladiator in this wild world.

This long-distance trail (26 km) is the only access into the western side of the Nephin

River Owenduff and blanket bog, Western Ballycroy National Park.

mountains and the Owenduff bog, the largest intact lowland blanket bog in Ireland. It is a wild expansive peatland – one of Ireland's natural treasures. Looking west, the sunlight catches a mosaic of bog pools – a patchwork of life, glittering with the reflections of an ever-changing sky. It's like a universe of planets, each one teeming with life, a minute world within the vast space of bog. The ruins of a cottage along the trail inspires reflection on the many lives that have passed here and, remarkably, some who would have lived here. It was a life dictated by the seaons, where summer grazing for stock brought people into the hills to live. This cottage is long abandoned and nature is reclaiming it. Lichens and mosses decorate the stones and a stunted rowan tree takes root in the tops of the tumbled wall – eeking out nutrients from the slow accumulation of soil in its cracks. The sound of silence can be overwhelming, interrupted

Carabus clathratus, *rare beetle typical of peat bogs.*

occasionally by the guttural croak of a raven, or the descending trill of a meadow pipit. A flash of gold among the dancing bog cotton steals your attention and then a plaintive call. It is a golden plover calling to its mate. This beautiful bird is a delight, it is the pot of gold at the end of the rainbow.

The National Park is managed by the National Parks and Wildlife Service (NPWS), part of the Department of Arts, Heritage and Gaeltacht, and encompasses approx 14,000 ha, including a recent consolidation of lands to the east of the Nephin Beg mountain range, which previously had been managed by Coillte Teoranta (Coillte) for commercial forestry. These lands, like many of the peatlands in

Ireland, were viewed as 'marginal' lands in the 1950s and 1960s and of little economic use – so they were drained, modified and planted to create the monoculture of Sitka spruce and lodgepole pine that now dominates the landscape. These uplands have also been characterised by decades of overgrazing by sheep – a consequence of the broken subsidised system of the European Agricultural Policy in the 1980s and 1990s. This led to serious overgrazing in the hills, with soil erosion, siltation of the rivers and loss of biodiversity.

The Nephin forest plantation is approx 4,000 ha and fringes the entire eastern section of the National Park up to an altitude of 250 m on the eastern slopes of the Nephin Beg mountain range. NPWS acquired these lands with the specific intention to rewild and to allow natural processes to become the dominant driver in shaping this highly modified landscape – where biodiversity is enhanced, functioning ecosystems restored and people have the freedom to engage with nature. A place where the visitor can experience solitude and reconnect with nature. We intend for this area to be the 'honey pot' for the National Park, where visitors will have an opportunity to explore the rewilded landscape along a network of trails. From here the visitor can venture further into the heart of the National Park along the Bangor Trail, where there are opportunities for primitive and challenging recreation in a wild and remote landscape, free from mobile phone coverage, free of houses and roads, free from the noise of a busy world. A place where time passes slowly.

The National Park lands are divided into primitive, semi-primitive and semi-developed natural zones. These zones will guide us on how to manage recreational access, with the overarching theme of a minimal tool approach. The National Park is also designated as a Dark Sky Park, a designation from the International Dark Sky Association. We have committed to maintaining our pristine, unpolluted skies from light pollution.

The rewilding project is ambitious for such a large, highly modified area – and with no budget secured yet for conservation initiatives, or extra staff, the challenges can seem overwhelming when you look at the project in its entirety. The invasive *Rhododendron ponticuum* is a notable concern, with significant mature stands in the south of the site – with the prevailing strong westerly winds, the seeds spread with vigour and wild abandon.

The first major step, though, has been to set out the vision for the rewilding project. A 'Conversion Plan' was completed in 2018 setting out a strategy for the next 15 years, the vision

to move from a commercial forestry plantation to a place where the conditions have been prepared for nature to become the dominant force. Specific measures have been identified for forested and non-forested areas, as well as riparian and aquatic zones. Blocking drains and bog restoration is essential to mitigate against flooding, improve water quality, and enhance linkages and wildlife corridors.

Felling of conifers over the next five years will be significant, with the purpose of creating an open and diverse forest with improved connectivity between bog, mountain, lakes and rivers. Habitat conditions throughout much of the plantation are currently not suitable for native woodland, so the vision is to develop low-density forest which will allow old growth. Broadleaf cover with native tree species will be promoted on suitable soils, as well as introduced tree species of high ecological value (Monterey pine). We will focus planting of native trees along riparian zones and where soils are drier.

We have already started planting small trial plots of trees (aspen, Scots pine, birch and rowan) to monitor success rate in various site conditions. There are significant pressures from grazing animals (deer and sheep), but we have planted aspen on steep ground to avoid browsing animals. The aspen has been propagated from various locations in the west.

We hope to have tree-planting events where local community groups, volunteer groups and schools can come and get involved in the rewilding process.

Deer management as well as rhododendron clearance and control will be essential to allow native trees to establish. The concept of long-term management may be at odds with the overall principle of rewilding, where nature is the dominant force. Without natural predators, though, these two invasive species become the overall dominant force and hinder the natural processes – so it is likely that management of deer and rhododendron will need to continue into the future. Many rewilding projects include the introduction of top predators or large mammals – beaver, crane, black grouse, wolf, lynx – to create a trophic cascade that will balance the ecosystem. It is indeed visionary to try and establish the trophic levels that would have existed here during the postglacial period. Is this a feasible option, though, in Wild Nephin National Park? The state, as landowner, cannot rewild this area without the enthusiasm and support of the local communities. We want to maximise benefits for people as well as the environment. Benefits in terms of environmental services, opportunities to grow ecotourism and 'cottage industry' initiatives.

The National Park should not be a separate place to the local community; it needs to be part of the community. This landscape has been influenced by humans since the Neolithic period. Ancient human remains, discovered by a local hillwalker in a natural boulder chamber in Ben Gorm (part of the Nephin range) in 2016, date back to 3,600 BCE. Research suggests that this site was used as a burial chamber for over 1,000 years. The large ring fort, Lios na Gaoithe (Fort of the Wind), in the northeast of the rewilding site, would have been sited at a strategic location (500–1000 CE) with clear views south and north along the river valley. These

Ballycroy National Park.

views were lost as the conifers grew – but with time and sensitive management this important fort can become part of the wild landscape again, reconnecting the past to the present.

The possibilities are endless, our ambitions and vision are evolving all the time – but with initial small steps and with many steps together, we hope that this place, Wild Nephin National Park, will become an integral part of the community, allowing connection to our past, present and a wild future. A place where peace is found and nature is protected.

A Wetland Wilderness
Catherine Farrell

Hundreds of birds create shadows across the landscape. It's winter. Curlew, lapwing, whooper swan and a range of other birdlife have flocked to the Lough Boora Discovery Park, in the heart of Ireland, to make use of the wide range of habitats that spread across over 3,000 ha of this Irish Midlands refuge.

The Boora Bogs have been central to many changes over the course of their history. Up until the early 1900s most of this area of middle Ireland was a rich tapestry of sphagnum-dominated raised bogs, with associated streams, bog woodland, flushes and the odd human settlement in between. A tranquil place, with little or no industry. But those deep and wet bogs were to become the source of the highly-valued peat that fed the Ferbane power station in County Offaly, and the domestic fire places of families across

Large heath butterfly.

Ireland. To mine the resource, the great bogs were taken on by Bord na Móna (the Irish Turf Board) in the 1930s, working with the local communities who were forging a living in an otherwise bleak time, for the nascent Irish Republic. And so, the wild bog became industrial bog, and habitats and species that had existed there for millennia were pushed to the edges.

At the time, there was no one to shout 'stop'. That didn't come until the late 1970s and 1980s, when the view of the Irish bogs gradually shifted from being one of 'resource and wasteland' to 'wildlife wonderlands and super ecosystems'. The work of ENGOs, such as the Irish Peatland Conservation Council, championed the bogs, and now they are seen more as heritage, than places only worthwhile once drained.

Now that the use of industrial peat is rapidly coming to an end, the future of the

bare, barren, brown peat fields is in sight. The work by the Bord na Móna pioneers at Lough Boora has shown that with targeted and minimal intervention the cutaway bogs can be utterly transformed into a new tapestry, this time with wetlands, such as poor fen, marsh, open water, reedbed and pioneer birch woodland – all precursor habitats of the former great raised bogs. Each of these habitats is of value, and present opportunities for a wealth of species as well as a feast for the eyes and ears. A walk through Ballycon Bog during May will yield vistas of extensive bog cotton with breeding lapwing calling happily amidst a frame of birch woodland. And so, the bogs that had become electricity and heating, and supporting systems for tomato plants, are now the newborn wetland and woodlands mosaic within this rapidly changing landscape.

Because of the extent of the Bord na Móna lands – in the region of 80,000 ha, or thereabouts – there is room for everything. Local community walkways, targeted management for rare and 'on the brink' species like grey partridge, ecotourism, renewables in the shape of wind turbines and solar panels (you must produce electricity somehow!), and the space and solitude for true – what could be called – wilderness.

My own involvement in these landscapes began in the mid-1990s, when as a research student I was tasked with giving 6,500 ha of Bord na Móna industrial cutaway blanket bog, a helping hand 'back to nature'. This was in the west of Ireland close to what is now referred to as the Wild Atlantic Way. The approach I took was to observe what happened when the cutaway bog was left to nature's devices. What I found was that heavily modified landscapes do need a helping hand – especially those bare industrial cutaways of the west. Drain blocking, creating berms to hold water and allowing time for recovery proved to be the best approach. We worked together – nature and I – along with great support from the Mayo bogmen who drove the diggers and excavators, to rewet and rehabilitate the land. When the last drain was blocked, we let go of expectations and left the pockets of bog-moss to grow. And it does, slowly, steadily.

Next to the Midlands, in the mid-2000s, to basically do the same again, albeit on a grander scale. I began a journey of walking through those far less dramatic and exposed industrial bog units, learning from where peat fields had been taken out of production, and imagining how things would be when the Bord na Móna machines passed through that last time on their rehabilitation run.

Where the deeper peat layers are exposed by industrial peat production, fen communities establish with fringes of birch. Where deep peat remains, these are the places where a bit of extra effort can recreate those sphagnum-dominated habitats and true bog formation can be restored.

Like in Ballydangan Bog in County Roscommon. Here, the Bord na Móna ploughs barely scratched the surface and this allowed the *active* raised bog to persist while peat harvesting continued in neighbouring bogs. Ballydangan Bog also acted as a space for the extremely rare Irish red grouse to persist, despite its disappearance from the surrounding bogs. The local gun club and wider community have taken charge here, working to control the fiercely unbalanced predator effect and sustain curlew and grouse, thankfully, successfully and promisingly.

The rehabilitation and restoration work on the Bord na Móna lands today is being coordinated by a small group of ecologists working with a wider team of bog engineers, project managers, surveyors and machine drivers. And, let's not forget the finance people. But those who drained the bogs – the true bogmen – are critical to the successful post-peat phase. Draining a bog for decades creates an understanding of hydrology, and

the fundamentals of ecology. Blocking drains, raising outfalls, turning off pumps – it's all part of enabling the future.

The work to date has been truly transformative, with values for carbon, water, people, renewable energy and nature. With barely 15% of the lands rehabilitated or restored so far, and another 60,000 ha to go, who knows what benefits are to come? The network of sites across the Irish Midlands will link up other state and privately owned lands zoned for nature, and while people will have their place, it will be alongside thousands of species that will find space in an otherwise crowded-out-by-agriculture landscape. Some people talk about the possible return of the great bittern, lost to the wetland drainage of the last century. Others talk about reintroducing the crane. But maybe they'll find these wetland-woodland mosaics on their own, along with who knows what other species.

Let's leave that door, and our minds, open.

Rewilding the Marches Mosses
Joan Daniels

The key to landscape-scale rewilding of damaged wetlands is the restoration of the hydrological conditions necessary for their long-term self-maintenance. For 27 years, I have been lucky enough to lead Natural England/Natural Resources Wales's rewilding of the centre of Fenn's, Whixall, Bettisfield, Wem and Cadney Mosses Special Area of Conservation (the Marches Mosses), which straddles the English/Welsh border near Whitchurch in Shropshire, and Wrexham.

Over the last 10,000 years, a 1,000-ha rainwater-fed lowland raised bog climax community has developed there because of the amazing powers of sphagnum bog-moss. This has created cold-water-logged, nutrient-poor, acidic conditions: pickling a peat dome, 10 m higher than the current flat, drained landscape

Four-spotted chaser, Whixall.

– swallowing up the wildwood and spreading over the plain of glacial outwash sand, to the limits of its enclosing moraines.

However, for the last 700 years, this huge wilderness has been drained for agriculture, peatcutting, transport systems and more recently forestry and even a scrapyard. By 1990, the centre of the moss had a peat-cutting drain every 10 m and mire plants and animals had been eradicated from most of the site. Nationally, less than 4% of lowland raised mires were left in good condition by then: consequently, many raised bog plants and animals are internationally rare and raised bog is one of Europe's most threatened habitats.

A large increase in the rate of commercial peatcutting in the late 1980s led NGOs to form the Peatlands Campaign Consortium, to save the Mosses and others like it. The campaign was driven by Shropshire Wildlife Trust's

Cowberry.

(SWT) local volunteer Jess Clarke. North Wales Wildlife Trust staff, including myself, and SWT staff, aided by brave Nature Conservancy Council staff, particularly Mark July and Paul Day, pushed to get the government to take on the restoration of this devastated site. The realisation that there was not enough raised bog in good condition to meet Britain's

international conservation obligations, combined with the new peat-extraction company finding that the Mosses' peat quality was inadequate to meet their site-rental costs, resulted in the Nature Conservancy acquiring the centre of the Moss in 1990.

Since then, Natural England and Natural Resources Wales have been doggedly acquiring more of the bog, clearing smothering trees and bushes, damming ditches and installing storm-water control structures. SWT mirrored this on the smaller Wem Moss, at the south of the peat body. The knowledge of our local team of ex-peatcutters, particularly Bill Allmark, and Andrew and Paul Huxley, has been invaluable in understanding how to reconstruct the Mosses.

In 2016, a land-purchase opportunity led to a successful funding bid by a partnership of Natural England, NRW and SWT for the five-year, €7-million European and Heritage Lottery-funded Marches Mosses BogLIFE Project, which aims to make a step change in the rate of rewilding of the Mosses.

Importantly, the project addresses a problem affecting all British raised mires – the loss of our mire-edge 'lagg' (fen, carr and swamp communities), whose high-water table sustains the water table in the mire's central expanse. Restoring the lagg involves buying marginal forests and woodland and clearing their smothering trees, buying fields, disconnecting their under-drainage, stripping their turf and reseeding with mire species. A new technique of linear cell damming or 'bunding' the peat then restores water levels. Lagg streams, canalised within the peat during the Enclosure Awards, to lower marginal water tables, will be moved back to the bog's margin, so peats can be hydrologically re-united. And all without affecting our neighbours!

The project also involves adjusting dams on the central mire areas and bunding peats which haven't got a cutting pattern to dam. The project even addresses clearing up the scrapyard and beginning to tackle the problem which is affecting most nature conservation sites nationally – high levels of aerial nitrogen pollution and, at the Moss, its consequent high coverage of purple moor-grass.

So why bother with this mammoth struggle on such a damaged peatland? In the 1980s, the main driver was biodiversity – its unusual bog wildlife, its cranberries, all three British sundew species, lesser bladderwort, white-beaked sedge, its raft spiders, large heath butterflies and moth communities, including Manchester treble-bar, silvery arches and argent and sable moth. Despite its devastation, this huge site provided corners for rare wildlife to hide in, waiting for the restoration of mire

water tables. Today crucial bog-mosses have recolonised central areas and flagship species like the white-faced darter have been dragged back from the brink of extinction. Now, in spring, rare mire picture-winged species like *Idioptera linnei* dominate the cranefly community and the mire spider community is breaking national records. Regularly, invertebrate species, often new to either countries or counties, like micro-moth *Ancyllis tineana*, emerge from hiding, and the wetland bird community now is of national importance.

But today the driver for rewilding the Mosses is also restoration of the ecosystem services provided by a functioning bog – regulation of water quality and flow (particularly important with increasingly frequent flood events), re-pickling the bog's vast carbon stores so their release doesn't add to climate change and encouraging future carbon sequestration.

The growing pride for the restored Mosses in the local community and the increasing numbers of visitors from far afield, boosting the local economy, are a testament to the success of rewilding this quagmire and will be helped by further sensitive provision through the BogLIFE Project.

Wading through knee-high bog-moss on Clara Bog in central Ireland some years ago, brought home to me the potential resilience of bogs and their capacity to regenerate themselves after damage. The bog was acting like a giant shape-shifting amoeba: localised marginal drainage for domestic peatcutting had made the crown of the bog dome move, channelling more water and nutrients to a shrunken area, accelerating the accumulation of bog-moss and ultimately restoring the bog's profile. Even at our devastated Marches Mosses, particularly with the challenges of climate change, the only viable option for the landscape seems to be a return to functioning raised bog. The bog is shrinking towards the lowered water table set by Enclosure Act culverts, making other land uses progressively less economically viable. Now forests fall down, marginal fields flood and pumping costs have become more expensive and cause further peat shrinkage.

Now, like at Fenn's and Whixall, it is the time to capitalise on these devastating consequences of past drainage, to be bold, to grasp opportunities and to rewild our wetlands and regain their age-long benefits for all of us.

Curlew in flight.

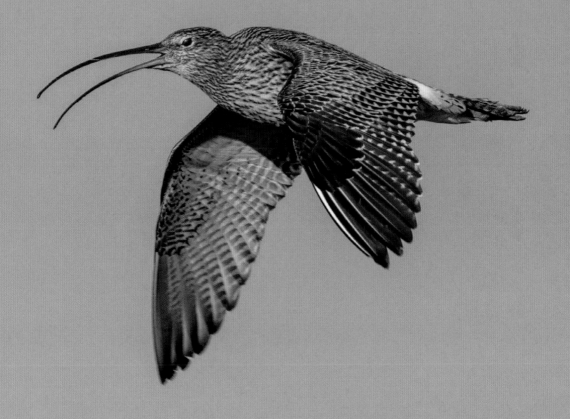

Kielder's Wilder Side
Mike Pratt

Kielder wildwood is a wilding project with an especially big ambition. It is a woodland restoration and creation project in its own right, but is also conceived as a means to a much greater goal – that of integrating degrees of restored natural processes across the vast landscape of forest and open land between Whitelee Moor on the Scottish border and the whole of the wider Kielder Forest and Water Park landscape. Indeed, the wider vision is to extend this wilding approach across the Scottish border and to complement the already largely rewilded Border Mires – one of the largest restored peatscapes in England.

Thus, we are working with our partner landowners the Forestry Commission and Kielderhead (cross-border) Committee and others, to make all of the area wilder by degrees, recognising that even within the commercial forestry areas, there are already integrated wild

Rewilding site, Kielderhead Nature Reserve.

lands, such as impressive riparian corridors. If nothing else, this Kielderhead wildwood concept is ambitious and certainly landscape-scale – more a 'future proofing', area-wide approach, than a mere project.

Part of the vision is very much about creating a 'forest for the future', a more natural, open montane woodland of mainly native species, with a more complete ecosystem over the longer term. Initially, this will focus on a 94 ha area of the Scaup Burn valley, which will be planted with 39,000 trees over three seasons, all by volunteers.

We recognise we are starting not in prehistory but in the twenty-first century, in a commercially important, working forest context and we have reasonable acceptance of this in species-mix selection, management and establishment techniques.

This vast area of open land runs for over 8,000 ha up to the Scottish border. Today many of the hillsides beyond where plantation forest

is still maintained are devoid of trees and, because the blanket bogs on top of the moors are important open landscapes in themselves, tree cover is actively discouraged. Large areas have special conservation designations to protect their special habitats and species, though often such land has the marks of human interference, being prepared long ago for possible forestry use.

The idea is to create 'future-scape wildwood', which has elements of species and habitat that thrived in prehistoric times here when the ecosystem was more complete. We aim to plant locally appropriate species such as downy birch and rowan, willow (some of which is already recolonising areas), juniper and many other species.

People are closely involved, despite the area's remoteness. We started gathering local seed early on, including from rare old pines, growing seedlings with a view to planting to local seed stock. We draw additional inspiration from historic and prehistoric perspectives locally.

One key feature is a group of old Scots pines, the 'William's Cleugh Pines', long thought be possible remnants of ancient or even prehistoric lineage – if true, they would constitute the first confirmed specimens of native English Scots pine.

Genetic work that has been carried out is inconclusive, but nevertheless the possibility remains of Scots pine being a surviving component of prehistoric forests. Evidence of the ancient forests is seen in the peat beds underlying the site and exposed in banksides and the burn – a layer of horizontal forest dated to 7000 BCE, including pollen and preserved evidence of pine.

In addition to this, a branch was discovered in the side of the burn that dated to the fourteenth century and clearly exhibited beaver activity! In these historic remains we have perhaps some historical precedent, if we needed it, to develop a restored and more natural ecosystem.

Thus far we have initiated a massive volunteer effort in the middle of nowhere and started the establishment phase – the rewilded landscape is already taking shape, with 7,000 trees planted in the first year. We bid for and won Heritage Lottery funding, which is now enabling staff, volunteer effort and material planting and development of the project. We've brought on board world-renowned experts and undertaken micro-propagation from those old pines.

We are also addressing the cultural resonances of this remote part of the Anglo-Scottish landscape, a disputed land for

centuries and perhaps also in the future, as border politics have definitely not completely gone away. Allied to the wildwood project we have successfully undertaken the Restoring Ratty project, aiming to restore water voles to the catchment.

What then might the future look like in decades to come? Ecological change is a certainty, natural processes will be restored, more natural and complete ecosystems come into effect and this should include the restoration of absent species.

Despite the very man-made nature of Kielder Forest and Kielder Water, the scale and breadth of wooded and open habitats across the whole area makes for a very natural feel, similar in character to parts of Scandinavia, and it is already surprisingly diverse relative to other areas of the UK.

Kielder already carries significant populations of key species like red squirrel (largest population in England), roe deer, badger, tawny owl, otter, wild goat and now, once again, water vole. Pine marten are recolonising themselves, golden eagle have just been reintroduced over the border and we hope may re-establish. We have osprey and other rare raptors that have come in – and a very wide range of bird, amphibian, reptile, insect and plant species, as expected.

So, in the future it can be envisaged that this rich range of species will be strengthened and extended – and joined, eventually, by beaver and even, perhaps, wildcat and other larger predators and herbivores: judiciously reintroduced after proper inclusive consultation and preparation. Reintroduction of species is only a long-term aim here and not the prime focus of the wildwood and Kielder in these early stages. Habitat restoration and development, though, will tend to lead the way to this.

This is a large, potentially resilient, forest area and, as it becomes more naturalised, will develop a sophisticated ecology. Balanced against this will always be the needs of commercial forest interests and the views of local farmers, and communities who live here and manage large areas nearby for other complementary uses. They too are part of the developing ecology of a 'Wilder Kielder'.

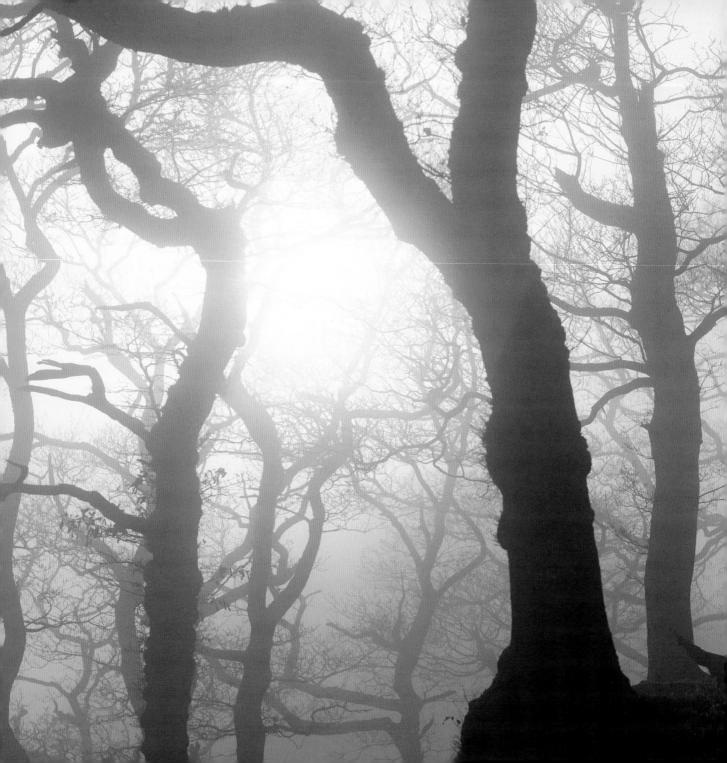

Minimum-Intervention Woodland Reserves
Keith Kirby

The composition and structure of British woods has been shaped by centuries of management. However, in the second half of the twentieth century many semi-natural woods were left alone, either deliberately set aside as minimum intervention reserves, or left largely unmanaged because there was no market for the timber. Most of these areas are small, typically a few tens of hectares; mostly young-mature stands with dense canopies.

Such reserve areas were set up in Wytham Woods under the guidance of Charles Elton, shortly after the woods were donated to Oxford University in 1942/3. He later commented:

> It is ... clear that Wytham Woods have not for many centuries been 'virgin', though if given the chance to do so they might well

Oak woodland at sunset.

return to something resembling a natural woodland, even if this would be different in composition from the original Saxon forest. What could be more fascinating than to watch this happen and record its progress over a hundred years or more, armed with the methods of modern ecology?
> (*The Pattern of Animal Communities*, 1966).

He did not use the term rewilding, because it had not yet been coined, but some of the underlying ethos is in this quote: recognition of past management effects, a willingness to step back from future intervention, an implicit acknowledgement that this could lead to unforeseen changes.

Another Oxford ecologist, Eustace Jones, was at the same time making baseline records in what has become the best-documented example in Britain of a minimum intervention reserve at Lady Park Wood in the Wye

Valley. Subsequently George Peterken and Ed Mountford have described the changing fortunes of different tree species in the face of disease, drought, mammal attack and falling off cliffs. Lady Park Wood has had highly dynamic tree and shrub layers – other stands, such as that at Sheephouse Wood, have shown very little change over 35 years, apart from a few individual oak tree deaths.

Underneath the canopy, the ground flora of these rewilded unmanaged broadleaf woodlands has tended to decline in species richness at the plot level: light-demanding species are particularly affected. Dead wood has generally increased, although evidence for increases in associated specialist invertebrate species is limited. Losses of existing veteran trees that have become overtopped by younger growth have not necessarily been matched by new ones developing due to stand age structures.

The original 'non-intervention' intention has often had to be set-aside: increases in deer range and abundance since the 1950s have forced interventions (fencing, culls) because of the small size of the stands. Trees by paths have sometimes had to be felled for safety reasons. There may be future human-induced changes due to the build-up of nitrogen in the soils from emissions from nearby roads, power stations, etc.

Large-scale rewilding has emerged independently as part of the conservation toolbox in the last decade, but there are lessons that can be learned from studying the longer-running minimum intervention woods.

- Different sites will follow different trajectories and the long-term outcomes are not always predictable.
- Species may be lost as well as gained; areas may become less diverse in the short term as the effects of past interventions fade out, even if there is scope for longer-term diversification.
- External pressures may require some form of human intervention from time to time.

Rewilding is an exciting approach to conservation that should run alongside existing species and habitat management. However, we need more modelling and projection of what changes in landscape pattern are likely to emerge under this approach, along with long-term monitoring of places such as the Knepp Estate (pp. 139–43) and Wild Ennerdale (pp. 59–61) where it is being put into practice.

Pearl-bordered fritillary, Denbighshire.

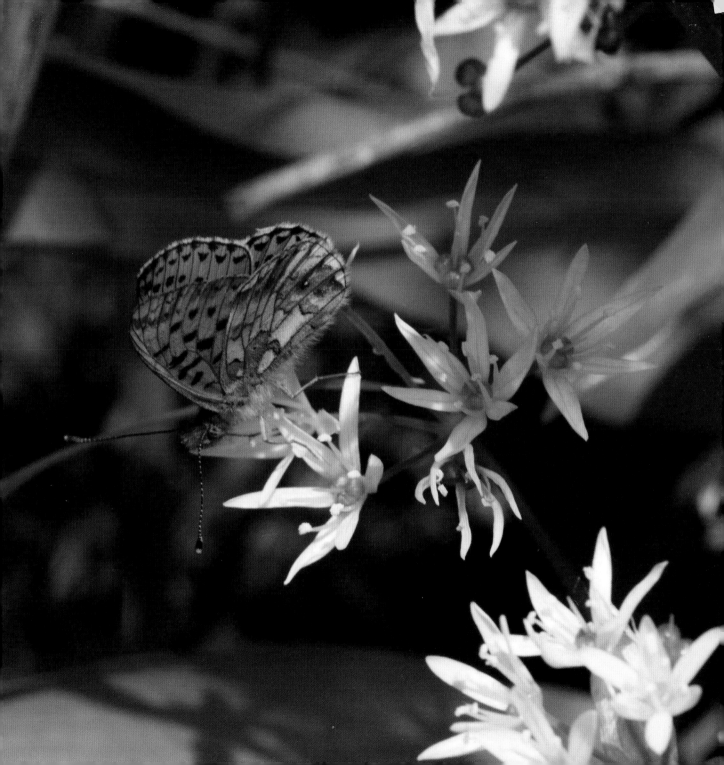

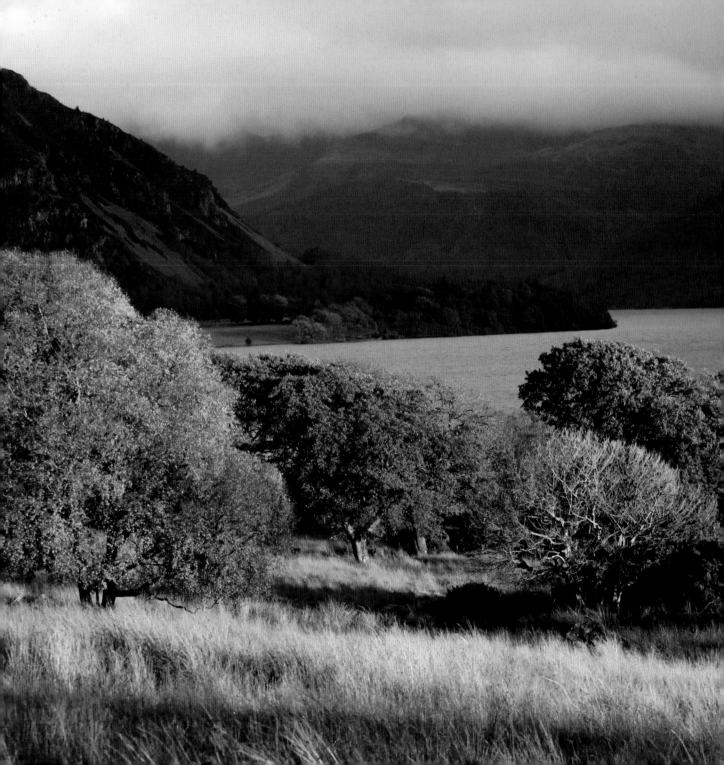

Wild Ennerdale: Shaping the 'Future Natural'
Rachel Oakley

Everywhere you look there is hope; something blossoming, or growing, or recovering, or just being there in balance with nature.

Simon Webb,
Natural England and Wild Ennerdale

Hope is essential for anyone involved in nurturing our landscapes. Channelling that optimism into delivering real change takes an open mind, patience, courage and resilience. Multiply that among a group of people to make things happen and that energy can be a powerful tool and reap great rewards for a place.

Ennerdale allows us to nurture aspirations. It has a unique beauty within the Lake District landscape where forest, rivers, lakes, mountains, woodland, wildlife and people combine to give a sense of nature being in charge. It's a landscape that's seen the ebb and

Oak trees and Ennerdale lake.

flow of human activity for thousands of years and is far from being ecologically pristine.

In the late 1990s, discussions started about how to do things a little differently in Ennerdale, triggered by the changing economics of commercial forestry and farming, along with a new staff member for National Trust. Wild Ennerdale began as a concept in 2003, establishing both a partnership and a set of guiding principles. The partnership brought together the three largest landowners with the principal aims of working at a landscape scale (covering 4,700 ha) with more freedom for natural processes. Key to the vision was people:

To allow the evolution of Ennerdale as a wild valley for the benefit of people, relying more on natural processes to shape its landscape and ecology.

Over the last two decades we have engaged with many different audiences and advocates,

from local school children to key government advisors. Each experience is different and a learning opportunity for us. What is consistent is that we need to continue with what we are doing and do more of it – for nature's sake and our own. The benefits of connecting with nature for health and well-being are well documented. We are learning, too, how nature can deliver more for us through better functioning ecosystems. This was most apparent when Storm Desmond hit Cumbria in 2015 and had a devastating impact on many communities. The clean-up in the aftermath at Ennerdale was negligible, while around the county the recovery remains ongoing, with millions of pounds spent on rebuilding visitor infrastructure and flood defences.

Natural processes are a key driver for our ambition. It's a term we can now illustrate through practical delivery. While our starting point isn't 'ecologically pure', there are processes at work which we can facilitate through more (or sometimes less) intervention to evolve from one state to another.

A shift away from Sitka spruce is one example and none have been planted within the last decade. While the existing non-native spruce will always be a part of the Ennerdale landscape (and indeed tell a story of its industrial past), there are now more broadleaf

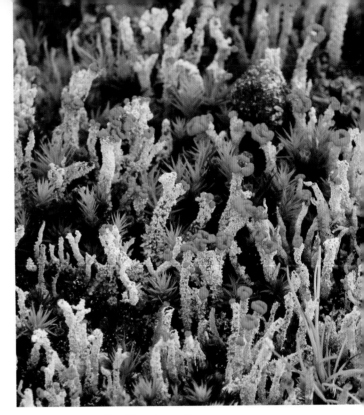

Cladonia *lichen with red fruiting bodies.*

species of oak, rowan, alder, holly, aspen and birch, along with thousands of juniper. Many have been actively planted by volunteers and contractors. In other parts of the valley, trees are flourishing naturally from seed, aided by grazing Galloway cattle. A small herd of nine cows was introduced in 2006 and now graze extensively (about 40 cattle) over 1,000 ha of the valley. These hardy cattle, combined with a reduction in sheep numbers, are changing the farmed landscape. Simply having a more

varied forest with scrubby ground vegetation of species offering depth, structure, colour, shelter and habitat – along with a large herbivore grazing and disturbing within – is an achievement in itself. Harsh boundaries between farmland and forest are starting to blur and new habitats are expanding and recovering upslope beyond existing treelines.

The River Liza is a formidable force within the valley. It's rare in a Lake District context, having the freedom to function naturally along its entire length: from its source at the valley head, through the heart of the middle valley to the lake at Ennerdale Water. It asserts its route with dynamism and energy and has space to connect to its floodplain. The obvious benefits this river delivers is inspiring to observe, particularly after high-rainfall events, with the majority of debris shifted and deposited in the upper valley, well away from the lake downstream and communities beyond. Large boulders, gravels, silts, scrubby vegetation, trees (all shapes and sizes) are on a journey of destruction and creation within a constantly changing river system. In terms of intervention it needs very little, but that in itself is active management. Where existing barriers did exist (such as a concrete ford in a tributary to the Liza), we've removed them. This aided the natural flow of that mountain tributary into the Liza along with the gravels and vegetation it carries. It has also opened up 5 km of new spawning habitat for migrating fish. Along the riparian corridor, the reintroduced marsh fritillary butterfly is now thriving, as wetlands increase and the host plant devil's bit scabious is plentiful.

Whatever we do in the valley and wherever we do it, the impacts of our actions are considered across the whole landscape. It's a balancing act on a big scale, where people and nature are so intrinsically linked that they shouldn't be viewed as separate entities, but rather as processes working more in harmony to encourage a more diverse, healthy and resilient landscape into the future.

Rewilding should be challenging, but not at the expense of action. It is the responsibility of all those of us involved in helping to look after the land to ensure our actions are suited to that unique location, understand our starting point and to tailor different approaches accordingly. By engaging people along that journey, whether advocates or critics, the ambition can become a reality and whatever uncertainties lie ahead, there's optimism that we are on the right track.

Epping Forest: A Wildwood?

Judith Adams

'Whoever looks around sees eternity here'

John Clare

A fragment of the Royal Forest of Essex, dating from around 1100 CE, Epping Forest is London's largest open space of 2,500 ha, supporting the largest number of veteran trees (50,000) of any site in Europe. Crescent in shape, it stretches from East London's Manor Park to Epping in the County of Essex. It provides a playground for Londoners and the northern part in particular, largely from Chingford northwards, is London's 'wildwood'.

The Epping Forest Acts of 1878 (and 1882) brought the remaining forest land into the guardianship of the City of London as conservators, securing its protection as a public open space for the recreation and enjoyment of

Little boy in an Epping den.

the public – while also preserving its 'natural aspect'. It is the first protected conservation area in the UK. Some 70% is now designated as a Site of Special Scientific Interest, with most of that also a Special Area for Conservation. A Green Heritage and Green Flag site and part of the Royal Commonwealth Canopy, it has over 4.4 million visits a year. It continues to be managed by the City of London.

Considering its earlier history, from establishment as a Royal Forest in Norman times, the use and perceived value of the forest has changed. Forest law protected the rights of the King for its use as a hunting forest. The Forest Charter of 1217 gave commoners (freemen only) rights of grazing, cutting of wood and allowing pigs to forage, establishing what we now identify as wood pasture.

As the significance of the Forest laws declined, the Lords of the Manor played a

greater part and, particularly from the mid-1700s, forest land was lost through enclosure – some land taken as parklands for great houses and, later, many acres accommodated the expansion of London. Lopping continued on the forest wastes, but as railways developed and coal became available, lopping declined. After the 1878 Forest Act withdrew lopping rights, lopping only operated in the Parish of Loughton in the more northern part of the forest.

The Victorian period saw the advent of public holidays and tram and rail access to the forest, and the development of recreation, including donkey rides, picnics and outings by pubs, workhouses, churches and workplaces. Golf and cricket began to be played too along with the growth of retreats and large tea houses. Since the early 1970's, schools have visited the forest, supported by the FSC, to undertake field studies and research, along with an increasing number of academics.

Given the forest's high conservation status and its ever-increasing popularity as a place of recreation, the challenges are great.

The current focus of conservation management, largely in the northern part of the forest, has been to re-establish a more open 'wood pasture' habitat – protecting and increasing the longevity of the veteran trees and creating new pollards. This work aims to support and nurture the rich biodiversity associated with these ancient trees and the more open ground and scrub layer flora and fauna associated with grazing – both historic features of forest management/exploitation.

This has involved significant areas of felling/clearance; mainly silver birch and holly, along with some beech and hornbeam and the reintroduction of grazing. Of key concern is the absence of 'middle age pollards' that would provide habitat to accommodate the invertebrate and fungal communities associated with the veteran trees, which now have a reduced lifespan. Will the younger pollards, even with the use of veteranisation techniques (whereby younger trees are 'damaged' in a way which can speed up the process of production of valuable habitats), be able to support these communities?

As the focus currently is to recreate a past management regime in a new time, rewilding has no place here. The threat to the biodiversity, still in evidence from the historic land management would too great to give consideration to rewilding. It is similar to our remaining chalk grasslands, where grazing is being reintroduced to ensure the future of these species-rich grasslands.

But what of its wildness? H. L. Edlin, in *Trees Woods and Man* (Colllins New Naturalist, 1956), expressed great relief that pollarding had stopped: 'Lopping has ceased, and at last

Epping trees of natural form are being allowed to succeed the sorry, grotesque pollards as they gradually decay, so that eventually there will arise a forest of real grandeur.'

What we see now are veteran pollards of real grandeur – celebrated by artists, photographs and our visitors. We too, like the poet John Clare, can experience eternity in the forest – it lifts hearts and provides solace in times of trouble and lies just 12 miles east of St Paul's.

The recent work to restore wood pasture management is changing the forest again, in some areas making it more difficult to get 'lost' in the forest.

So how should this be addressed and does it matter? Wood pasture restoration is designed to secure a future for the rich biodiversity. We don't have a great understanding of exactly what the forest was like over the centuries and how it varied in various manors of the forest over time, from the more productive areas on London clay, to the acid rich soils where the pollarded beech are more common. There is

Ancient beech pollards in mist.

the risk that the increasingly open forest will over-facilitate access to the forest, including mountain bikes, placing the fragile soils and the trees at risk. There are questions around how the current approach will fare in an area with multifunctional use, increasing population and in a period of climate change. Is it sustainable?

What of the 'natural aspect', enshrined in the Act? What will become of it in the future? Will future generations love, value and warm to this wonderful area of Epping Forest? And will it still seem wild?

These are questions that can only be answered by those who follow us. It is so important to work tirelessly to preserve the biodiversity associated with ancient trees. There is an ongoing need for research both of the habitats and species, along with historical studies – what was it really like in past times? And of course, a need, too, for an ongoing assessment of the value of our efforts.

The Burren: History of the Landscape
Richard Moles

The Burren is a large area of karst, covering about 260 km² in County Clare in western Ireland, with a relatively mild, windy and rainy climate. The bedrock is Carboniferous limestone and soil cover is thin, often non-existent, but with scattered patches of deeper soils where glacial sediments were deposited. It encompasses lowland and hilly terrain with level ground rare, but the area provides a very wide range of habitats and supports, in some places, very high biodiversity, including many rare species. Most is used for cattle and sheep grazing, in often small fields separated by stone walls. Larger areas are not effectively enclosed, and these are often heavily grazed by domestic animals and, especially, feral goats. The area was heavily glaciated several times up to 10,000 years ago and in some places it is likely surface sediments were scoured and transported

Mullaghmore, the Burren, County Clare.

elsewhere by moving ice sheets – but seeds may have arrived in sediments transported by incoming ice. Before Bronze Age times, about 3,000 years ago, pine, hazel and yew woodland dominated higher ground, with oak and ash in valleys with thicker soils. Neolithic people cleared some ground for agriculture, but Bronze Age people in Ireland used fire to clear much bigger areas and pine woodland would burn easily. In many places, thin soils on often steep slopes and without trees to protect them then eroded rapidly, creating the multitude of habitats we see today, from limestone pavements with deep grykes and patches of grassland, to hazel thickets and pockets of forest in sheltered valley bottoms, plus temporary and permanent lakes and marshes.

The Burren is a crucial biodiversity hotspot, in part because of habitat diversity, but also because mechanised agriculture is not possible in most areas. Also, following the Irish Famine of

Common spotted orchid and buttercups.

the nineteenth century, the number of farmers in the area plummeted. In addition, the Burren flora contains a puzzling mixture of plant species rarely found elsewhere in Ireland. The spring gentian is locally common in open habitats from uplands down to coastal dunes, but elsewhere this is considered to be an Arctic–Alpine species

(whose seeds will not germinate without frost). Similarly, the woody perennial mountain avens is usually associated with much colder climates, but flourishes in the Burren millennia after the end of the Ice Age and again is not restricted to higher ground. It is not clear where these species persisted when forests dominated the landscape and why they have not been out-competed by Atlantic species adapted to a warmer climate. But, it has been suggested that forests did not cover all areas, creating refuges for these and other species. Adding to this diversity are other species whose distribution is even harder to explain. For example, the Irish orchid is locally common only in the Burren and in a few Irish mountainous habitats. It is not found in Great Britain and, indeed, in Europe is restricted to limestone soils close to the Mediterranean. There is no very clear explanation of where it came from, but is hypothesised to have spread from the south during the Ice Age when sea levels were much lower.

Goats have grazed the Burren since Neolithic times. The terrain suits them, and, unusually, most females produce twins annually. Today the goats are feral, not owned by any farmer, though some kids are taken and occasionally some adults are rounded up and removed. In recent winters, flocks of over 400 goats have been counted and their impact

on the vegetation cannot be over-estimated. Cattle and sheep grazing have more localised, but significant, impacts. The impact of this grazing pressure on vegetation can be gauged by excluding domestic and feral animals from fenced-off areas (exclosures) and monitoring what form rewilding takes inside. One such exclosure on lowland limestone pavement has now been in existence for over 20 years. Outside is largely bare pavement, with small patches of grazed grassland and hazel scrub kept low by browsing goats, which also reduce holly and blackthorn bushes, rooted in protective grykes, to bonsai proportions. Inside, almost all the bare rock is now covered by vegetation, and in some places an organic rich soil cover has developed surprisingly quickly. Heather, not found on pavements outside the fence, dominates in about 25% of the enclosed area, and six other species of woody plants grow taller – including five yew saplings, the seeds of which presumably arrived in excretions from birds feeding on yews surviving on nearby cliff faces. Perhaps if grazing pressure was permanently reduced, parts of the Burren would become covered by yew- and pine-dominated woodland (as is the case today on a limestone outcrop in the Muckross peninsula near Killarney in County Kerry) with large stands of aspen –

the few stands that still persist are aging, as regeneration is prevented. Recently, a stand of Irish pines, long thought to be extinct, has been identified, growing in grykes. Soil erosion is a crucial issue in karst conservation – today, in the many places where grazing has damaged the vegetation cover, soils continue to erode. In wet weather, it is easy to see surface water coloured brown with soil fragments disappearing down grykes and notice that rock outcrops expand in size and vegetation patches shrink as the soil cover thins.

Mountain avens.

Ox-eye daisies.

Limited areas selected for their special biodiversity richness are protected to an extent within the Burren National Park and a nature reserve. A few grass fields within the National Park are managed very successfully to maintain very high plant diversity, with a carefully maintained winter grazing regime. Outside the Park, many farmers have agreed to work with conservationists in an attempt to minimise ecological damage while maintaining livelihoods. Farmed areas vary greatly in plant diversity, but some are relatively species-rich, where grazing pressure is lower. This creates the need for imaginative strategies as, if grazing pressure is reduced within a rewilding plan, ecological succession over time will likely produce first heathland with hazel, hawthorn and blackthorn dominated scrub, and perhaps eventually, a woodland climax. Under this scenario, grassland will become much less widespread, and diversity lost. A management action within the Park has been to attempt to reverse ecological succession by cutting back hazel scrub where it is seen

to be invading grassland. But the Burren is too big and too inaccessible for this to happen everywhere, even if wanted. It is common wisdom that some grazing is required to stop grasses growing tall and excluding other plants. However, it is difficult to identify appropriate native herbivores to replace domestic and feral herbivores – or, indeed, predators to replace farmers in controlling herbivore numbers. Deer would lack adequate cover for many decades and the terrain is often too uneven for them – and too many people live close by to allow reintroduction of wolves to be considered. Thus, while on the one hand current management maintains biodiversity (at least in some places, over the short term) on the other hand, if present rates of soil erosion continue, there will be very negative consequences in the longer term. However, it could be argued that species diversity persisted for millennia when the Burren supported large areas of woodland, so why prevent ecological succession?

The National Park, as policy, provides access for people to explore the Burren, though the rough terrain means that numbers walking are never very large. Thin soils and fragile vegetation on way-marked paths are easily destroyed even at current levels of usage, and soil erosion becomes a greater problem as walkers extend the width of paths to avoid newly exposed rocky ground. This represents another dilemma: a goal of Irish National Parks is to encourage people to experience the more natural world, but within the Burren even small numbers of walkers can have serious consequences for maintenance of biodiversity. Near to paths, ugly piles of cut hazel branches shade out plants and reduce the sense of naturalness, again pointing up the difficulty of unwanted outcomes arising from well-meaning actions. Maybe an argument for rewilding is that human attempts at management for biodiversity seem quite likely to backfire?

Climate change is likely to bring very major changes to the Burren. Thin soils on porous limestone are very prone to summer desiccation, even in short-lived dry weather spells. In recent years, vegetation dieback has been very evident in approximately one year in five. The summer of 2018 was especially dry as little effective rain fell for a month or more, with unusually high temperatures and sunshine totals. Vegetation dieback affected woody plants as well as grassland plants. In the future, longer and more severe droughts may well have a much greater impact on Burren biodiversity than any achieved by human intervention.

Red Squirrel

Craig Shuttleworth

Back in the late 1990s, the indomitable Esmé Kirby and a small circle friends decided to reverse the fortunes of the native red squirrel on Anglesey. What developed may have been at times a little cavalier, but it was always a pioneering, dynamic and community-based programme of grey squirrel eradication and red squirrel population restoration. Success saved the red squirrels and led to the creation of a national island refuge. Quite unexpectedly, some animals even crossed the Menai Strait and colonised mainland woodlands in and around the city of Bangor.

Although nobody had yet coined the term 'rewilding', those early days of the Anglesey initiative would easily fit into any ethos of restoring natural balance: a native animal close to extinction, as a result of competition from a non-native species, which also adversely affects

Red squirrel on tree.

forest ecosystems by bark-stripping hardwood trees and spreading a variety of viral infections to other forest dwellers. As it happens, the removal of grey squirrels did not just result in red squirrels returning to large mature conifer and broadleaved woodlands – they also became a regular sight foraging in hedgerows, parkland and suburban gardens. Indeed, occasionally an animal can be seen dashing along the pavement in the centre of Bangor – bounding across town rooftops, or sitting perched high on top of a lamp post, much to the delight of passers-by. The landscape-scale return of this popular and iconic woodland species has seamlessly created opportunities for the general public to learn about or participate in conservation efforts. A testament is the project's Facebook page which always contains vibrant discussion and a myriad of bright and colourful pictures of these little red garden visitors brightening up people's days. This sharing of experiences and sense of

common partnership is exactly what Esmé had envisaged all those years ago. People have taken red squirrels to their hearts.

Over the decades there were several separate releases of captive-bred red squirrels on Anglesey. The animals were provided by zoological collections from across the UK, each individual being carefully selected to maximise the resulting genetic diversity of the wild North Wales population. Initially, there were many in the conservation movement who decried the use of captive animals, suggesting they would lack the skills and experience to survive in the wild. However, the reality is that the squirrels quickly adapted to a life ranging high in the treetops. Although not everything proved to be smooth sailing, the challenges faced and lessons learned from the island release programme have underpinned subsequent successful reintroductions elsewhere – including those in the north of Scotland and Clocaenog Forest in Denbighshire. More recently, captive-bred red squirrels are poised to be released in Cornwall, to end a 40-year absence in the wild. In all the reintroductions, local volunteers have been empowered with the practical skills and knowledge to participate in and, in some cases, to manage every stage of the release programme. The public effectively took ownership of the Anglesey project, leading ultimately to the creation of the community company Red Squirrels Trust Wales, which carries forward red squirrel conservation through public events, including working groups and guided walks.

The successful return of the red squirrel has now heralded a programme to reintroduce another charismatic forest spirit, the pine marten, to northern Gwynedd. Historical releases of pine martens in the UK have encompassed both the formally approved (e.g. Galloway Forest and mid-Wales) and the more clandestine (e.g. Borders of Scotland). These have almost universally relied upon capturing, moving and then releasing wild-living animals. In Gwynedd, the approach is a little different as the programme uses captive-bred pine martens sourced from across Europe and thus is another partnership with zoological collections. As with the earlier red squirrel projects, there is an opportunity for community outreach to encompass zoo visitors, many of whom may live at considerable distances from the location of a release, yet may very well wish to learn about and support the work. It's often suggested that the pine marten is not a particularly obliging visitor attraction as in the wild the species is not frequently active during the day. However, the captive animals at the Welsh Mountain Zoo have obviously not read the script! They

are regularly active in daylight and when not exploring their enclosure, they will lie up on top of a nest-box lid or a branch while gently dozing in the sunshine.

Two decades of working with native mammals in north Wales have been hugely rewarding. Whether we choose to use the term rewilding, integrated land management, applied conservation or ecosystem restoration to describe it all, the essential ingredients for success remain the same: an understanding of species behaviour and habitat requirements, sufficient resources and community support. Local people made a huge difference through their support, enthusiasm and encouragement, and seeing the pleasure that the presence of red squirrels has brought to them is fantastic.

Pine marten preying on a grey squirrel.

Rewilding Oxwich NNR
Nick Edwards

Many years ago, a much-admired colleague and mentor told me that nature was messy – it was never usually neat or tidy, it didn't come with straight edges, it didn't conform to human ideology, or health and safety – and trying to tidy it up was a battle you could never win. Instead, he suggested, let nature overcome, survive and succeed, as it will be here in all its natural forms long after we are gone – the best we can do is help it on its way and protect it as best we can.

Some people would assume that a National Nature Reserve such as Oxwich would be a wild and natural environment, untouched by human, a haven of wildlife preserved in time, land that needs little management or interaction – they would, of course, be mistaken. Oxwich is a coastal site with an impressive amount of SSSI and SAC habitats and species, knitted together with

Grey heron among the reeds.

transition zones, to make one of the most diverse and important networks of land in the UK.

Some perceived areas of wilderness, such as Oxwich, have been sculpted over time – pieces taken away, some added, changes in landscape often mirroring changes of ownership. The use of the land for economic gain, or recreational enjoyment has had a huge impact on what we see today.

Oxwich National Nature Reserve sits in the heart of Britain's first Area of Outstanding Natural Beauty (AONB), a relatively small Nature Reserve, comfortably sitting under 200 ha, from sea to broadleaf woodland. It boasts over 600 recorded flowering plants between its SSSI and SAC designations.

It's fair to say that most of Oxwich is 'man made' or, at the very least, 'shaped' by the hand of humans, who have owned or influenced the landscape since the Middle Ages. A busy

Lesser horseshoe bats roosting.

commercial port, Oxwich saw the import and export of natural resources from its hub: limestone quarried from the bay, coal, livestock and food, from Gower and beyond, were shipped to Devon and Cornwall on a regular basis ... carefully avoiding the infamous pirating along the Gower coastline.

A twelfth-century Norman castle sits on the hillside, perched over the lakes of Oxwich, later transformed by the landowner Thomas Mansell Talbot (1747–1813), who commissioned Willaim Emes, a student of Capability Brown, to landscape the area – including the excavation of a serpentine lake, in recognition of the Hyde Park system. An area of saltmarsh, with a deep channel utilised by the ships, was drained and a sea wall built to keep the encroaching influx of the formidable Swansea tides at bay, allowing freshwater lakes to be filled by the Gower tributaries.

These lakes, now commonly referred to as North, Middle and South Ponds, are hugely important to the whole Gower ecosystem – they contain important macrophytes and invertebrates, provide a haven for wildfowl, including teal and gadwall, and offer feeding opportunities for the very local lesser horseshoe bat. The ponds, despite being shallow, are populated by large numbers of fish – perch, roach, pike, as well as eel – and provide a good source of sustenance for the breeding otter and herons.

The lakes at Oxwich offer a very important role for the local ecology of the NNR, but, more significantly, play a vital role in the ecostructure of Gower as a whole. As the largest body of freshwater on Gower, Oxwich is a haven for migratory birds. Cettis, sedge and reed warblers, swallow and swift utilise the reed beds –and the occasional bittern can be seen, and sometimes heard, during colder spells.

The management of these lakes has changed over time, more in delivery than conception, spawning a plethora of ingenious man-made floating crafts, powered by engine, people or both. The need to remove vegetation to clear a certain amount of open water has always been the primary objective, creating a richness of habitat attractive to all the associated species, while hopefully encouraging more to succeed.

To manage and maintain these ponds today, bespoke equipment is hired in or purchased to cut the vegetation from the shallower areas of open water, while carefully avoiding the plants we protect. Opening these areas of water, while keeping the fringe vegetation is a careful management method, allowing the balance of species to survive and thrive for the future.

The future plan for Oxwich is to ensure that the balance is maintained across the whole of the freshwater marsh – the need for open water, with fringe vegetation, is hugely important to our aquatic plants, the fish and the animals that feed on them. Wildfowl, whether resident or migratory, need security and space to survive. Our unusual visitors, such as bittern, need encouragement to stay, through carefully selective cutting of reed, with channels, to create their optimal habitat. Successful breeding otter move around the system from water, to bank, to reed bed – the reed bed is also important to our migratory flocks, carefully caught, ringed and recorded by BTO volunteers.

Managing wildlife and the wilderness they inhabit, whether man-made or natural, is a wonderful job, and one that should be cherished and protected, the learning curve can be steep, and the outcomes varied, but with time and trial, the outcome is usually rewarding both for the people doing it and the wider environment.

Cabragh Wetlands

Tom Gallagher

Cabragh Wetlands is a natural fen extending to around 80 ha along the banks of the River Suir, about 3.3 km southwest of the town of Thurles in County Tipperary, Ireland. It has remained a haven for insects, plants, mammals and birds, both native and migratory, for centuries. Some exceptionally rare species have survived here. It is a proposed Heritage Site and a candidate area of conservation.

To preserve this unique natural ecosystem, the Cabragh Wetlands Trust was formed in 1992. It works together with local farmers, neighbours and relevant authorities to protect the integrity of the whole marsh and its diverse range of habitats. The Trust is committed to Conservation, Recreation and Education (CRE) – *cré* is Gaelic for 'soil'.

The Trust is a voluntary organisation supported by Tipperary County Council, The Heritage Council, Tipperary Leader, FAS, TÚS, Shannon Development, Tipperary Enterprise Board, Thurles Lions Club and many other generous benefactors.

In more recent years we have come to value wetlands in a whole new light. They are a flood control system in the landscape. They help recycle and purify water. Wetlands are a haven of biodiversity and they are an effective carbon sink.

The centre is committed to raising awareness among the public of environmental issues across the county and beyond. This is done through a programme of networking, public lectures and courses. We publish a weekly article in the local newspaper *The Tipperary Star*. The centre is used by the Scouts on a weekly basis. Our National Parks and Wildlife Service and Birdwatch Ireland use it as a base for bird-ringing, bird counts and habitat studies. Thurles Farmers'

Summer snowflake, a rare wetland plant, Cabragh.

Donal O'Ceilleachair with his son, Oisin, in an old oak.

Market Group, Suir Farm (the local farmers' organisation) and the Allotment Group hold their meetings there. An art group use it as their base. The Diocese of Cashel and Emly have conducted eco-spirituality workshops and many other organisations rent the centre from time to time. This is happening because of the networking the volunteers at Cabragh engage in with a wide variety of organisations within the county and beyond.

The local community gather there to promote our natural heritage: music, folklore, indigenous wisdom and traditions. People come to the centre on the first Tuesday of each

month for an evening of music, dance, song and poetry. We celebrate important turning points in the year such as the summer and winter solstices and the equinoxes. Over the years, we have celebrated the Celtic Festivals of Samhan, Imbolc, Bealtaine and Lughnasa. At the heart of our environmental concerns is our sense of disconnect from nature. How very different this is from our ancestors who celebrated the fruits of the earth at Lughnasa, or rounded off the year at Samhan, while preparing for the year ahead. At each celebration people with particular talents and knowledge in mythology, botany and meditation offer their gifts. Those present add their insights. St Brigid's Eve is a special celebration. We collect rushes for the making of St Brigid's Crosses. It is the highlight of the evening when people weave their own crosses and bring them home, reflecting the ancient belief that it would protect their homes from fire.

We offer outings for primary schools, based mostly in the outdoors. The programme covers some science strands of the school curriculum. From the outset we were very lucky to have two ponds at Cabragh Wetlands. Dipping the pond and viewing the wildlife quickly became a favourite with the children. Using keys, the children identify the pond creatures. It is very satisfying to see children being drawn into the mesmerising movement and activities of life in the pond. Our experience over the years is that children are as stimulated and energised by nature as any previous generation. The critical thing is access to the natural world and the time to explore.

Secondary school students come for field studies. Like the primary pupils they work outdoors as much as possible. Generally they are students of biology and follow a prescribed worksheet. Our experience is that young people respond positively to nature and they are concerned for the future of the planet.

In 2017 we constructed a Cosmic Walk near the centre. It is a series of ten large sculptures in wood and stone that creatively tell the story of the universe from the great flaring forth to today. It is a great teaching aid for all age groups. The Cosmic Walk offers us a comprehensive story of our relationship with the whole of creation. A copy of the script is on our website (www.cabraghwetlands.ie).

We believe that centres like Cabragh Wetlands are essential as focal points in the community to address all things environmental – as places where people can come to share their concerns and wisdom, and connect with the natural world.

Lough Carra

Chris Huxley

The 1,820 ha of County Mayo's Lough Carra, together with significant areas of lakeshore habitats, is designated as a Natura 2000 site (SAC and SPA), as well as being a Natural Heritage Area and a Wildfowl Refuge. Despite these supposedly protective designations, the lake has suffered an ongoing decline in its ecology over the last 30 or 40 years. But the lake and its surrounding habitats are some of the best-studied in Ireland, and the research that has been carried out here has demonstrated that the degradation of the ecosystem is a result of fundamental changes in agricultural practices, especially intensification, together with some lesser factors such as the appearance of invasive alien species.

The underlying cause of this catastrophic ecological decline has been the 'unwilding' of large areas of semi-natural habitat in the

Rushes at sunset, Lough Carra, County Mayo.

lake's catchment. This has been a process of converting habitats such as limestone grassland, scrub and woodland into 'improved' agricultural grassland for intensive livestock farming, as well as drainage of wetland habitats such as fens and water meadows for the same purpose. Thus, between 1970 and 2000, around 25% of the catchment was converted into intensive agricultural land. The fact that many of the soils were too poor for such conversion to be successful without the addition of large quantities of chemical fertiliser and slurry meant that the catchment experienced an increasing input of nutrients over the same period. These processes continue today, with the result that the lake is becoming enriched and consequently losing its unique quality as Western Europe's finest large, shallow marl lake.

What is now needed to reverse this trend before irreversible damage is done to the lake

(assuming, optimistically, that we have not reached that point yet) is for two major changes to land use in the catchment. Firstly, there must be a reduction in the amount of nutrients that are leaking from the land into the aquatic ecosystem. Secondly, much of the land that has been converted needs to be 're-converted' – allowed to revert to semi-natural habitat. Thus, land must either be taken out of agricultural production (through such programmes as the Native Woodland Scheme) or more sensitive agricultural techniques should be adopted. This last option could include organic livestock, changes to grazing regimes to prevent the loss of species-rich habitats through inappropriate grazing in spring and summer, and the provision of incentives to replant hedgerows, allow wetlands to flood in winter, etc.

Is this realistic? Can we really expect farmers to support this type of rewilding after they have been told for decades that they must intensify and increase production. This to the extent that their basic subsidy payments are often reduced if their land is deemed to be insufficiently intensive, such as having a few trees or some rushes in their fields. I think that if the right incentives are available and the authorities promote their uptake, then many farmers will be glad to revert to what are, in essence, more traditional practices.

The form of rewilding that is envisaged here is a return to land management that encourages and supports native biodiversity. Grazing livestock are, of course, essential to maintain a flower-rich (and thus insect-rich) pasture, but selection of appropriate breeds is important, as is the timing and extent of grazing. On our 2-ha smallholding in the Lough Carra catchment (previously a single field of intensively grazed rye-grass), we used Dexter cattle and Shetland sheep and rotated grazing around several small paddocks to ensure that the grassland flora was able to thrive. We planted small areas of native trees and shrubs and around 100 m of hedgerow. After 18 years, we now have a rich mosaic of habitats with vastly increased bird, mammal and insect species as well as three species of orchid and a rich grassland flora. We have rewilded our two hectares, but with the advantage that we were not farming commercially. Can this be done on farms in the catchment even when a living income must be derived from agriculture? I think the answer to this depends on the government authorities realising that many current agricultural practices are unsustainable and that incentives must be provided to encourage a return to more environmentally sensitive methods. In the UK, the Countryside Restoration Trust has been demonstrating for decades that it is indeed possible to combine

commercial farming with sensitive land use and a rich biodiversity. This successful model could, and should be replicated in Ireland, perhaps through the recently formed Lough Carra Catchment Association following the example of the LIFE project in the Burren, County Clare.

The reversion of land to semi-natural habitat in the Lough Carra catchment would also involve the recreation of areas of scrub, woodland and a variety of wetlands. As small 'family' farms (25–30 ha) run out of children who want to take them over, there are two main options: either they fall into disuse (a form of involuntary rewilding) or they are purchased by the large and very intensive farms. The latter option guarantees the perpetuation of the problem, whereas the former leads to a natural

Marsh fritillary.

process of recreating semi-natural habitats. This can be enhanced through the provision of grant-aided schemes designed to encourage taking land out of intensive production.

If the drive for more intensive agriculture and greater productivity continues in the Carra catchment, then Lough Carra seems destined to become eutrophic and to lose the very characteristics that protected area designation was intended to retain. But if significant areas in the catchment can be reconverted to the rich, semi-natural habitats that existed in the relatively recent past, there is still hope of saving this unique ecosystem.

Time is Running Out
Drew Love-Jones & Nicholas Fox

There has been much talk over the past few years from some of the 'big hitters' of rewilding. Talk of wolves and bear, elk and lynx. They sell us a dream of vast landscapes over which top-down natural processes can take place. Herds of deer being pursued by the noble wolf. The wolf taking the old and the sick and the lame, habitats being restored by reduced feeding pressure and so on. Yes, it works, we only have to look to Yellowstone (although there is now some argument over the validity of these claims), but Britain is not Yellowstone, we have very different land ownership and management models and a very different set of pressures on our ecosystems. If we had vast tracts of state-owned land, well, yes, maybe reintroducing apex predators could

Beaver in Bevis Trust breeding pond.

work – but we don't. We have a very fragmented countryside and an awful lot of fences.

We need to think of many things in the debate about rewilding. Food security, timber supply and public access among them. Then we must also think of our responsibilities to the planet, our own species and other species, not to mention our anthropocentric attitudes. When we drill down into our responsibilities to the planet, we can very quickly realise that overpopulation of a single species has pretty much been responsible for all the ills our world is now suffering. Our inability to recognise this and act on our findings will most likely lead to the end of our species. While we work on a way to sort out this problem, we have a duty to preserve, and, where possible, restore species to the best of our abilities. Recreating a mammoth

from frozen DNA is all very interesting, but it solves nothing. Realising that we, in Western Europe, have lost 75–80% of our insect biomass in the past few years is not sexy science, like the mammoth, but is of the utmost importance. If this rate of change continues, we will see food webs and ecosystems crumbling faster and faster. Time is running out.

So, where does rewilding sit in all of this? Is it even relevant? What is 'the wild'? Has anyone defined the term 'wild'?

Britain is a group of islands over which there are huge numbers of different land uses, users and owners, massive division over how our land should be managed and a great variety of land types. How on earth does one begin to bring together all the disparate, single-issue groups – all so vociferous in defence of their chosen icon? Anglers want fish, farmers have to deal with Nitrate Vulnerable Zones, other folks want to introduce lynx, some want to preserve certain lichens ... the list goes on *ad infinitum*. Often, one group's ambitions are diametrically opposed to another's. For us to move forward, there must be common ground, a common cause. That must surely be to have people living side by side with nature in healthy and sustainable ecosystems.

So, where do we start? From the ground up! The soil and the myriad systems within it. So many of our soils are depleted and are lacking in the vital microorganisms that form the base of any food web. We need 'wild' soils – soils that are teeming with their own native ecosystems, soils that are healthy and productive, not burdened with chemical time bombs.

How do we begin to achieve this? It is easy to say that we must cut back on agrochemicals, fertilisers and the application of slurry, but paradoxically, whilst they are part of the problem, we cannot maintain our current population levels without them. So there has to be balance. We have to farm the farmable land well – with reduced inputs and a higher reliance on technology to improve yields, but we also have to give the more marginal areas to the 'wild'. On our farm we have done precisely this and the benefits are legion. We have high populations of pollinators, wildflowers in profusion and make some damn fine silage. Then we took it a stage further: rather than just let nature take its course, why not help it along? A fag-packet calculation revealed that it would take over 5,000 years for early purple orchids to spread from one side of the farm to the other, even if there wasn't a road though the middle. The logical thing to do is help them to spread. We did. They are flourishing.

A stage on from this was thinking about how nature can help nature. After a bit of cogitation it became obvious that beavers had

a huge role to play. As habitat creators they were the perfect tool to help restore some of our degraded ecosystems and indeed create some new ones. Four years on from the arrival of our first pair, we are now breeding around nine real Welsh wild beavers every year. These are going off to help other projects around the UK to get established.

But what of the habitat? Well, it has taken us around 30 years to dig and naturalise 30 ponds on the farm. The beavers have added the same again in just four. Their leaky dams slow flood water run-off and help to filter out sediment from slurry. We readily accept that they will not be welcome everywhere and should be managed robustly, but in the places they can do a good job – boy are they needed.

Without evangelising beavers as a panacea for all ills and without taking the rewilding 'hard line', there is still much that we can achieve in small corners of farms, parks and even gardens. We must employ joined-up thinking, make full use of the farm-payment opportunities potentially offered by Brexit and we must reach out to the hard-to-reach groups. We can, and indeed must, achieve meaningful things for nature, but our watch word must always be balance.

Beaver in wetland.

The North Atlantic Salmon
Allan Cuthbert

For millennia salmon have travelled from the rivers of their birth to the distant waters of the North Atlantic – gathering around Iceland and the Faroe Islands to feed and grow, before returning to to their birthplace. Named by the Romans *salmo salar* (salmon the leaper), it is a fish once so prolific that apprentice's indenture papers would often include an agreement that their employer would not feed salmon to them more than three times in a week. Salmon was considered paupers' food! Yet now these amazing fish are at risk of extinction. This is not my opinion, but that of the Environment Agency in England and Natural Resources Wales (NRW), the bodies, responsible for the health and well-being of our environment. In their combined document *Salmon Stocks and Fisheries in England and Wales 2016*, they

River Findhorn, Strathdearn, Highlands.

classify salmon stocks in the major salmon rivers in their areas as follows:

- of the 41 English rivers, 23 are classified as 'probably at risk', 13 are deemed to be 'at risk' and 4 'probably not at risk'. No rivers are currently classified as 'not at risk'.
- of the 23 Welsh rivers, 10 are considered to be 'probably at risk', 11 are deemed to be 'at risk' and 1 'probably not at risk'. No rivers are currently classified as 'not at risk'.

'At risk of what?', you ask – as did I when discussing this issue with a member of fisheries staff. At risk of extinction. These conclusions are based upon targets relating to the estimated number of salmon eggs laid and the estimated survival rate of the newly hatched youngsters. If insufficient eggs are produced, too few offspring will be borne,

Salmon leaping at Gilfach Nature Reserve, Powys.

numbers will decline and eventually the species will become extinct.

In an effort to reduce the decline of this iconic species, and its close relative the sea trout, the government organisations responsible for their well-being are doing their best to improve in-river habitat and agricultural practices. However, these monolithic organisations are limited in what they can do, so need the help of volunteers to make a greater difference. Organisations like the Rivers Trusts, of which there are a number in England and Wales. These Trusts are, for the most part, headed by the great and good of

the angling fraternity. Anglers, perceived by many to be participants in a cruel sport, have, in recent years, become true environmentalists. They make up the great majority of the volunteers working for the Trusts, and have made voluntary changes to their angling practices: most carefully return the salmon and sea trout they catch, as well as the wild brown trout. Game angling, the collective name for the sport of fishing for salmonids, is no longer carried out to kill fish for the table, but, rather, by those that respect and wish to protect these iconic fish. Many clubs impose a voluntary catch and release policy, with which most anglers are happy to comply. In the case of wild brown trout, these changes have meant a noticeable increase in bigger fish. One club, which has kept meticulous records of all fish caught and their size, has seen the size of recorded fish dramatically increase, such that fish now caught and returned are bigger than have been recorded for over 100 years.

Anglers used to clear all fallen trees and debris from the rivers they fished – now it is common for angling clubs to secure what is called 'woody debris' to river banks to provide protection from predation for small young fish. Trees which once may have been removed to allow easier access to the water for anglers are now not cut down, but rather judiciously trimmed, so that the trees provide the dappled sunlight from which the fish benefit.

The rewilding of our rivers cannot succeed without the consent and cooperation of the angling community. As well as many becoming far more environmentally conscious, it must be remembered that the very presence of anglers on the river banks is a serious deterrent to illegal activities such as poaching, poisoning from dumped or spilled waste and any number of other environmentally damaging riverside activities.

I have used salmonids as an example of currently critically endangered fish; however, the threat to our lowland rivers is, in the long term, no less critical. Especially if we and our children continue to lose our connection to the environment and the attendant benefits that come from being part of the green that makes up so much of our countryside.

For rewilding to be meaningful and successful, it is essential that the general public become aware of their environment and its importance to our well-being. The current obsession with social media and cyberspace is blinding many to the reality that our very survival depends upon a healthy and protected natural environment. Walking along river banks, or sitting by the side of lakes simply fishing, is not only healthy, but life enhancing and results in improved social skills. We need to re-educate before we rewild successfully.

Riverine Integrity
William Rawling

I am just in the process of stepping back from my farming career and slowly handing over the reins to my son and his family.

I have enjoyed my life as a farmer in the Ennerdale Valley and am pleased the next generation chooses to continue the Rawling farming heritage. Rawlings have lived and farmed at Hollins farm at least since local records began in 1545. I was born and raised on the farm and have farmed the place either alongside my father, or with my wife and latterly with my son and his partner and their 18-month-old daughter. My granddaughter is called Juniper; *einir* is an old Norse word for juniper. Hollins farm lies in the western part of the Ennerdale valley, extending east to the fell land at the head of the lake. The lower, enclosed, land, or *inby*, straddles the

Sheep being taken off the fells, Borrowdale, Lake District National Park, Cumbria.

Croasdale Beck, a major tributary of the River Ehen; this land is heavily wooded with natural semi-improved pasture among the trees. The fell land is accessed by walking the sheep from the inby, along the shores of the lake then through the Sitka forestry, to the higher grazing above the forest fence. This land is around the 600-metre mark, with the forestry fence excluding sheep from the lower, more sheltered, fell grazing now covered in trees. From the top of Great Bourne or Starling Dodd over which the Hollins fell sheep are hefted, generations of Rawlings have looked down the valley over our inby land and out to the Isle of Man and the Galloway hills – on a good day you can see the Mountains of Mourne. In the other direction the whole of the Lake District stretches out towards the Eden Valley and the Pennines. This is something very special and, if my sheep are in the foreground, what could be better.

I have an affection for and understanding of the family farm and surrounding area that is has shaped my own life and the history of previous generations. I have spent all of my life farming Herdwick sheep, in pretty much the same way as all of the other Rawlings have, over the years.

Agropastoralism (extensive livestock management) has been the business of the valley for thousands of years. The historic Celtic settlements in the mid-part of the valley are probably evidence of the first farmers. These basic dwellings, established on the fell side above the treeline, are the classic model. A hearth in the centre, surrounded by a circular shelter with an outer ring wall to protect the grazing animals during the hours of darkness. Ironically, many of these pioneer farmsteads are now cloaked in regimented rows of commercially managed Sitka spruce. More on that later.

DNA testing suggests that I have traces of Viking blood and, indeed, the family name is derived from the 'Norman' De Rawnsley – a knight who was rewarded with northern lands by the last invader of the British Isles, William the Conqueror.

I consider myself to be a member of an indigenous race of farming people, using a dialect language heavily influenced by Old Norse, one member of a living testament to the efforts of those people who worked so hard to establish the living landscapes of the Lake District.

The valley in which I have been privileged to have spent my working life has seen many changes since those first farmers chose to settle down. Things slowly became more structured – wealthy, manorial landlords established more recognisable farmsteads. Later, mineral exploitation on the coastal plain fuelled investment in land, the landlords changed. Some more established families bought land themselves and became owner-occupiers, no longer beholden to the landlord – the Rawlings made their mark. In my late grandfather's and father's lifetimes, two world conflicts triggered significant change. Food production was important, the nation needed food and wool. Sheep that had underpinned the British economy, in the form of wool production for millennia, became even more important. Government encouraged increased production and adoption of new technologies to help the war effort. The Ennerdale farmers responded and did what they could, but the fell-going flocks were, to a great extent, unsuited to this purpose because the terrain dictated stocking levels and management techniques. The development happened in the lower parts of the valley. The

fields were drained and hedges were created, moorland became more productive pasture, the nation was fed. Ennerdale did its bit and agricultural support payments kept the price of food low and the consumers quiet.

These World Wars took a greater toll on the valley in the shape of afforestation. The West Cumbria coal and iron ore mines needed pit props, the Ennerdale valley was only 10 miles away from the industrial belt and the port of Whitehaven. Trees became the shape of the future, fast-growing Scandinavian Sitka was the tree of choice – another Viking invasion was underway. Along with European and Japanese larch, the lower slopes of the Ennerdale fells were blanketed with foreign conifers. Native woodland was cleared to make way for the new age and the valley turned a dark green. Gillerthwaite, the largest sheep farm in the valley, the only one at the head of the lake, was compulsorily purchased to feed the new hunger for timber. Unfortunately most of the mines were closed before much of the new resource was big enough to be used. The timber is still considered a commercial crop. Most of it is now used in the form of wood pulp for paper manufacture, or wood chip for the biomass boiler that provides the energy for the paper mill. The sheep farming continues in the same way it has always done but now only above the lines of foreign trees.

Thankfully, the threat to the British people has lessened in the last few decades and conservation has become more of a focus. Hollins farm was an early entry into the new support systems, signing up to the Environmentally Sensitive Area scheme and subsequent Higher Level Stewardship schemes. My wife and I were encouraged by, the then, English Nature to get involved because our fell land had the second-best stand of heather in the Lake District: we accepted. However, this heather, which had survived generations of Rawlings shepherding sheep on it, was considered under threat and we were asked to reduce stocking levels: fewer sheep. We reluctantly agreed, otherwise we would get no financial support and the artificially low price of food meant we were unable to remain viable without government support. A 40% reduction in sheep numbers and complete removal of sheep in winter was what was require, so we were told. We did what was asked of us, played by the rules. The heather today is becoming overgrown with purple moor-grass and has actually disappeared in some places. The enclosed fields are being put under more pressure due to the changed management system. The very thing that created and maintained the magnificent heather (it really was magnificent) – sensitive

management systems based on local experience and natural process – have been removed. We continue to work with, the now, Natural England, who genuinely seek to look after our precious landscapes and habitats. We farmers have the same ideals, we rely on our landscape being healthy – it supports our businesses – but we are often the last to be consulted and sometimes, seemingly ignored. Even when we deliver an outcome based on knowledge and good practice, which our Natural England officers are pleased with, we are not able to pass on the farmer message, because we probably had to bend the rules a bit in order to get the job done. Where is the partnership working? Where is the trust? What is the best way to use a lifetime, or even generations, of knowledge? We need to get answers to these questions.

Recent years have seen the valley become the first area of England to be formally rewilded. A partnership of the The Forestry Commission, United Utilities and The National Trust (the new lords of the manor), alongside Natural England, has established a project called Wild Ennerdale. The very well-meaning conservation groups set about turning back the clock and returning the valley back to its natural state. This involves the removal of non-native trees, including some mature beech trees (apparently beech is not native to northern England). Native hardwoods are being planted, native cattle have been introduced to some of the conifer woodlands, old farm boundaries have been removed to allow supposed natural process. The River Ehen and its population of freshwater pearl mussels are being protected and, to some extent, managed. Farming continues in the western valley and the sheep still graze the upper fells above the artificial treeline. Commercial forestry is still practised on the northern side of the valley and diseased larch requires attention on the southern slopes. The lake no longer provides water for the west coast communities – new pipelines from coastal boreholes and Thirlmere ensure no one is thirsty and the flow levels in the River Ehen remain at the right level for the pearl mussels. Water-course fencing along river and tributary channels keep the grazing animals out of the becks. Two smaller farms adjoining the river have been purchased by United Utilities (water company) and taken out of production. One of the farmhouses is scheduled for demolition and the other falls into disrepair, while young valley residents are priced out of the village community.

In principal, I have no objection to conservation, even rewilding in some areas. I respect the valuable work that many people do, for all the right reasons, to protect our fauna

and flora. I do sometimes wonder if they have got it right; after all, it is a big experiment without a known outcome. I am sometimes pretty sure they have got it wrong, but I am no scientist. I wonder who decides which particular part of evolution we are trying to recreate and how do we know what it looks like, or when we get there. Maybe another Ice Age is the answer. It sculpted the valley and the volcanic activity prior to that provided the rock and minerals to work with. These activities made the soils that the plants needed to establish themselves and in turn support wild populations of animals. Animals that became our hunted quarry and then farm livestock. Humans remain the one species that can trigger change. Problems are worldwide; we do need to respond, but in an inclusive way that everyone signs up to.

I do know that the Ennerdale fells still look spectacular, even though they have been farmed in the same way for centuries. I know this because my family has been responsible for a part of the valley for a long time. I know that sensitive, extensive grazing provides us with food and fibre. I know that the fells have received no fertiliser or crop spray. I am proud of the fact that we still shepherd the flock on foot with our sheep dogs. I love the land I farm and I only want to make it better for everyone

in the future. I have no reason to destroy a resource that has supported generations of my family and continues to support me, my wife, my son and his family. I enjoy being part of the valley community, even though most of the residents now work at the nearby nuclear power station and know nothing about Lakeland shepherding. I get a buzz from making them more aware of exactly what is around them – a farmed environment that has been infiltrated by industrial needs, but is still considered worthy of protection. We need to be careful what we choose to preserve; if some of it is allowed to disappear it will never come back. Let us keep Ennerdale as a working valley with all the required skills we need to keep it functioning. The valley has undergone huge change but the farming is a living reminder of how it all started: best not to forget.

Those Celtic settlers would recognise the way my son and I go about our sheep farming; I wish the new settlers even understood the basics. Anyway, they can rely on a good income from energy generation – they will probably never be hungry.

Moorland

Geoff Morries

As you value your life or your reason, keep away from the Moor.

The Hound of the Baskervilles

'Moor' or 'moorland' is defined as a 'tract of unenclosed, often heather-covered, waste land or of similar land preserved for shooting'. Waste land is defined as 'uninhabited, desolate, barren or uncultivated', and the word 'moor' is in fact from the old English meaning 'dead' or barren. Thus, moorland is defined in terms of its utility (or the lack of it) to people, and by people's emotional reactions to it, as much as by the facts of its intrinsic physical character. In general, it was, and still is, seen as wild, untamed and unfamiliar, if not downright hostile – perceptions immortalised in Victorian novels such as *Lorna Doone*, *Wuthering Heights* and *The Hound of the Baskervilles*. More recently,

Langholm Moor, Dumfries and Galloway.

the real-life atrocities of the 'Moors Murderers' helped to reinforce the idea of moorland as a dark and dangerous place. And walkers do still get lost, injured and die from hypothermia on moors. By way of contrast, William Atkins' recent bestseller, *The Moor: A Journey into the English Wilderness* (2014), describes a series of uplifting and enlightening experiences, but also shows that a view of moorland as 'daunting and defiant' is alive today.

While justifiable in part, the view of moorland as 'waste' may reflect the fact that it is most typically a feature of north and west Britain – in other words far from the Home Counties (although 'moor' has also been used to describe wet riverside meadows and other rough swampy areas in the lowlands). A divergence of interests in British moorland can be traced back at least to the time of the Normans, who set aside large areas of what was then wild land in England as 'forests'

or 'chases' where royalty and nobility could enjoy the pleasures of hunting deer. After the medieval period, much of this land was enclosed and settled, but considerable tracts remained as open moorland. For those folk who actually lived on or by the moors, the land could provide rough grazing for livestock, heather for thatch, peat (and wood) for fuel and food, by way of wild birds and animals, or fruit. Well into the twentieth century, bilberries were harvested in industrial quantities in Shropshire and loaded onto trains for the Lancashire mills, where they were used to dye cloth. Although moorland has been a diminishing resource for centuries, the human impact on the large areas that remained 250 years ago was relatively slight.

From the eighteenth century onwards, the work of agricultural 'improvers' who urged that moorland should be reclaimed for more productive uses – industrialisation, sporting and other recreational interests – has changed that picture substantially. So how natural are our moorlands today? To answer this, we need to look briefly at how they originated. In very simple terms, moorlands have developed in two ways. Firstly, with the onset of a cooler, wetter climate in Britain some 2,500 years ago, elevated plateaux in high-rainfall areas developed peat-forming 'blanket' bog based on

the growth and incomplete decay of sphagnum mosses, where trees had formerly grown. Secondly, scrub or woodland on thin, usually acidic, soils was felled or burned by human settlers, and subsequently grazed by farm animals to maintain a largely treeless upland landscape. This process may have started in a small way as long ago as the Mesolithic period (around 8,000 years ago) and accelerated in later prehistoric times. There is even evidence of prehistoric field systems and arable cropping on what is now moorland in a few places. Thus much of our moorland owes its existence to human activities.

The most complete change, of course, is the actual loss of moorland through reclamation and enclosure – by energetic landowners, or the growth of upland industrial settlements based on water power or mineral extraction, as well as the locally knotty problem of squatters. However, more than local industry, it was the rapid growth of towns and cities, and their industries, in Lancashire and Yorkshire in particular, that had the most dramatic effect on the high moorland vegetation in the mid-Pennines. By the middle of the twentieth century, air pollution was so bad that only cottongrass survived, as one writer put it, 'rooted in soot and watered by sulphuric acid'. Elsewhere, drainage of blanket bog, regular

burning of the vegetation to benefit sheep or red grouse, and increasing numbers of sheep in particular have simplified the structure and diminished the biological diversity of what remains. Wildfires, started deliberately

Iron Age hillfort and Offa's Dyke, Vale of Clwyd, Wales.

or accidentally, have also had a major impact of this kind locally, as in parts of the West Pennine Moors.

One of the earliest ways in which moorland came to be seen as a strategic asset in the public interest was as water-gathering grounds for new reservoirs, and from the 1850s onwards, large areas in the vicinity of northern towns and cities were acquired in order to supply their inhabitants with clean drinking water. The water undertakings have been both a force for change and for conservation. Farming tenants were severely restricted in terms of what the land could be used for and what could be used as manures and fertiliser. Many small farms were abandoned altogether in the interests of safeguarding the water supply. At the same time, significant areas were drained and often planted with fast-growing conifers on the grounds that this reduced erosion of the peaty soil. The destruction of wildlife-rich bog in order to plant conifers continued until fairly recently in Scotland, driven purely by financial incentives.

The other obvious way in which a wider section of the community claimed a stake in what happened on moorland was over public access. While in practice there had long been unrestricted access to moors in Scotland, this was a hotly contested issue, particularly in the

Bilberry bumblebee.

southern Pennines – leading to actual physical violence between members of the gamekeeping and rambling fraternities, most famously on Kinder Scout in 1932. The appropriation of moorland for military training has also provoked conflict with recreational interests. Indeed, not until the passing of the Countryside and Rights of Way Act in 2000, was a general right of public access on foot established, with conditions that allow sporting and military activities to continue.

So what of the present day and the future? Conflict, as ever, grabs public attention more than compromise or co-operation. Grouse shooting can be very lucrative, but maintaining artificially high numbers of grouse depends not just on land management (which can benefit other wildlife), but has led to the controversial use of medicated grit and the illegal persecution of rare birds of prey, especially hen harriers. Although mountain hares are being killed in Scotland for the sake of grouse, the Langholm Moor project in the Scottish Borders has set out to show how sporting and wildlife can co-exist.

Some of our most degraded moorland is now regenerating itself as atmospheric smoke and SO_2 levels have fallen dramatically – although rising levels of nitrates in the air and soil could affect this process in the future.

Conservation bodies, water companies, as well as some private owners are taking active steps to restore moorland by reducing livestock numbers, blocking drains, reseeding eroded areas, managing access better – and plans are afoot to reintroduce lost species. In 2018, dwarf cornel flowered at its most southerly locality in Britain, north of Bolton, the first time at this location since it was exterminated by wildfires in the 1970s.

Such actions have clear objectives and are supported by scientific knowledge of moorland ecosystems. With increasing concern about climate change and its effects, the conservation of moorland in its proper sense (wise use) is likely to gain traction in the light of what we now understand about the role of peat, in particular, in storing both carbon and water, thereby reducing carbon dioxide emissions and mitigating against catastrophic flooding. Rewilding involving, for example, permanently excluding livestock from large areas (raising the possibility of moorland reverting to scrub woodland), allowing wild herbivores to multiply unchecked, or the introduction of large carnivores, might best be consigned to the proverbial long grass, at least for the time being.

Reflections on the Summit to Sea Project
Rebecca Wrigley

O'r Mynydd i'r Môr, or Summit to Sea, is a big idea. It's a call for the renewal of wild nature and rural communities in mid-Wales, across an area that stretches from the Cambrian Mountains, down wooded valleys and along the Dyfi estuary, and out into Cardigan Bay.

Many of us who know and love this part of Wales will have looked out across the sweeping landscape from the high slopes of Pumlumon and asked what the future holds for this place.

This is a region rich in natural and cultural heritage. Pumlumon itself is the source of the rivers Severn, Wye and Rheidol. Owain Glyndŵr, the last Welsh Prince of Wales, won a famous victory against English forces in the hills here, 600 years ago. The river, winding its way to the sea, is flanked by precious floodplains, intertidal marsh, raised bogs and finally the dunes of Ynyslas.

Ospreys nest on the raised bog near the Dyfi estuary, Ceredigion, Wales.

But this is now a fragmented ecosystem, following centuries of mining and, more recently, intensive grazing and the march of thickset, commercial timber plantations. It's missing many of the wild sights and sounds that would have been familiar to those living in and visiting the area even a few decades ago. And many people still struggle to make a living here.

In the summer of 2017, we sat down with over 40 people from the area and shared thoughts about the future of the land and sea. They composed postcards to themselves about how they wanted the future to look. There was so much common ground and shared vision.

Those who attended the meeting saw opportunities for all ages, connected communities, and working economies. They saw the challenges of making change, finding balance and of keeping things going. And they saw the prospect of belonging, in thriving places rich in nature.

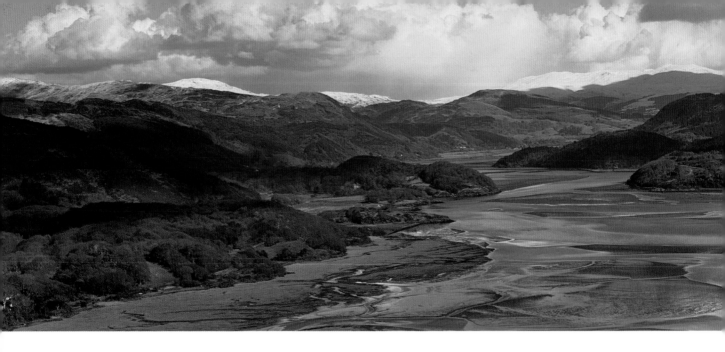

This is what Rewilding Britain was set up for. Since 2014, we have been looking at how we can demonstrate a different model for the land and sea, that works for both people and nature.

Over the past few years, we've been working behind the scenes with conservation organisations, landowners and community groups, as well as public bodies and businesses, to shape a vision for Summit to Sea. Funding was secured in autumn 2018, as one of eight European projects selected by the Endangered Landscapes Programme, to begin in earnest.

There's much to be learned. Some of this will be about rediscovering knowledge. Although we have a long history of coming together to manage the land and sea, we're now not so used to doing so. And working together can be hard.

Thus the greatest challenge will be to find effective mechanisms, for people to have an ongoing role in the governance of Summit to Sea and to allow for revenue and other benefits to be shared.

A core group of conservation bodies have been actively involved from the start. They bring a combination of practical expertise plus areas of land and sea that are already managed for nature conservation.

Many local people and other organisations have helped design the project too. These range from farmer and landowner representative bodies and a number of local farmers to

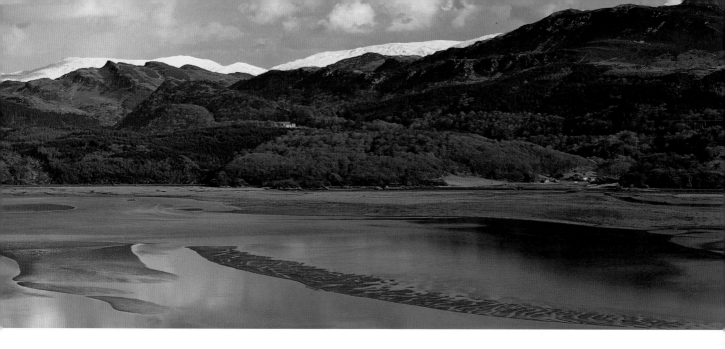

Business Wales, Dyfi Biosphere Reserve, Cambrian Mountains Initiative, Ceredigion and Powys County Councils and Welsh government.

We have opened a conversation with as many people locally as possible about the potential for Summit to Sea, and have been delighted by their openness to having that conversation – and for raising any doubts or concerns. There are many more conversations to come.

Summit to Sea offers hope. Imagine standing on the high ground of Pumlumon in 20 years and looking out towards the sea across a rich mosaic of forest, glades and wild pasture, that shifts and changes in response to natural processes.

Mawddach Estuary, Snowdonia NP, Gwynedd.

I'd like to watch black grouse picking their way through the trees; to look over at the revitalised buildings at Maesnant and see young people having adventures in the landscape; perhaps catching a glimpse of a beaver cutting through the waters below.

I've been involved in conservation and community development programmes for over 25 years. More than at any other point, I feel that we have a moment of opportunity, to demonstrate that renewal and hope is possible, for us, for the places we live in and for wild nature.

The South Downs

Phil Belden

The South Downs, haven of peace and tranquillity in over-busy, built-up, South East England. Development-led, nature-tamed, rewilding is a relative term. Here a more natural environment survives; the challenge is to help it thrive.

Our blunt, bow-headed, whale-backed Downs, escarpment rising up as a sheer wall to the Weald, magnificent and imposing (see Kipling's 1902 poem, 'Sussex'). Yet it's not 'wild'. Over the millennia its form has been softened, to form rolling hills and coombes, pleasing to the eye, a curvaceous feminine landscape. This chalk downland, draped in verdant veil, modestly hides the drinking-water aquifer, life-blood to over a million people.

There is a lack of formality. This is not the perceived English countryside (that

Fulking Escarpment, South Downs National Park, West Sussex.

quintessential patchwork quilt of fields), but bold and open, expansive rolling hills, clean of officious fence or hedge, half-wild and wholly tame – well, relatively so.

The South Downs lost its wildwood some 6,000 years ago, cleared by early man. Its abundance of humps and bumps – ancient routes, fortifications and ritualistic burial grounds, pock-marked faces of hills, scarred by Neolithic flint mines, to more recent linear terraces of medieval field systems – are clear evidence of earlier habitation.

Gazing in wonder at this big-country glory, it's easy to overlook the detail. Underfoot, the soft, springy turf. Strolling over this herb-rich pasture, serenaded by the song of the skylark, smell the air, hints of thyme and marjoram. Drop to your knees and enter a world as rich as a rainforest. It may not be a towering jungle, but this chalk grassland is the most diverse habitat of northwestern Europe, where you can find up to 50 species per square metre.

A flash of vivid blue, an Adonis blue butterfly, eggs laid on its larval food-plant, the horseshoe vetch, needing the meadow ant to protect it to pupation. Nearby, the glaucous-creamy furry cushions studded with yellow vetch flowers, the aptly named kidney vetch, sole food-plant of the small blue butterfly, hanging on in a grassland fragment, threatened by invading scrub.

There are countless examples of the symbiotic ecology in this rich turf, with these chalk-loving plants adapted to surviving in harsh conditions. Extensive grazing over the millennia has conserved this habitat and its species diversity.

Modern times, with development, agricultural intensification and neglect has resulted in a shocking decline in biodiversity – successive *State of Nature* reports audit our wildlife genocide. Less than 5% of the South Downs remains as traditional chalk grassland! A huge loss, broken into fragmented pockets: a small blue colony on the Shoreham bypass cutting, separated by arable fields; another hangs on among the invading scrub on Southwick Hill; precarious footholds of the Duke of Burgundy butterfly, on shrinking downland patches to the west.

The South Downs National Park lies in the core of the UK's overheated economic world, southeastern suburbia providing the homes for the City's financial workers. Overwhelming development pressures, more housing, more roads ... the unsustainable monster is fed.

Traditional extensive grazing, obsolete, overtaken by modern intensive agribusiness. Nitrate-fuelled wheat and barley plains, the dull flaxen-coloured corn, sometimes sprinkled poppy-red; fields of lurid, sickly yellow rape; or, more pleasing to the eye, the softer pale-blue flax.

The wild country is under siege; add to that its abandonment, neglect and the future looks bleak. We've been here before, but not to this scale of threat. The 1920s early development boom was succeeded by the 1930s agricultural depression. Ironically, the war preserved the Downs, albeit as a military training ground; post-war it was to become one of Britain's first National Parks, but the farmers made up for lost time in the 1950s, responding to the drive to maximise food production, and it was judged that the recreational value of the South Downs as a potential National Park had been considerably reduced by extensive cultivation, so it was crossed off the list (National Park Commissioners Report, 1956).

Protected Area status in the 1960s (AONB) helped stop the development creep over the Downs, but agricultural policy ploughed on. It was only in the 1980s that the UK heard the Silent Spring of the 1960s and began to

Green hairstreak.

wake up to the dawning reality of agricultural intensification's side effects. The South Downs became one of the first Environmentally Sensitive Areas, a voluntary scheme paying farmers to manage areas of their land more sympathetically. Early monitoring evidenced the success of this approach and quinquennial tweaking saw some significant benefit to the downland landscape, wildlife conservation and archaeological protection.

However, it didn't touch everywhere. The majority of the Downs is still intensively farmed and other areas suffer neglect. There is a pressing need to do more, much more. Custodian of much of our landscape, the National Trust has done sterling work to recover Devil's Dyke's internationally rare chalk grassland. To the east Blackcap, to the west Southwick Hill, both needing that Dyke effort. Ditchling Beacon, tarnished jewel in the crown of the East Sussex Downs, assessed as being in 'unfavourable condition', another chalk grassland fragment

at risk; the managing Sussex Wildlife Trust hampered by myopic East Sussex County Council highway engineers who won't agree to put cattle grids on the minor road that slices the nature reserve in two, preventing its grazing recovery.

The South Downs, never far from the limelight during these years, took its next big step with National Park status. A journey begun back in the 1920s when housing development threatened the open downland; hope cruelly dashed in the 1950s; then, the resurgence, a ten-year battle, with two public inquiries and the hallowed designation finally confirmed in 2009.

The National Park Authority is slowly starting to show its teeth, not before time.

South East development pressure intensifies; more sustainable access is needed to curb crazy road-building and to positively manage this most popular of Britain's Parks, with its many millions of visitors every year. Timely too, as we ponder the fate of our agri-environment schemes post-EU. This is a golden opportunity to really deliver public payments for public benefit, with new enlightened UK policy, radical plans, with a strengthened and improved delivery at the local level. The National Park Authority must be at the helm, working in partnership with all the downland interests, it has to seriously influence government and emerging agri-environmental policy and practice.

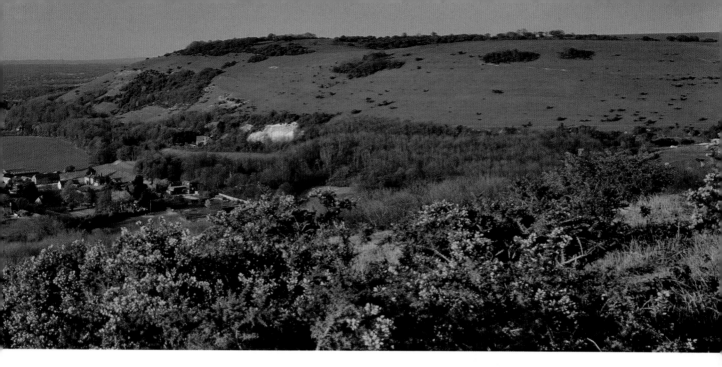

The first purpose of National Parks is to 'conserve and enhance', but that's not good enough. The South Downs, its chalk grassland, to name but one of its priceless habitats, needs restoring and recreating. Rewilding, if appropriately defined, could be the saviour.

The rewilding dichotomy, to intervene or not? Both could apply to the South Downs. A quarter of the National Park is woodland, half of it ancient or, rather, vestiges of its former state – there is the chance to seize the moment and act; not planting new forests, but stepping in to recreate those ancient, native broadleaved climax woodlands. On the other hand, for our precious rare chalk grassland

South Downs National Park, West Sussex.

(plagioclimax), abandoning it will destroy it, cause wildlife extinctions, leaving a tangled mess of dark, impenetrable scrub and inferior secondary woodland; recreating the wildwood is unrealistic and undesirable here.

We have to reverse our wildlife decline, and to value our natural environment and all the associated benefits it brings seriously. Chalk grassland rewilding is restoring and recreating this richest of habitats from agricultural land, to regain the prize of a biodiverse-rich, floristic tapestry, flitting and buzzing with the myriad of associated fauna.

Landscape-scale Conservation of Butterflies and Moths

Russel Hobson

As a species conservation charity, we are obviously focussed on land management that benefits butterflies and moths. With over 2,000 species of Lepidoptera in the UK, there are certain species that still rely on purely natural processes – for example, those associated with soft cliff erosion such as the Glanville fritillary butterfly, or, at the other extreme, veteran tree specialists such as the Welsh clearwing moth. However, for many species, human intervention is essential.

When we look up from our conservation strategies and priority landscape maps, what do we see? Across the countryside where we seek to conserve threatened species, the common denominator is people. Looking at our successful conservation projects, the role of people is evident.

High brown fritillary, Ogmore Down, Vale of Glamorgan.

The common land around the Alun Valley, the last locality for the high brown fritillary in Wales, is struggling to be maintained by a dwindling number of graziers. To help stem the tide of woodland succession and create the niches the butterfly needs to breed, to recreate the small-scale intervention formerly delivered by adjacent residents, a team of volunteers, with the help of contractors, is coppicing and managing scrub and bracken.

In Scotland our work on the central belt mosses relies on dedicated staff and volunteers, as well as landowners and land managers, to deliver bog restoration work. To restore populations of the large heath butterfly requires the restoration of natural processes. Essentially, this involves undoing previous interventions such as blocking dykes to raise water levels and removing trees that have invaded as the bog dried.

Peacock on blackthorn.

To guide our work we use data from our extensive survey and monitoring programmes to determine species priorities, and robust scientific evidence to guide our conservation programmes. Some 40 years of scientific research has contributed to the successful reintroduction of the large blue butterfly.

We also want to give people the opportunity to engage with butterflies and moths for their own well-being. This should be wherever they live – urban or rural – and either as general nature lovers, or as active volunteers, or because they live and work in a locality.

Restoring ecosystem resilience is about kick-starting natural processes. This needs to happen at scale across landscapes if we are to move away from trying to preserve successional stages on individual sites. For insects, the size of a functioning landscape varies with their mobility.

And it is the early successional stages that are currently missing. People-scale disturbance

can include direct activities such as harvesting scrub and cutting turfs, or use of livestock, particularly ungulates. To reintroduce disturbed ground after a long absence often requires larger-scale interventions involving machinery. For instance, deep ploughing of sandy soil in the Brecks of Norfolk has been used to create habitat for the grey carpet and basil thyme case-bearer moths.

On a grander scale, it is the more intensive symptoms of human use of the environment – air and light pollution, habitat fragmentation, pesticide and fertiliser use – that are likely to be the key drivers of the dramatic declines in wider countryside species. Before mitigating these impacts, we need to focus research on the precise drivers and their interaction – developing solutions and then piloting projects to test those solutions.

In the broad church of rewildling, there is plenty of scope to accommodate the needs of our threatened Lepidoptera. However, many species are associated with human-modified habitats. Rewildling initiatives need to be carefully targeted where they will bring biodiversity benefits and not put at risk traditionally managed land, offering to bring greater landscape diversity as part of a mix of land uses.

Silver-studded blue.

Rewilding in the Context of the Conservation of Saproxylic Invertebrates

Keith Alexander

As an ecologist working primarily in nature conservation and specialising in the invertebrate fauna which is part of the natural recycling process of wood decay, current interest in rewilding is both exciting and challenging. Until recently, conservation had been about trying to protect threatened species and habitats within conventional agricultural, forestry and urban environments, where there were invariably serious constraints to achieving naturally sustainable conditions. We have moved from trying to protect veteran trees, and the deadwood that they generate at site level, to considering tree population ecology at landscape scale.

Progress with developing ideas has been hampered by conflicting ideas about what a wild landscape should look like. Pollen data

Brown tree ants on rotting wood, Epping Forest.

from palaeobotanical studies has long been interpreted as indicating the development of closed-canopy forest conditions in postglacial Britain, and that people initially lived hunter-gatherer lives, before clearing the forest to creature pastures and land for growing cereals and other crops. But clearance of dense forest would have been a herculean task for people with limited technology. And dense forest just did not fit with what we know about the ecology of saproxylic invertebrates under modern conditions, where the richest sites are the ancient wood pastures and historic parklands. If 'natural' forest was closed-canopy, then why was the modern fauna favoured by open conditions? Surely, the richest places would have been closed forests? A parallel hypothesis developed by Frans Vera came to the rescue – that large herbivores are key drivers of vegetation structure.

Palaeozoological studies had demonstrated the presence in postglacial Britain of large herbivores, notably aurochs, horse, deer and boar. How did these influence the vegetation? It is difficult to imagine some of these living under closed-canopy forest conditions – even deer and boar today spend much of their time in open country and deer are regarded as forest destroyers! The closed-canopy hypothesis just did not fit the facts, especially when one of the commonest tree species in the forest was oak, which we know to be a light-demanding tree, not being able to sustain itself under closed-canopy conditions.

Palaeoecological studies have also found a wide range of beetle remains in the dated deposits and researchers have been exploring what might be learned by the species present in those postglacial forests. Objective analysis by modern analytical tools demonstrates that these beetle remains indicate very open conditions, very similar in character to today's ancient wood pastures and historic parklands – a perfect match for some of our richest sites. But many palaeoecological researchers remain blinded by the old assumptions and continue to publish papers on the closed-canopy postglacial forest – it is very easy with modern statistical techniques to demonstrate nonsense. But the evidence for open country

with trees and shrubs is building up and has recently been reviewed in *British Wildlife* magazine (June 2018).

All of this is beginning to inform rewilding ideas and projects, providing improved understanding of what wild landscapes would have looked like in Britain and the key role potentially played by large herbivores. Fortunately, most large-scale rewilding projects have already adopted naturalistic grazing as fundamental to achieving wild landscapes. And the late-twentieth-century interest in minimum intervention woodland – as surrogate closed-canopy postglacial forest – is increasingly being undermined by evidence for declining species-richness in ground flora, etc.

The contributions made by studies of saproxylic beetles on the development of rewilding ideas may be small – and unknown to many of the people involved – but they are fundamental to the evidence base. The British countryside still retains relict old forest species which have the potential to benefit from large-scale rewilding – the richest places for saproxylic beetles are the larger-scale surviving wood pasture and parkland landscapes such as Windsor Forest and Great Park, the New Forest, and Epping Forest. Richmond Park is one of the larger historic parklands full of veteran trees and rich in saproxylic beetles. Ideally the

surrounding landscapes should be targeted for
rewilding projects – even urban environments
have the capacity to contain diverse tree
populations, if only the obsession for tidiness and
minimal risk can be moderated to more sensible
levels. Tidiness is expensive as well as damaging
to wildlife, so why is it seen as of paramount
importance in our towns and cities? Rewilding
needs to look at the urban environment as much
as the countryside. The Lawton principles of

Rotting wood, Epping Forest.

'more, better and joined up' do not need to be
confined to wild habitats but can apply equally
to the maintenance of open-grown trees and a
diverse age structure within urban areas and this
is the only way forwards for important sites such
as Richmond Park and Epping Forest, which are
now virtually surrounded by urban development
in outer London.

REWILDING

Great Bustards
David Waters

I have always loved birds but have never wanted to be a birdwatcher. To me watching them is just not enough – almost a shallow voyeuristic pleasure. I compare birdwatchers with the number-scribbling trainspotters, and then consider the hands-on railway enthusiasts who re-lay tracks and rebuild steam trains. Rewilding is an ill-defined, vague term and most habitats and species need some degree of management to survive in our overcrowded island. This management can be providing nest-boxes, food, modifying farming techniques or restoring once extinct species. There is precious little in the UK that may be considered truly wild.

The great bustard is perhaps the most famous inhabitant of Salisbury Plain. It features on the Wiltshire coat of arms, and as a badge of many county organisations. Restoring

Young great bustard.

this huge and magnificent bird, previously pushed to extinction, has occupied the greater part of my life for over 20 years. The extinction came about through changes in agriculture and through hunting and collection of specimens by ornithologists – geologists collected rocks and ornithologists collected birds. The loss of any species is a matter of great importance and the loss of such a fantastic bird in my home county was something that filled me with disappointment, even as a child.

The great bustard was lost to the UK in the mid-nineteenth century, and around the same time it also disappeared from much of Europe. It was not going to return on its own. If it were to be restored, it would have to be by the hand of humans. In 1998, I created an organisation to look at this undoubtedly ambitious task – the Great Bustard Group (GBG). I knew there would be many challenges and many

problems, but I did not expect so many to come from British government bodies and other conservation and birdwatching organisations. Nobody seemed to want it to start – and when it started, most seemed to want it to fail. Academic opinion considered the Spanish great bustard population to be genetically isolated (although no research had backed this up). The populations in Germany and central Europe were small and subject to expensive conservation actions and were not suitable as donor populations. I found surprisingly enthusiastic support in Russia and, leaving my previous employment as a police officer, I set about the political, logistical and financial challenges in turning eggs from a Red Data Book bird in Russia into a new population in Wiltshire. A scheme was developed where eggs rescued from nests destroyed by mechanical weeding in Saratov Oblast were incubated at a remote field station. Approximately half the resultant chicks could come to the UK. The remaining birds stayed in Russia, either in captive breeding projects, or were released into the wild. From 2004 to 2011, the GBG was able to release great bustards in Wiltshire. A small breeding population was established but the survival rate was low and only a handful of

Salisbury Plain.

birds were breeding. In 2012, the University of Chester supplied a genetic comparison of the European great bustard populations. The GBG was able to provide genetic material and with the support of some museums could also retrieve genetic material from old British specimens, particularly ones known to have been killed in Wiltshire. The results showed there was very little variation between the different national populations and the closest extant population to the original British birds was to be found in Spain.

The Spanish authorities were both helpful and enthusiastic in arranging the licences and permissions to allow the GBG to collect eggs, and from 2013 to 2018, eggs were imported into the UK. The UK great bustard population began to steadily climb – rising from 10 birds in 2012, to nearly 80 birds in 2018. The reasons for the tremendous increase in the survival rates have nothing to do with the different seeding populations, although various commentators, ignorant of the facts, have suggested so. Both populations showed an almost complete first winter dispersal, and the lack of any other annual or seasonal movements. The differences come from the improved quality of the released birds and from the development of an age and social structure within the population. Birds from Russia hatched in difficult conditions,

had great distances to travel, health checks and handling at two airports and a very restrictive quarantine for at least 30 days, during which the birds were repeated, caught and handled. Each time they were retrieved, feathers were broken. Birds from Spain were transported as eggs. They were hatched at Birdworld, a bird zoo less than an hour from the project base, and reared without the deprivation chamber conditions insisted upon for the Russian quarantine. Add to this over ten years, experience of developing a good diet and improving release techniques and the birds were now being released in perfect condition.

The UK great bustard population is now self-sustaining. The current population is close to 80 birds and is increasing. The GBG is active in international bustard conservation and is supporting reintroduction proposals in Poland and Romania.

Rewilding Bumblebees

Dave Goulson

A recent study estimated that 60% of global mammal biomass is made up of livestock, mostly cattle and pigs. A further 36% is made up of us humans. Wild mammals make up a measly 4%. Similarly, 70% of the world's bird biomass consists of domestic chickens. Since the dawn of civilisation, the study calculated that the biomass of wild mammals has dropped by 83%, and that of wild plants by about 50%.

I find my heart sinking when I read such figures, for they illustrate how far we have gone, and how little of nature is left. During my 52 years I have watched the remorseless demise of butterflies, moths, wild birds, fish stocks, large mammals and the world's tropical forests. It has been said that we have entered a new, man-made geological age, the Anthropocene – an age in which the activities of one species are irrevocably changing every corner of the

Buff-tailed bumblebee in crocus.

planet, wiping out countless wild species, contaminating the oceans with plastic, and changing the climate.

The appeal of rewilding is that it appears to offer an antidote to our loss of nature. As a university teacher, I find that it captures the hearts and imaginations of students in a way that conventional conservation management does not. George Monbiot argues passionately that we humans yearn for wildness, and I think he has a point.

My speciality is bumblebees, the large, furry, often colourful bees that bring movement and a buzzing sound to our flowerbeds and meadows through the British spring and summer. I have studied them for 25 years, exploring the details of their behaviour and social life, how they keep warm, combat predators, gather food and so on. In particular, I study the causes of their ongoing declines, and how we might combat them. Bumblebees have been declining for

Buff-tailed bumblebee on sea holly, Roeburndale, Lancashire.

perhaps a hundred years. Where once Britain was a patchwork of flower-rich hay meadows, chalk downland, thick hedgerows and clover leys, now most of our farmland is a sterile, flowerless monoculture, sprayed repeatedly with a cocktail of pesticides. Along with most other wildlife, bees struggle to survive in this green desert – there are few undisturbed places to nest, and few flowers to feed them. Nature reserves seem to offer little protection – in the UK, they are usually just a few hectares in area, too small to support more than a handful of bumblebee nests, which is not enough to form a viable population. When once one might have found 15 or more bumblebee species in a patch of flower-rich habitat, now one rarely finds half as many – only the toughest few remain. A recent study of

nature reserves in Germany found that the daily biomass of insects caught in traps dropped by 76% between 1989 and 2014. We are in danger of losing most of our insects.

If nature reserves are too small to protect bumblebees and other insects, what can we do? I would argue for a three-pronged approach.

Firstly, we can rewild our gardens, city parks, road verges and roundabouts – grow more wildflowers, mow less frequently, set aside areas of meadow that are cut just once per year, abandon the use of pesticides. There is the potential to turn our 1 million ha of gardens into a huge network of nature reserves, if only enough people can be recruited to help.

Perhaps, too, we can bring more nature back into our farmland. Brexit, whatever you may think of it, provides an opportunity to escape from the Common Agricultural Policy, which has promoted industrial farming for decades. If our government is willing, farm subsidies could be exclusively tied to farmers delivering environmental benefits, for example by sowing wildflower strips, planting hedgerows, converting to organic farming, and supporting permaculture and agroforestry systems. A recent large-scale field experiment in Buckinghamshire found that taking 8% of farmland out of crops and putting it into wildlife schemes actually did not result in any loss of yield; the farmers took out the least productive land, and the improvement in pollinator and biocontrol agent populations boosted yield in the remaining 92%. Perhaps we could take 8% of land out of production on every farm.

Finally, perhaps we could just set some space aside for nature; true rewilding projects. The Knepp estate in West Sussex is a wonderful example (see pp. 139–43). As conventional farmland, the estate struggled to break even, for it is on heavy clay, which is not great for growing crops. Fifteen years ago the owners decided to stop farming and allow nature to take its course across the 1,600-ha estate. They introduced cattle and pigs, which roam free, along with red and fallow deer and Exmoor ponies. Today, Knepp is magical to visit – a wilderness in crowded southern England. There are nesting nightingales and turtle doves, the UK's largest population of purple emperor butterflies, and at least 50 species of bee that we have found so far. Would it be too much to have a similar rewilding project in every county, so that all of us can easily visit a place where nature is in charge? Nature may not be able to cope with all that we are throwing at it in the Anthopocene, but it has a remarkable power to recover if we just stop. Sometimes, the hardest thing for humans to do is nothing at all.

New House Hay Meadows

Martin Davies

The hay meadows at New House are far from being a wild habitat, but are a by-product of the farmer's objective of ensuring ample supply of fodder for his livestock during long, harsh winters. The annual cycle of grazing and mowing with the addition of 'muck' to fertilise the hay crop, and working closely and co-operatively with nature, has created and sustained something of beauty that is rich in wildlife at New House.

The Yorkshire Dales were once full of these flower-rich meadows but, sadly, the number of traditionally managed, species-rich meadows has drastically declined. It is estimated that over the last 50 years 98% of meadows in the UK have been destroyed. Past successive governments have provided

Sweet cicely and buttercups against a wall.

financial support and incentives to farmers to 'improve' their grasslands and increase productivity of cheap food.

New House is a special little place – the farm is designated as a National Nature Reserve and the meadows are also part of the North Pennine Dales Meadows Special Area of Conservation – but it forms a tiny wildlife-rich oasis surrounded by a relatively large area of agriculturally improved land, isolating the meadows and pastures from other areas of species-rich grassland within the wider landscape. The farm is also a very small unit of only 26 ha, which in this day and age is not a financially sustainable unit, particularly with all the restrictions to management associated with these designations. Here lies the dilemma for the future management and longer-term sustainability of New House.

In recent years the meadows at New House have slightly suffered in quality due to the prescriptive nature of agri-environment schemes with regard to land management, with their fixed dates for shutting up and cutting meadows and livestock calendars. However, nature and the seasons do not seem to recognise this prescriptive and structured way of managing the land for either the benefit of nature, or for the production of a hay crop.

New House was farmed by Walter Umpleby over a period of 42 years, from 1954 to 1996, and he kept a daily diary of his farming operations during this period, which provides an invaluable record of the ordinary life of extraordinary people on this small farm. Walter recorded 'shutting up' dates and the duration of hay-timing from year to year, details of stock management, as well as recreational activities and visits by family and friends. Using Walter's diaries, Professor John Rodwell (Lancaster University) carried out research linking the data contained in the diaries to the meteorological data from Malham Tarn Field Centre over the same period of time. This piece of work has helped towards our understanding of the complexities of climate and the hay-making process at New House and with developing and adapting the management of this special place.

Thirty years of agri-environment agreements have achieved significant environmental enhancements on many of our National Trust farms in the Dales. Despite these achievements, my vision for the National Trust landholding in the Yorkshire Dales (8,000 ha) is about creating a landscape which is more robust, has resilient and well-functioning ecosystems that are fit for our climate-changing future and in which nature has a more powerful influence. Using our experience of managing the land for nature on Malham Tarn and New House National Nature Reserves, we are trialling a new way of working with our farmers to deliver more for nature on our farms. A small group of farm tenants have helped us develop and trial a different way to farm our land, with nature and quality food production at the heart of this trial project – Payments for Outcomes.

Payments to the farmers are based on the outcomes they deliver and this is aimed at moving to low-input farming systems, creating a more varied vegetation structure. For example, in place of uniform vegetation there will be variety, from locally trampled areas through to tussocky vegetation and areas with some shrub and tree growth. Low-input means a move away from fertilisers and animal feed, but with no reduction in the need for animal husbandry and stock management.

This change aims to deliver enhanced habitat condition, more diversity in habitat and increased niche opportunities for species. It could include/involve contributions to natural flood management, enhanced carbon storage in peat and trees, along with the maintenance of archaeological and landscape features.

The land management required to achieve this is within our grasp and we are excited that a number of our tenants are very keen to work with us on the task, with others being open to persuasion. Relations with tenants are generally good in the Dales and the property team have been looking for ways to transform 'good' to excellent, working towards developing a truer partnership with tenants to achieve environmental objectives at the same time as helping sustain their farm businesses.

Additional information:
In terms of the National Vegetation Classification (NVC) the meadows at New House are classified as MG3 *Anthoxanthum odoratum–Geranium sylvaticum* grassland. This community is largely restricted to northern England and, elsewhere in Europe, has affinities with some Scandinavian grasslands. These meadows are all characterised by abundant sweet vernal-grass (*Anthoxanthum odoratum*) with hairy oat-grass (*Avenula pubescens*) and meadow foxtail (*Alopecurus pratensis*). All fields are herb-rich with varying amounts of species such as wood crane's-bill (*Geranium sylvaticum*), lady's mantle (*Alchemilla* agg.), pignut (*Conopodium majus*), water avens (*Geum rivale*), bugle (*Ajuga reptans*), meadowsweet (*Filipendula ulmaria*), great burnet (*Sanguisorba officinalis*), meadow saxifrage (*Saxifraga granulate*), rough hawkbit (*Leontodon hispidus*), yellow-rattle (*Rhinanthus minor*), meadow buttercup (*Ranunculus acris*), red clover (*Trifolium pratense*) and ribwort plantain (*Plantago lanceolate*). Melancholy thistle (*Cirsium helenioides*) and common bistort (*Polygonum bistorta*) occur commonly in the two eastern fields; meadow crane's-bill (*Geranium pratense*) also occurs here close to field edges. Marsh-marigold (*Caltha palustris*) occurs in damp areas, often with sharp-flowered rush (*Juncus acutiflorus*).

Pigs Breed Purple Emperors: Changing How We Look at Nature

Isabella Tree

No one could have predicted that our rewilding project at Knepp would, today, host the biggest breeding colony of purple emperor butterflies in the UK. Britain's second-largest butterfly, and arguably the most spectacular, it is also one of the rarest, found in significant numbers in only a handful of ancient woodlands like Alice Holt in Hampshire, Savernake Forest in Wiltshire and Fermyn Woods in Northamptonshire. Its appearance at Knepp in such huge numbers – 388 recorded in a single day in July 2018 – has provided new information about this remarkable species and its preferred habitat. It is changing the text books. It is also helping to change the way we look at nature.

Pigs create the perfect habitat for purple emperors.

Eighteen years ago, our 1,400-ha farm at Knepp Estate in West Sussex was under the plough – intensively farmed for arable and dairy. In 2000, after 17 years of struggling to make a profit on the heavy Sussex clay, we secured funding from the Countryside Stewardship Scheme and, later, Higher Level Stewardship, to turn the entire estate over to a nature restoration experiment. We were inspired by the work of the pioneering Dutch ecologist Dr Frans Vera, author of *Grazing Ecology and Forest History*. A key feature of our rewilding experiment is the introduction of free-roaming herbivores, mimicking the disturbance generated by the great herds of megafauna of the past. Large herbivores, according to Vera, are the drivers of habitat creation. They co-evolved with our vegetation

and their interactions with it are a fundamental stimulus for biodiversity.

Scale is crucial. If you are to establish natural processes on the land again, Vera advises, you need space for these processes to function. Human intervention has to take a back seat, and nature be allowed to take over the driving. The herbivores we have chosen for the job – old English longhorns (proxies for their ancestor the aurochs), Exmoor ponies (descendants of the original tarpan), red deer, fallow deer and Tamworth pigs (proxies of wild boar) – are hardy, ancient breeds that can live outside all year round, without supplementary feeding. They wander wherever they like, eat what they like, sleep where they like. Their disturbance – their different eating preferences, the various ways they graze and browse, their trampling, nesting and rootling, smashing through the undergrowth, breaking branches and even de-barking trees – creates vegetation structure and complexity, and myriad opportunities for other wildlife. Their organic dung and urine, processed by invertebrates like dung beetles (a keystone species), facilitate soil restoration.

The key, in the absence of predators, is keeping stocking densities relatively low. Too many animals (like conventional grazing), and you get tightly cropped grassland, with no opportunities for complex vegetation to emerge. Too few, and you get ubiquitous encroachment of scrub, leading, eventually, to closed-canopy woodland – again, a species-poor habitat. What you want is a closely contested battle between the two primary processes in nature: vegetation succession and animal disturbance. That's what creates the dynamism, the shifting, messy margins, the habitat complexity – that is rocket-fuel for biodiversity.

And, miraculously, this is what we've seen at Knepp: an astonishing proliferation of species across the board, many of them nationally rare. Knepp is now home to one of the country's largest concentrations of nightingales and turtle doves. We have peregrines, ravens, sparrowhawks, lesser spotted woodpeckers, spotted flycatchers, woodlarks, lapwings, yellowhammers, snipe and woodcock – all 5 UK species of owl; 13 out of the UK's 18 species of bats. Populations of insects and small mammals are sky-rocketing, too. All these species have found us, magnetised by our new habitats and food resources. In just under 20 years our land has gone from being a depleted, biological desert to one of the most significant areas for nature in the country.

No species better illustrates this wildlife explosion, and the driving forces behind it,

than the purple emperor butterfly, non-existent on our land 20 years ago and now present in astonishing numbers. The reason is emerging groves of sallow – naturally hybridising willow. Sallow, like thorny scrub, is considered useless and is not tolerated on agricultural land today. Yet, once, not so long ago, sallow was common – used for tools and wicker ware, winter fodder for cattle, fuel and medicine (the painkiller and anti-inflammatory aspirin was originally

Turtle dove on willow.

derived from salicin, a compound found in sallow bark).

It is also the food plant for purple emperor butterflies. Sallows produce multiple types of leaves, and the choosy purple empress lays her eggs on leaves with just the right thickness, soft to the touch and with a matt, rather than shiny, finish. These leaves amount to only a tiny

Male purple emperor sunning itself.

proportion of any given stand of sallow. It is the expansive range of sallows at Knepp, with a wide diversity of leaves, that has provided purple empresses with their successful nursery.

Sallow requires specific conditions to seed. The seed is only viable for a couple of weeks in May. Every few years or so it occurs in great blooms of fluff, drifting on the breeze like a snow storm. In that narrow window of time, it needs to find wet, bare ground to germinate.

Originally, our arable fields, left fallow after their last harvest, would have provided this opportunity. But there is still significant recruitment of sallow on our land. 2014 was a conspicuous mast year for sallow and the areas where seeds successfully germinated, where new sallow saplings are now beginning to grow, were damp patches of earth exposed by the rootling of our pigs. Pigs – and presumably, in the past, wild boar – provide opportunities for sallow succession. The expansion of the purple emperor's empire at Knepp may well depend, in part at least, on the accommodating diggings of our Tamworths.

Until the explosion of purple emperors at Knepp, this dramatic and elusive butterfly was classed as a 'woodland' species, dependent on stands of ancient oaks. Thanks to butterfly experts Neil Hulme and Matthew Oates' observations of the emperors at Knepp, swooping freely around open-grown trees and through sallow scrub, this is no longer considered true. And this, in large part, is the magic of rewilding. Process-led conservation allows nature to reveal the limitations of our own understanding. We assume we know what a species needs but we forget that our landscape is so changed, so desperately impoverished, we may be recording a species not in its preferred habitat at all, but at the very limit of its range.

Naturalists believed the purple emperor was a woodland butterfly only because – with no significant areas of sallow left – that is where it has clung on.

Like so many species resurgent at Knepp, purple emperors have defied expectations. What we're seeing is something known in scientific circles as an 'emergent property' – a complex system made up of numerous components which, on their own, as individual parts, are ineffectual. At Knepp, previously missing or dormant components are coming together, striking up extraordinary and unexpected outcomes. Two and two is making five – or more. Some of the components – the ingredients that, together, provide a species with an optimal chance at life – may never be fully revealed. That is where humility comes in – the recognition that nature, in contrast to us, has had millions and millions of years of R&D. Rewilding allows nature to express herself, and it falls on us to observe and learn. The purple emperor butterfly, with its complicated life-cycle involving numerous stages, requiring different conditions over the course of almost a year, beats its wings to the tune of the entire symphony orchestra that has conjured it into being.

Pant Glas

Nick Fenwick

Once or twice a year, I bump into William Howells, who now farms Pant Glas, the hill farm where I grew up and which we left 35 years ago.

Our conversations are held in the Welsh language, which is ubiquitous in the agricultural community of north Montgomeryshire, and he refers to the fields by the same names used by my family half a century ago – names which are recorded in the tithe records, seven generations ago.

The names of fields close to the farmhouse are still apt – Cae Celyn (Holly Field), Cae Pistyll (Spring Field), Cae Bach (Little Field), but further up into the mountains the names recorded in the 1840s have lost their relevance, and so have gone out of use – not least because the areas they describe are now indiscernible parts of open mountain land or are buried under conifer plantations.

Grassy hillside with soil creep, Pumlumon, mid-Wales.

But names such as 'Gwaith y Chwech Gwr' (the work of six men – the number needed to cut a field with scythes) and the banks denoting what were once houses, farmyards and sheep pens, tell of a time, hundreds of years ago, when the mountains were scattered with many more families who worked the land, growing crops, and rearing sheep and cattle.

A far earlier document from the early thirteenth century, recording the grant of the land by Prince Gwenwynwyn ap Owain Cyfeiliog to the Cistercian abbey of Ystrad Marchell, also contains familiar names which continue to be used by farmers in the area – Nant Hanog (Hanog Stream), Hafod Owen (Owen's Summer Pasture), Nant yr Eira (The Snow Stream) and Cwm Calch (Lime Valley) to name just a few.

Sadly, no earlier records exist, but the use of already established Welsh place names and landmarks in a document handing over agricultural land 800 years ago shows the depth of the roots which tie our people to the land.

Given that the latest radiocarbon dating places the arrival of agriculture in Wales at some time shortly after 3,800 BCE, by the time the Romans arrived, almost two thousand years ago, it's fair to assume that the landscape in the area would have been something similar to what archaeologist Dr Toby Driver describes in *The Hillforts of Cardigan Bay*:

> Ceredigion in the Iron Age was not a dark, forested landscape with hillforts rising above a dense blanket of wild woodland. On the contrary, agriculture and widespread clearance had already transformed the landscape during the Bronze Age or even earlier ... the prehistoric farming regime along Cardigan Bay is likely to have been mainly pastoral, with sheep and cattle predominating ...

Those Iron Age farmers spoke the same language their descendants do now – although the modern Welsh language has the usual dose of Latin thrown in by all Roman occupations – and they practised transhumance, just as their descendants do now through a system called 'Hafod a Hendre'.

Given such a history, and that for most livestock farming families in the area, their previous occupation could accurately be described as 'hunter-gatherer', and in such enlightened times, we might imagine the preservation of a last outcrop of Brythonic Celtic culture as being sacrosanct.

But just as farming sheep and cattle seem to be in the DNA of the Welsh, the DNA of our neighbours seems predisposed to telling others what to do with their land and culture.

The rewilding dream of turning the clock back to before agriculture arrived in Britain in around 4,000 BCE is an attractive one – especially for those who eye the beautiful and inhospitable wilds of the Pyrenees or Apennines with envy.

But when such ideas are predominately English and urban-based, and build compelling arguments against rewilding the first areas altered drastically by the arrival of agriculture (Suffolk, Sussex, Surrey, Kent, Essex), instead earmarking as ideal areas far further afield – or other people's countries – alarm bells should start ringing. Britain might not have the colonies any more, but in their absence, colonialism, like charity, seems to begin at home, with 'home' extending to other people's countries long-since invaded.

The lust for rewilding is clearly a symptom of a sad detachment from farming, nature and the land perhaps inevitable in a country which led the Industrial Revolution, but it is sadder still that this overrides moral compasses

Oak tree shadow in 'field of the haunted dog', Nant-Y-Ci.

which should have been firmly set in light of the mistakes made during centuries of colonialism.

If a group of well-meaning Welsh farmers were to get together and propose the replacement of all powered vehicles in London with horses and carts to reduce pollution and traffic accidents, and the introduction of wolves to solve the urban fox problem, the idea would be treated as ignorant and preposterous.

For those families that have farmed the uplands for millennia and understand the interdependence of farming and nature,

proposals by foreigners to turn the clock back thousands of years are equally preposterous – not least because they have witnessed the disastrous impact on nature of policies which reduce livestock numbers and increase forest areas.

Their knowledge is generally regarded with disdain and overruled by grand ideas such as rewilding. Perhaps the only true lesson is that history repeats itself.

The Pontbren Project
Wyn Williams

The Pontbren name originated from the stream which drains this small headwater catchment of the River Severn. The group was established by Roger Jukes, who in 1997 collaborated with two neighbouring farm businesses with the same ethos and principles of sustainability, to provide the farms with more shelter for livestock by planting trees and hedges in strategic places – to benefit both the environment and the individual farm businesses. The direct benefits and mutually collaborative approach of these pioneers, attracted other neighbouring farms into the concept they started and by 2001 the group had increased to ten members who managed a total of over 1,000 ha of farmland across the region. The average size of a Pontbren holding is just over 100 ha and they are all owner-occupied, and over half the farms have been managed by the same family for generations.

Pontbren Project, Banwy Valley.

When the group formed, we were in the throws of the foot-and-mouth outbreak of 2001, the severest test for all individuals with livestock, and witnessed the effects on farms and individuals with livestock affected by the outbreak. When the outbreak was under control, we began to meet regularly to start drafting plans and ideas of what we could do as a group, and also what was achievable on the individual farms – each with different types of businesses, even though we were all close neighbours. With this we worked up a plan for our farm and then pulled all the ten plans together. The next step was to assess what support was available for a programme such as ours, which had been mapped and costed accurately, with valuable assistance from David Jenkins of Coed Cymru, who has proved an invaluable asset to the group from its formation, through to its continued existence. It became clear that none of the available schemes were appropriate for what

Flooded Severn Valley.

the group was trying to develop, as they were too inflexible, and so we could not sign up. So we developed our own scheme and looked at alternative sources of funding. With this in mind, and with excellent assistance from David at Coed Cymru, we managed to secure funding from the Enfys Foundation. This resulted in the group setting up a system of accounting and regulatory control.

When tree planting began, only 1.5% of the Pontbren land was woodland – mostly neglected riparian woodland and small areas of larch – but, ten years later, 120,000 new trees and shrubs have been planted. Some

16.5 km of hedgerows have been created or restored and nearly 5% of Pontbren land is now woodland. This has all been done with no loss of productivity. The group is still managing the landscape with the same ethos and ideas – demonstrating that effective and productive businesses can be delivered, with environmental benefits running side by side.

The evolution of new and improved habitats became evident and was not confined to the woodland. Fencing stream side-corridors, prevented faunal access and reduced disturbance, allowed bankside vegetation to develop and the streams to resume a more natural profile, with riffles and pools which are used by trout and otter. There have also been sightings of water voles – one of the most endangered mammals in the UK. Twelve ponds were also created within the group. These can have multiple uses, such as supplying piped water to livestock in the fields close by. On one farm, materials excavated in the creation of a pond were used to construct an earth bank for a new hedge. Pontbren is also home to many wild birds, such as the hen harrier, lapwing, skylark, linnet, barn owl, snipe, kingfisher, curlew, red kite, cuckoo, stonechat and woodcock.

Pontbren Group also worked collaboratively with research and development teams covering a wide range of issues such as flood management. Between 2004 and 2011, the Flood Risk Management Research Consortium (FRMRC) set up plots on the farms to gather detailed hydrological data, involving soils and water flows, to provide information on stemming flooding risks – producing impact assessments and advice on slowing the source of water moving down country. Montgomeryshire Wildlife Trust also commissioned a detailed inventory of the plant life in all the fields – there were also studies involving carabid beetles and small mammals.

As a group we do not, perhaps, realise the full power of community, yet we still meet yearly for a social get-together – one recent highlight was a visit from HRH Prince Charles and the Rural Affairs Minister Carwyn Jones, who is now First Minister of the Welsh government. We invited the local contractors who, on the day, all attended, and it was great to see over 30 individuals being introduced. Our experience shows the importance of thoughtful investment into the rural economy, with potential benefits to both the businesses and also to the environment – locally and on a larger, landscape scale.

Lynbreck Croft

Sandra & Lynn Cassells

Lynbreck Croft is 150 acres of pure Scottishness – heathery hill, woodland, grassland and bog. We moved here in March 2016 after years of dreaming and months of searching for our forever home. We never meant to be crofters – in fact, we were only looking for a couple of acres: enough to grow veggies, keep hens, offer a couple of camping spots and live 'the good life'. But when we came to Lynbreck for the first time, we knew we were destined to spend the rest of our lives here.

The croft was in a semi-derelict state when we arrived. With no background in agriculture, we had a blank canvas to start with, something we now see as a blessing but in the early days was a terrifying mountain to climb. So where to start? We drew on our backgrounds in

Highland cattle, Lynbreck Croft.

conservation and quickly realised there was only one way we were going to make our new way of life and business a success – we had to follow nature's guide and develop a model of farming *with* our environment in a challenging landscape, terrain and changing climate.

We observed a small army of Scots pine trees that had started to march their way up our hillside. The ground was clearly trying and wanting to become woodland, so we decided to give it a helping hand. Some 17,400 native broadleaf trees later, we had planted the forest we always dreamt of. A whole 40 acres that, in time, will be a haven for wildlife and a safe place for our animals to shelter from weather extremes and dine on a feast of woodland flora and tree leaves.

And so our journey of farming with nature continued. We introduced native Highland

cattle and Jacob sheep as part of our 'Team Lynbreck' grassland restoration team. We move them daily into new paddocks, mimicking their natural instinct to always be on the move, avoiding the danger of predators and on the search for fresh, tasty forage. We make sure they never take too much grass, never staying long enough in one place to over-graze, but always depositing the important natural fertiliser we need to keep our land healthy.

We use rare breed Oxford, sandy and black pigs to break up dense, tussocky vegetation and open up niches for other plants to have a chance to seed and grow. With regular, weekly moves, they never stay in one place long enough to root up and expose large swathes of bare soil. We have hens that live in mobile houses in our hedgerows and field, their job to keep back weeds and scatter and clean up grubs in cow pats. And then we have our native Scottish black bees, a flying squad of pollinators, hungry for nectar and spreading nature's goodness as they stop to feed.

We believe in happy, healthy animals that are able to express their natural behaviours and we offer high-quality produce direct to the consumer. We use our work to help reconnect people with where their food comes from and educate them.

We don't believe that sustainable farming is enough. We practise regenerative farming – a method that aims to build soil, enhance nature and reconnect people. Sustaining the current equilibrium is simply keeping what we have already destroyed from getting worse. We aspire to work with our neighbours and other landowners to look after our wider environment in harmony – we want to make crofting landscape-scale. It's not about everyone doing the same thing – that is impractical and takes away the fundamentals of individual living relationships with the land. But it is about everyone working towards the same vision – farming with nature.

We want to get away from the idea of 'land management'. Nature is the most efficient system that exists in this world and if we really believe we can 'manage' it, we will always be fighting a war where we will lose battle, after battle, after battle. To truly restore, regenerate and even rewild ourselves and our land, we must change our mindset to one of 'working with'. Copying nature and natural processes can only result in a successful farm business which has its foundations deep into the soil.

Through education, we want to empower people to make better informed food buying choices – to see that cost is not the only factor, but that the environmental and animal welfare impact is just as, if not more, important. At the end of the day, cheap food delivers cheap

health, which only ever costs all of us more in the long term. To date, selling our produce has not been a problem. Our first meat boxes sold out in a handful of weeks. We sell eggs by the roadside and to local members of our Egg Club – a venture where we ask for a monthly or annual subscription fee in return for a weekly box of fresh, free-to-range, organically fed hens eggs.

Planted trees, Lynbreck Croft.

We're beginning to see that people like what we do, like how we farm and like what we produce. We want to make Lynbreck a positive and bright shining light where an ecologically intensive farming system delivers for our business, for our land and for our community.

REWILDING

South View Farm
Sam & Sue Sykes

When we first moved to our smallholding high in the Yorkshire Pennines, part of our motivation was to be intimately connected with the hills and crags on which we had climbed and walked since teenage days. Although we were both raised only 10 miles down the valley, this upland wilderness was a world apart from the mining villages of our birth. 'The Moors' physically and emotionally dominated our horizon. It was a wilderness that enchanted, beguiled and sometimes frightened with its harshness, quickly changing weather and often unforgiving ground. It was, in short, a physical and emotional landscape – a product of myths, legends, folklore and ambitions cemented through the physical activity of leisure-time indulgence. Real as it is, our landscape was an intellectual construct, a release that emphasised some aspects and masked others to suit the timbre of my emotional attachment.

Marsh marigold by woodland stream.

Thirty years after moving here, we live in a different landscape. We see it through the prism of relentless hard work, trying to tame the acidic moorland edge into productive pasture while simultaneously balancing the competing needs of the wild fauna and flora that excite my emotions and frame every decision we take – what livestock will suit our economic needs while complementing the specific local conditions? What's the optimum stocking density to give us a financial return but retain the distinctive floral structure? Which areas should be left uncultivated and which gently assisted while others are sacrificed to greater productivity, without which we would be denied the flexibility to indulge our passions? There we go again, creating another intellectual landscape. And in doing so we are conscious always of the guiding hand of history.

You cannot live here and escape the land's past. The romantic vision of glorious purple heather moorlands are deemed glorious by

a 'modern' tourist mentality that looks and
admires, but does not work here. The 'moors'
are actually a by-product of the prehistoric
hard graft of early hunter-gatherers, who, with
primitive tools, cleared the pine, hazel and oak
scrub in their transition to agrarian settlers.
We don't know whether those earlier humans
enjoyed the landscape, or just exploited its
resources. We do know that agrarian changes
have evolved over millennia to produce this
landscape, but it is maintained today only
because another glorious vision – that of
shooting grouse – was consolidated by wealthy
landowners pursuing leisure in the nineteenth-
century, post-enclosure period – another
intellectual and emotional landscape that this
time relegated food and resource production
to the leisure interests of a new ruling class.
Today their descendants, and the small army of
gamekeepers and land managers they employ,
attempt to preserve this vision, not in aspic,
but in constant conflict with other modern
intellectual visions, from urban leisure seekers,
to re-awakened naturalists, all of whom wish to
press their claim for the validity of a particular
kind of landscape. Currently, the landowners
have the economic dominance and with it the
greatest ability to shape the landscape in their

Sue Sykes with young lamb.

image – but with Brexit on the horizon and 'sustainability' a core value of public policy, funding priorities will doubtless change and the zeitgeist may well swing towards the new economic mantra of leisure. It will be an interesting turnaround if after five or so millennia the upland landscape is reshaped towards a theoretical replica of prehistory to fulfil the emotional-intellectual-non-productive dreams of a leisured mass middle class.

Our own meagre attempts to create a vision is no less an intellectual construct determined by our own pasts, bits of arts and craft peasantry, semi-urban marginal smallholding (both our families grew their own food on small plots, a direct consequence of wartime austerity) and economic liberalism that allowed us to acquire a smallholding but required us to work in full-time jobs off-farm to sustain the dream. Marrying all these together requires walking the tightrope of dissonance. Forced to legally engage with Defra, we compromise many dreams to draw the benefits of subsidies – albeit only miserable amounts from a system designed primarily to support larger economic units. Increasingly, we are encouraged to embrace the new mantra of tourism and leisure but our experience is that many of the leisure users of our landscape are motivated less by the celebration of a productive environment and more by the desire for a sanitised experience where their 'journey' will introduce them to animals that can be cuddled, but not eaten; paths that can be trodden but mustn't mucky their trainers; trees that can be used to hang baubles and fairy lights; scenery that can be captured in a selfie – and where someone else will come along to clear the detritus of their consumerism. The ultimate irony is to watch a cyclist taking in 'natural' country air while discarding his plastic energy drink bottle along the route.

Some policy-moves towards rewilding seem inevitable, hopefully falling short of a reconstructed medieval idyll where wolves roamed freely and never ate the bucolic peasant's livestock. Our hope is that we recognise landscapes are made for people by people in pursuit of both intellectual dreams and pragmatic struggles for existence. Honest landscapes acknowledge and celebrate the whole historic multi-layered mosaic of our creation and its creators. To do this, it seems essential that our environment embraces both production needs and leisure interests without sacrificing one on the altar of the other.

Rewilding in My Corner of Epping Forest
Robin Harman

I have always had a fascination for bees and especially honey bees. Their ability to overwinter in large numbers, surviving just on the carbohydrates of honey and water, is amazing. This led to my hobby and now small business of providing bees and honey in the ancient woods of Epping Forest on the edge of London. I had previously had a stressful job and the peace and quiet of working with bees and nature in general has changed my life.

Bees had survived for millions of years without our interference, or help, until we started putting them in straw caskets in this country a few hundred years ago, and into other vessels a lot earlier in other parts of the world. Religious sites such as monasteries have regularly been the centre of beekeeping, due

Beekeeping in Epping Forest.

to the medicines produced using honey and, of course, the demand for wonderful church candles. In fact, one of this country's greatest beekeepers was Brother Adam of Buckfast Abbey – he was responsible for improving the genetics of the British bees by cross-breeding and a prominent strain is still called 'Buckfast'.

There is historical evidence of beekeeping near Epping Forest, with bee shelters, known as boles, at Eastbury Manor in Barking (built in the 1500s) and over a dozen more at sites in Essex. These boles (cavities or alcoves) would protect the straw skeps from the weather. When an opportunity arose for me to keep honey bees in Epping Forest on Corporation of London land, I could not refuse. This was an opportunity to increase the number of colonies foraging in the historic area and in turn increase the levels of pollination. The location provides a fantastic

array of flowers, shrubs and trees, giving a plethora of different tastes of honey. This can be the distinctive citric taste of lime trees, the sweetness of blackberry, or the almost clear 'Champagne' honey produced from borage. If lucky, honeydew honey, when the bees have foraged on the secretion of aphids, becomes available in the autumn, providing a honey which is deep tan in colour and possesses a very distinctive caramel taste. The range of coloured pollens brought in by the bees is amazing – from the bright orange of snowdrop in early spring, right through to the dark blue, almost purple, of viper's bugloss. Dozens of bees returning with their pollen baskets, or *corbiculae*, full of the brightest of colours is a sight to behold.

The demand for real, local unprocessed honey is amazing, with demand outstretching supply every year. There is a strong belief that local pollen will aid the symptoms of various ailments and, although this cannot be medically substantiated, both my local doctor's surgery and chemist request our honey. The interest in beekeeping has risen immensely over the last ten years with the media interest in bees and nature. The chance to produce your own honey is just fascinating for people – in my local area our club of 40 members, who were previously in the main mature in years, has risen to around 130. Our youngest beekeepers are in their teens and our oldest over 90 years of age and from diverse backgrounds. Many of our new beekeepers live in urban East London with traditional city gardens and roof tops. These colonies actually flourish fantastically well on the continued varied diet of back garden flowers, lime trees and fruit trees. Many council allotments now permit colonies to be kept to provide pollinator power for residents. Other hive locations include the top of a mosque in East London and the organic garden of an award-winning restaurant in Epping.

The public genuinely wants to have the opportunity to taste the best local produce, food that has been produced by genuine artisans. The processing of local honey is basically a simple filter that leaves in all the pollens and goodness – incomparable next to the high-pressure, forced cleansing of honey employed by commercial producers.

Honey and other bees have had a difficult time, with the Isle of Wight failures of hives at the turn of the century, the harsh winter of 1962/3, the unwanted arrival of the *Varroa*

Honey bees in a comb.

mite in the 1990s, neonicotinoid insecticides, and most recently the invasion of the Asian hornet. However, honey bees will always evolve to deal with these and other future problems. As we know, pollinators such as honey bees are crucial to food production.

I hope that our little part of Epping Forest will continue to prosper with bees due to our input and management.

Prayer for Red Kites at Gleadless

Martin Simpson

This is a prayer I believe, and a prayer that has been 40 years or so in the making.

My father introduced me to the love of nature when I was very small. It was in my back garden in Scunthorpe, under stones, in patches of moss and in the poplar trees and blackcurrant bushes that I began to look and to see. I was overjoyed by the possibilities of life and the richness and variety I found in tiny spaces, first around my home and then in the countryside on the many bike rides and expeditions of my childhood.

With my elder brothers, my father introduced me to the dean of Lincolnshire lepidopterists, Joe Duddington, who studied locally and obsessively. I learned the value of focus and of knowing your own home patch.

I started to collect butterflies, rather in the manner of the Victorians – a cabinet of

Red kite diving for food.

curiosities was my idea of a good time. I loved the ritual of pond dipping and of sugaring trees for moths. I borrowed animals from the wild and kept them usually briefly, although one summer I found myself harbouring short-tailed field voles in my bedroom for quite a long time. I became a regular visitor to Twigmoor, a nearby shooting estate, where my father introduced me to the gamekeeper. The gamekeeper's gibbet became the principal source of my collection of skulls and it did not occur to me then that it represented the wholesale slaughter of various species of native birds and mammals, in defence of pheasants.

In my early teens after much pleading with my family, I finally acquired a guitar, and my dreams shifted from the rainforest riches of South America to the dark treasures of the Mississippi Delta and the hills of North Carolina. Music moved me emotionally and, in time, very literally. By my late teens I was

a gigging musician travelling through Britain by whatever means I could manage, including hitchhiking. I would birdwatch from the roadside and look for caterpillars among the flowers and hedgerows on the verges. I became much less of a collector and more of a roving observer, which is still the case.

At some point in my early twenties I was booked to play at Lampeter University in mid-Wales. It was a winter gig, and I was a relatively inexperienced driver, so the trip from the Lake District, where I then lived, seemed quite a considerable undertaking. It had snowed heavily but the ploughs had done their work, and in the hills of mid-Wales the snow banks were piled high at the roadsides and the sun was shining on the blindingly bright and altogether enchanting landscape. I rounded a bend and directly in front of me, low down over the snow bank, a red kite was quartering. I was wholly unprepared for the shocking beauty of the bird.

At that time the red kite had been gamekeepered out of existence everywhere in the Britain but mid-Wales. The population had fallen to ten pairs in the 1930s and it was the rarest of creatures. My first sighting of the bird will never leave me.

In 1989, five red kites were released in the Chiltern Hills, north of London, close to the M40 motorway. I was living in the US at the time, and only returned to England several years later, at which point I became aware of the growing established population – much to my amazement. They were clearly visible from the M40 and were much admired by locals and passers-by alike. On each return to England I would gauge their continuing success by seeing which northbound exit from the motorway they had reached.

Other breeding programmes in Scotland (on the Black Isle, and in Dumfries and Galloway) and England (County Durham, Yorkshire, Northamptonshire and Cambridgeshire) are thriving, while the Welsh population goes from strength to strength. Some 20% of the world population now live in Britain. I regularly see a group of 40+ birds by the A1M near Peterborough – cruising above the landfill with extraordinary grace and elegance.

Some of the tabloids still publish the kind of nonsense which lead to the destruction of the kites in the first place – reporting on their predation of other birds species and attacks on cats and dogs. I'm sure a dead Yorkshire terrier would be of interest to a red kite, but a pile of earthworms or a bowl of cat food would be equally attractive. The main threat to the birds comes when they venture near those bastions of Victoriana and wealth, the grouse moors, where

poison, traps and shotguns are used wholly illegally by gamekeepers to destroy them.

For the last 15 years Sheffield has been my home. When I first moved here I lived in Meersbrook and I would walk out with my wife Kit through the woods which run so close into the city centre, along the river valleys. Sometimes our walks took us out to Gleadless, an estate built to the south of the city, on the sides of the wooded Gleadless Valley. In the bottom of the valley, in the woods, is a recycling centre over which buzzards fly.

The name of the place intrigued me, so I looked it up in the *Oxford Dictionary of English*

Gleadless Valley.

Place Names. To my delight it informed me that *glead* is the Middle English verb for 'glide' and was also the Middle English name for the kite – a 'less' is a clearing in a woodland or a meadow. Kite meadows, a place on the south side of Sheffield, in a country where place names often recall vanished species, has a great likelihood of becoming an appropriately named area once again.

My prayer is to see red kites in the sky over Gleadless; it is not too much to ask.

Species Introductions

Matthew Ellis

The landscapes of Wales have been changing because of range of socio-economic factors such as industrial and residential development, agriculture, tourism and – in respect of certain species – hunting, collecting and persecution. The outcomes of these changes for our biodiversity have included the decline, or loss, of our native flora and fauna. Recent conservation action based on reversing these losses or declines contributes to the rewilding of the Welsh environment

To provide context for species conservation actions, European, national and devolved administrations have implemented policies and legislation to address these declines. British and Welsh biodiversity action plans were initially prepared in response to the Convention of Biological Diversity, which was

White-tailed sea eagle, North Uist, Outer Hebrides.

agreed at the Earth Summit in Rio de Janeiro in 1992. These plans have provided the focus for maintaining or restoring the conservation status of a range of our endangered, threatened or iconic species and habitats.

At a European scale, the Habitats and Birds Directives were enacted as the European response to implementation of the Berne and Bonn Conventions. The overriding aims and objectives of the Habitats Directive are the maintenance or restoration of European habitats or species to their favourable conservation status. This can be achieved under the Directive by a variety of actions, including site designation, protection of species and the planned provision and management of connecting habitats such as ponds or small woodlands. However, other actions, such as reintroduction programmes, also contribute to conservation objectives.

These two Directives have provided the underpinning framework for delivering statutory nature conservation action in the UK. In summary, and perhaps simplistically, the concept of favourable conservation status can be defined under the Bonn Convention as: (a) what did we have; (b) what have we now got; and (c) what are the targets that we are trying to achieve?

Current conservation status can be described as the condition of a habitat or species – population size, range, extent, together with long-term prospects. These attributes are assessed under planned or *ad hoc* surveillance and monitoring programmes. Conversely, what is favourable needs to be defined, and its likely to be informed by a combination of both ecological and socioeconomic factors. The use and applications of the understanding of current conservation status – and what is 'favourable' – helps to inform the rationale for target and objective setting for rewilding projects that focus on restoring the status of our native fauna and flora. In Wales, more recent policy changes and legislation have focussed on the delivery of the sustainable management of natural resources. This holistic approach to the management of the natural environment is complemented by the Nature Recovery Plan for Wales, which aims to deliver targeted restoration action for key species and habitats.

Restoration action may involve either improving the current conservation status of a declining species (or habitat), or the reintroduction of a species that has previously become extinct. Species such as sand lizard, natterjack toad, pine marten and red squirrel are of ecological and cultural value to the Welsh landscapes. Beavers previously provided functional roles as engineers of ecosystems by creating dynamic wetland habitats. Consequently, since the mid-1990s there has been sustained action to reintroduce or restore the conservation status of some of these species, as a contributor to the rewilding of the Welsh landscape. Species action and recovery plans have been prepared at various spatial scales that articulated targeted measures to maintain or restore the current conservation status of these iconic species.

The natterjack toad was last recorded in the environs of the Clwyd Estuary in the 1960s. Reintroduction has now taken place within sites located in the environs of the Dee Estuary and associated sand dunes. Since then, individual colonies have been subject to continuous targeted surveillance and site management. Public, private and third-sector bodies have collectively worked together to

deliver sustained targeted action. The outcome of this collective action has been one of the most successful natterjack reintroductions in Great Britain. This site forms part of a network of southern Irish Sea populations that is the most significant in a British context. However, further continued action is required to ensure the population remains viable and resilient in the longer term. The concept of conservation status is utilised for the purposes of defining and justifying long-term goals.

The sand lizard is another species that has been successfully reintroduced to Wales. Like the natterjack, reintroduction commenced in the 1990s. Since then populations now breed in sand-dune systems across mainland North Wales and on Anglesey, and, following recent discoveries, in at least one site in South Wales.

The red squirrel has been subject to ongoing decline throughout Britain as a direct consequence of the introduction of the grey squirrel from America, persecution and losses or changes to their favoured habitats. However, the current conservation status of the species has been improved on Anglesey following the implementation of targeted species conservation. More recently, the population within Clocaenog Forest has been subject to reinforcement action, whereby additional individuals have been released to improve the

Natterjack toad, Talacre, Flintshire.

overall genetic diversity and overall resilience of the population.

In summary, the application of the favourable conservation concept can be used to inform and justify species conservation action. This concept provides the underpinning rationale and objectives for informing species conservation programmes that include species reintroductions or reinforcement. Surveillance evidence from species such as natterjack toad highlights that species reintroduction projects can be successful.

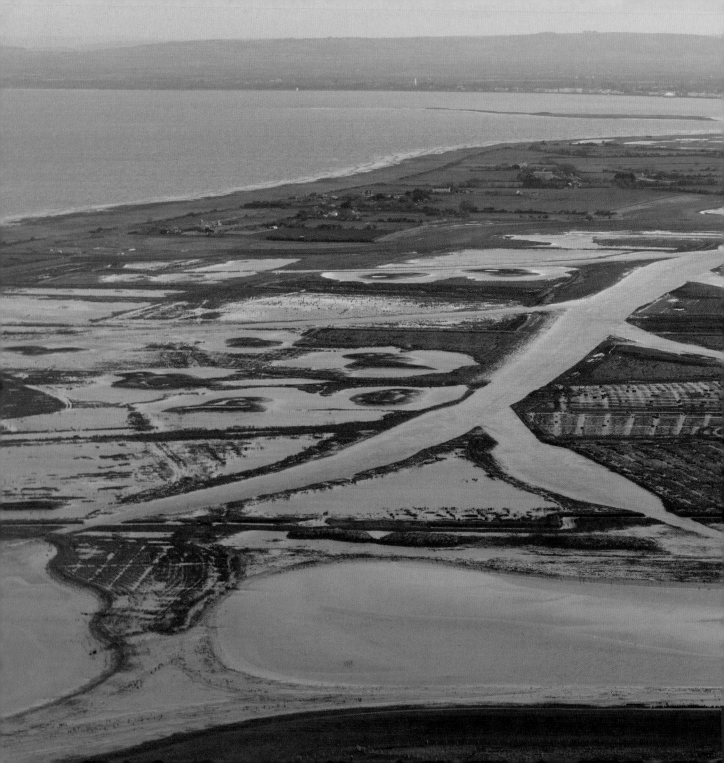

Steart Marshes: A Wetland That Works for People and Wildlife

Tim McGrath

WWT Steart Marshes is one of the largest coastal management schemes in the UK, covering 500 ha of the Somerset coastline, some 10 km northwest of Bridgwater. Driven by the need to compensate for the loss of saltmarsh habitat along the shores of the Severn Estuary, Steart Marshes delivers many of the benefits that landscape-scale habitat creation can bring. However, it also provides a safe haven for internationally important numbers of waterbirds; allows visitors to experience wetland conservation first-hand; and reconnects watercourses with their floodplains, reducing flood risk to properties and local communities.

In 2009, the Wildfowl & Wetlands Trust (WWT) was successful in its bid to the Environment Agency to become the future

Steart Marshes from the air.

site manager of a then-proposed flood-risk management scheme that had protecting people and wetland habitat creation at its heart. However, even within the recent past, the issue of coastline realignment has been fraught with controversy. The benefits of actively allowing the tide to reclaim land that it has been artificially cut off from, for generations, is always going to be a difficult message to get across, given the overriding imperative that people and their property need protecting from the devastation that flooding can bring.

Indeed, the risk to property was no more evident than in 1982, when a large part of the Somerset coastline was subject to weeks of tidal water stretching far inland as coastal defences were breached, following a storm surge. Higher, stronger defences are often the resulting call – but what this call very often misses is the need to give adequate space to the

Flooded house, Somerset Levels.

best natural tidal defences and absorbers of wave energy: our saltmarshes.

The increased frequency and strength of western winter storm fronts, coupled with the gradual and unstoppable rise of the average tidal height, has slowly pushed our saltmarshes into an impossible situation – both in terms of how they will survive a changing climate and how they can continue to function as a flood defence. Saltmarshes lie at the very point where highest tides turn: too many tidal inundations and they change into mudflats; too few and they become grass-dominated habitats. Hence, with the gradual increase in sea level around our coastlines, the lower reaches of our saltmarshes are inevitably turning to mud as they try and regain ground at the top of the inundation zone where only the highest tides reach. However, in reality this vulnerable zone, at the turn of the highest tide, is historically where flood banks have been constructed – cutting off any chance of the saltmarsh continuing its quest to develop inland naturally.

And of course, behind these historical man-made structures, the land – now divorced from the natural process whereby the sea deposits nutrient rich silts – has developed new, hard-to-resist demands, mainly in the form of agriculture, industry and housing. However, the cost of maintaining these defences is constantly subject to government scrutiny, and, whereas in the past, dyke defence of inland crops and grass for dairy and meat production was pretty much the sole consideration, other projects such as

the recreation of saltmarsh are again being carefully considered.

On the Steart Peninsula this decision-making process of whether to claim land from the sea, or allow the tide to do what it does naturally, has indeed been going on for thousands of years. Undeniably, one of the benefits of an extensive earthwork construction is that across the landscape historical patterns of coastal settlement have been uncovered. Prehistoric settlement, though uncommon, focussed on the seasonal settlement of raised areas of either silts, sands or tide-rolled pebbles and boulders. Roman remains are extensive, with homesteads, ditches and flood banks indicating a managed and farmed landscape. However for almost 1,200 years after the Romans left, the landscape was shown to be largely uninhabited, with silt deposits indicating that the area came within reach of the tide and again the peninsula was rewilded. Then, from the medieval period to today, the landscape was taken back in hand, with drainage ditches dug and flood defences built – many forming the foundations of those that can be seen today. Though the peninsula was widely settled again, only the properties at its elevated tip remain, with those across the low-lying areas having been lost or ruined.

So today, the Steart Peninsula has changed yet again, but this time it has not been lost but added to. The creation of such an extensive tract of saltmarsh now not only provides WWT with the opportunity of being at the forefront of extensive habitat creation, it also allows us to celebrate the wider functional benefits of realigning the coastline – it allows former wilderness to flourish, provides niche agricultural markets and a place where wildlife can survive on a grand scale. Now, when you stand on the new flood bank that protects both people and properties, and face into a biting easterly wind that has just weaved its way over the new saltmarsh, one can easily feel surrounded by a wild place – easily forget that the major cities of the South West are only an hour away. And then, gazing breathless at the thousands of waterfowl – squadrons of golden plover hurling themselves at great speed into a wild landscape to roost, or the clouds of thousands of lapwing drifting upwards like fog to avoid the hunting peregrine – you can only then begin to realise the enormity of what you have in front of you. Wild places can be increasingly hard to find, but at Steart Marshes with its panoramic horizons one can feel truly lost in a wide landscape that is both raw and thriving with wetland life.

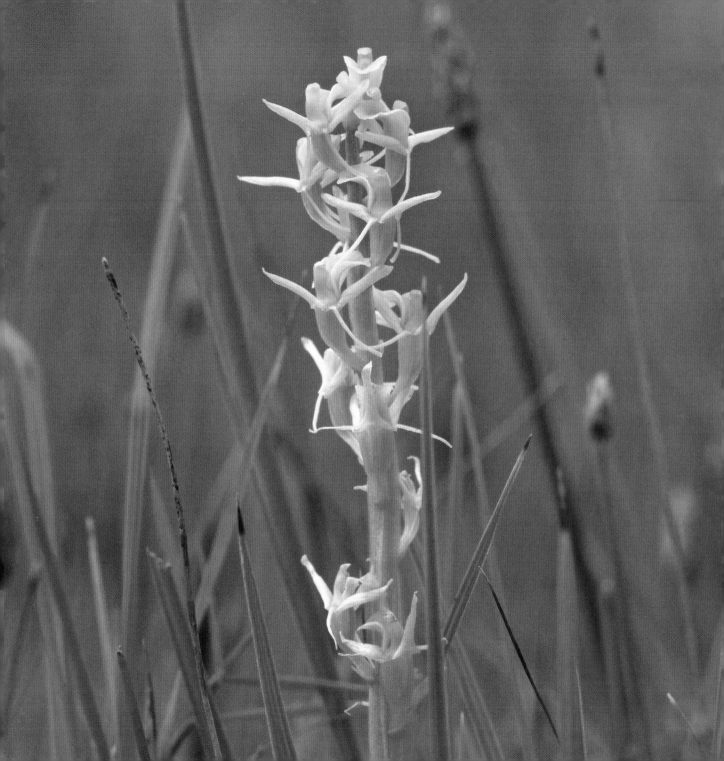

Whiteford Primary Slack

Nick Edwards

Whiteford Burrows National Nature Reserve, at the northernmost point of Gower, is the biggest dune system on the peninsular – a windy and wild beach, favoured locally for its commercial shell fish, bracing winter walks, and views of the iron lighthouse. It hosts an array of wintering birds, including thousands of feeding oystercatcher. Nestled alongside an expansive saltmarsh, Whiteford Burrows is a wilderness with a primeval feel that once encountered, is never forgotten. This is an area which has survived numerous attempts from industry, military and agriculture to impede its natural form – now a stunning National Nature reserve, with SAC, SSSI, Ramsar and SPA designations.

Historically, the dunes were used as a rabbit warren, a Norman influence from the brief period they inhabited the Gower area.

Fen orchid.

The Normans saw Whiteford dunes, among other coastal sites, as the perfect spot to breed and farm rabbits, as well as other livestock. The continuation of livestock grazing was apparent up until the designation of the site and purchase, in 1957, by a venture called 'Project Neptune'. Led by the National Trust, the aim of the scheme was to procure areas of coastline in Britain, to ensure protection and to manage for conservation, recreation and enjoyment. Today, livestock on the dunes operate purely for conservation management reasons, and the rabbits, unfortunately, have almost disappeared.

Surviving industrial intervention in the form of mass sand extraction, quarrying – and a brush with coal mining – the dune system remains one of the most diverse and important areas for flora. Rarities such as fen orchid, dune gentian and round-leaf wintergreen, sit among a plethora of orchids and other flowering

plants. Rare liverworts and bryums, as well as the smallest species of grass in the UK, early sand grass (*Mibora minima*), reside among the humid slacks and transitional areas in between.

Sadly, some of the iconic species have dwindled and fen orchid hasn't been seen on site since 2006. Once a haven for the flower, numbers started to decrease from about 1995, around about the same time as the slacks started to dry out – installed dip wells were showing low levels of water throughout the system.

As one of the most dynamic sand dune systems in Europe, Whiteford has welcomed ecologists from all over the world – conferences, meetings and workshops have gathered to see the erosion and accretion across the site, none more so than the resulting primary slack, which has developed from beach since the 1980s. This prolific area of habitat, was once the bathing point for the locals, who wax lyrical about walking down the path and straight into the sea – the sea now nestles behind a recently formed sand dune system.

Found among the washed-up organic materials is the strandline beetle (*Eurynebria complanate*) – this rare and fascinating creature is now only found in a handful of coastal sites in UK, nestling in and under wood, and rope, and sometimes among plastic debris washed down from inland rivers or from sea-going vessels. The protection of this invertebrate is key to the management of the NNR, providing suitable habitat while policing against the removal of the same material for firewood or decorative, commercial purposes.

This area of primary slack, which has been carefully monitored for the last 30 years, has undergone really dynamic changes, from beach to embryonic dunes, to enclosed saline lagoon, to saltmarsh – finally to a dune slack. Alder has started to encroach in and the rewilding stage has escalated almost to the start of coastal broadleaf woodland.

Lapwing have successfully bred here for a number of years, nestled in the hollows formed by the tide. The emergence of common reed and rush needs constant management to ensure the natural evolution is controlled for the protection of the habitat that is providing such a home for such interesting and diverse species. Since 2010, cattle have grazed the area, to keep the vegetation from taking over, mowing has also been undertaken to remove the excess the cattle don't eat – the use of both has resulted in thousands of orchids blooming throughout late spring and summer, including an abundance of early marsh orchid, and in particular the red

Strandline beetle.

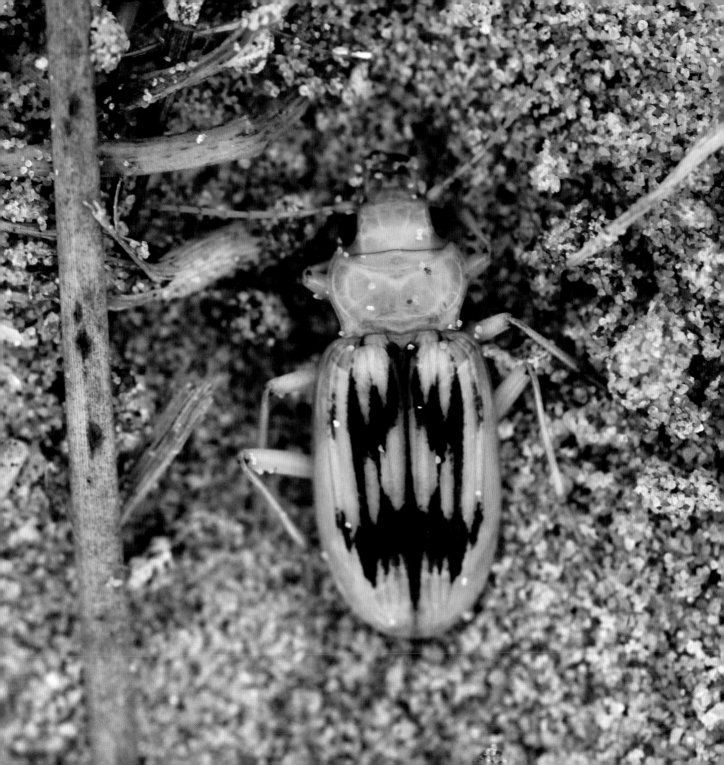

Dune slack, beach at low tide, Carmarthen Bay, Gower.

subspecies *coccinea*.

The loss of fen orchid in the early 2000s, alongside the dynamic changes to the dune system, has instigated a real surge in partnership working, especially with regard to research into local hydrology, topography and coastal changes through sediment loss and natural events. This research has enabled us to get a better understanding of what the future may hold for the dune system – major loss of the central sand dune, now only a few hundred metres wide, pressured on both sides by the ever-encroaching saltmarsh, tidal influx, the rising of sea levels. Eventually, the sand dune system may split into two separate dunes, one becoming a large island.

In 2014, under licence, fen orchid seed from another coastal site in Wales was harvested, and then spread across an area of the primary slack at Whiteford. This last-ditch attempt to bring in a new seed source was deemed imperative for the survival of the flower in Wales. Having another site, where fen orchid was once established would lead to the population and

succession of the rare flower for the future.

In 2016, there was the first sighting of two plants in a cold autumn; the seed had taken hold into an area which 30 years previously had been more accustomed to beach towels than flowers – this major success was built upon the following year, when another two plants were discovered. Mowing, grazing and careful monitoring, including water chemistry and levels, were initiated and observed.

As I write this piece, two proud fen orchids have flowered, seed pods in place, ready to spread seed to the wind – with strong hope for more plants appearing in later years. To be able to watch rewilding take place, literally in front of my eyes, is an amazing privilege – helping nature take over once again, developing a new ecosystem, a new environment where species have come in quickly and aggressively to stamp their mark. A gentle, helping hand to round the rough edges and protect what develops is all we have had to do. I look forward to seeing what nature has in store for the decades ahead.

Seashore

Richard Harrington

Take a trip to a seashore and spend just a little time peering at the pools, rocky outcrops and the mud, gravel or sand that lies between the tides. It usually bursts with life. You'll get the distinct impression on this land–sea edge that the ocean is already wild. How can it be rewilded further? It's a valid question, as the sea is a changeable, dynamic environment that is very different to any land or freshwater system.

Species introductions are rarely a successful option. Depending on what beach you are standing on, you may well see evidence of life forms that have travelled here with people from distant climes, whether wilfully or by accident. Anywhere along the south coast of Britain, empty slipper limpet shells wash up. They are so common, they make up the bulk of some beaches around Chichester and Selsey,

Dog's Bay, Connemara, County Galway.

for example. But these are alien to our shores, introduced accidentally with Pacific oysters when they were first reared for sale here. Our seemingly humble common shore crab is now naturalised over large sections of coast in South America, Africa and East Asia, outcompeting native fauna in places. There is not a lot that can be done to intervene; these aren't examples of rewilding, but lessons in sudden and haphazard colonisation. The addition of plastics to shores around the globe represents a similar ill-advised dispersal.

For the most part, conservation of the sea is about prevention, attempting to limit the transfer of these alien species, or the spread of pollution, and to keep damaging activities out of sensitive areas. It can be achieved through laws and policies, adopted globally – stopping whaling, or banning trade in endangered species – as well as locally. The rhetoric in

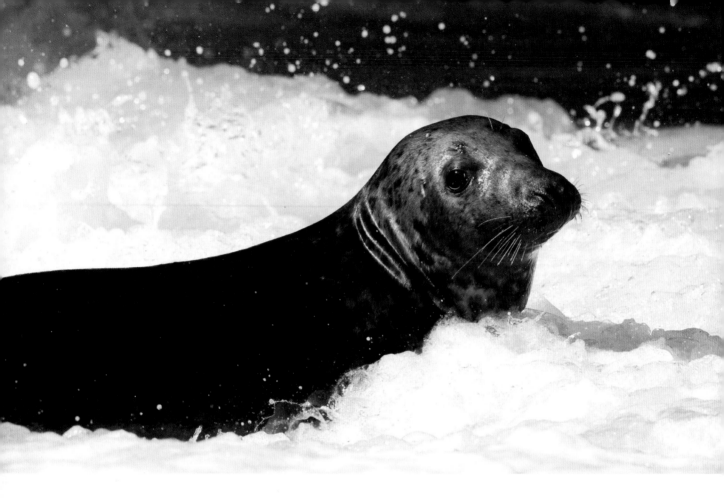

Bull grey seal, Little Orme, Conwy.

marine conservation is less about rewilding, and more about simply returning our seas to a natural state, which, only rarely, involves intervening directly.

But that's still an option. An exciting scheme on the Dornoch Firth is an attempt at a positive intervention to rewild an area. Here, among other measures instigated by the local Glenmorangie distillery, together with Heriot Watt University and the Marine Conservation Society, native oysters are gradually being reintroduced to the firth. In days before nets were dragged over the seabed, the seafloor all around our coasts was covered extensively by

a stabilising layer of life – the fabric of which comprised filter-feeding molluscs such as oysters, along with sponges, coralline algae and more. These formed three-dimensional living spaces with nooks and crannies and niches for a plethora of species to thrive in. Exploitation in the last century or two has left just remnants of such riches – oysters disappeared from the Dornoch Firth about a century ago. This intervention will hopefully return a rich reef to the seafloor here and be an example for others to replicate elsewhere.

There is something of a rewilding aspect to nature reserves in the sea. Many species are highly mobile, and migratory animals such as basking sharks and great whales, including humpbacks, would probably be seen more often if we were to protect a sizeable section of our sea area properly. They would, in effect, reintroduce themselves. This would be achieved if a network of sites, connected around our entire coast and sea area, were well protected.

Removal of anything is prohibited at a 'no take' zone at Lundy in the Bristol Channel. This little piece of the sea was not actually heavily fished before its set-up in 2003, but it would probably be targeted for fishing now, with its larger, older, more numerous lobsters and crab that now thrive under the protection of the zone. A network of sites around UK coasts

is gradually coming into being, with levels of protection varying from preventing trawling with heavy, bottom-towed gears, to, in many cases so far, very little being done at all. But it should all be a step in the right direction, and all of these sites have the potential to help us reach a more natural state with a thriving undersea environment once again.

Back to the seashore once more, it's reassuring and inspiring to find a microcosm of the big wide sea, with a mosaic habitat shaped by a range of foraging herbivores, active filter-feeders and predatory carnivores, play out before your eyes. Life here, like in the open sea, is resilient and bounces back from every storm. In this, we can take great heart.

Lesser black-backed gulls at dawn.

Little Terns
David Woodfall

Little terns are the second-rarest seabird in the UK and Ireland, after the roseate tern. Their major food source are sand eels that dwell in the seawater shallows. The terns are unable to dive much deeper than a foot under the sea's surface, and as climate change warms the seas, the sand eels are forced deeper in search of cooler habitats – beyond the reach of the little terns. These elegant little birds are indeed a potent bellwether of future climate change. Known as sea swallows, they nest on beaches, sand spits and shingle – and in the Outer Hebrides they nest upon the machair, often laying their two or three camouflaged eggs among the flower-rich strips of cultivated oats or potatoes.

My own association with this bird began in 1978, at Long Nanny in Northumberland, when I was coastal warden for the National

Kestrels prey on the little tern colonies.

Trust. We employed a warden each year to live overlooking the colony, but in 1979, when the breeding population was reduced to one pair, my boss decided to stop the project. Incensed, I elicited the support of Dr Peter Evans from Durham University who, the following summer, provided us with two PhD students to help with monitoring breeding success. To increase community involvement, I made a film about the colony with Eric Bird and as a result we had over 100 volunteers from the community assisting paid staff each year. The colony started to grow. I wrote the first of three academic papers on little terns and involved a bird-ringer to monitor the birds. We started to get a few Arctic terns nesting among the little terns – and then one night, over 1,000 pairs of Arctic terns decamped from the nearby Farne Islands to nest on the sand spit on the Nanny. Now over 2,000 pairs of Arctic terns regularly

nest there, with up to 50 pairs of little terns. This is an example of what informed positive conservation work can achieve. This site is now the largest mainland breeding colony of nesting terns in Britain and Ireland.

Elsewhere, their fortunes have varied, and the combination of rising sea levels, blown sand and greater concentration of numbers – attracting predators such as hedgehogs, kestrels, weasel and foxes – plus human disturbance, have all affected the national populations, with the overall pattern being a steady decline. Even the increase in manned protection schemes, with the RSPB funding a national protection scheme through a LIFE project, while maintaining, and in some cases increasing, some colonies, the overall pattern is of national decline. It's worth considering the picture at four colonies: the Long Nanny in Northumberland; Gronant in Denbighshire; Berneray in North Uist; and Kilcoole, just south of Dublin. In each of the sites the terns' adaptation is slightly different: in Northumberland they nest on a sand spit; in Gronant on a sandy beach; in Berneray on machair; and in Kilcoole on a storm pebble beach. In order to get close to the terns during the breeding season, I obtained a licence from each of the four UK and Irish government conservation organisations and over a period of time worked a bird hide to within 18 feet of their nests. Thus, I was able to document their lives at close quarters, from prior to egg-laying to, three weeks later, tiny chicks being fed sand eels every 30 minutes or so. Colour ringing (carried out by scientists associated with the Merseyside Ringing group) and other conservation work was carried out at the four sites. In Berneray I documented crofters managing the machair – harvesting crops, looking after their cattle – to show how integrated the machair is, with crofters forming an integral part of the management of this coastal land. I also documented the catching and relocation of hedgehogs back to the mainland, by Scottish Natural Heritage staff on the Uists – hedgehogs eat the terns' eggs. The Scottish government works closely with the crofters through an agri-environmental scheme and are compensated for their co-operation by ensuring the breeding success of little terns and waders on the machair. Crofters are thus able to sustainably manage the machair, allowing the birds to nest and raise their young among their crops and cattle. Sheep graze the machair during the winter months, the harvested wool being spun at Uist Wool's new mill on Grimsay.

Once little terns finish their breeding cycles, they return to west Africa where they

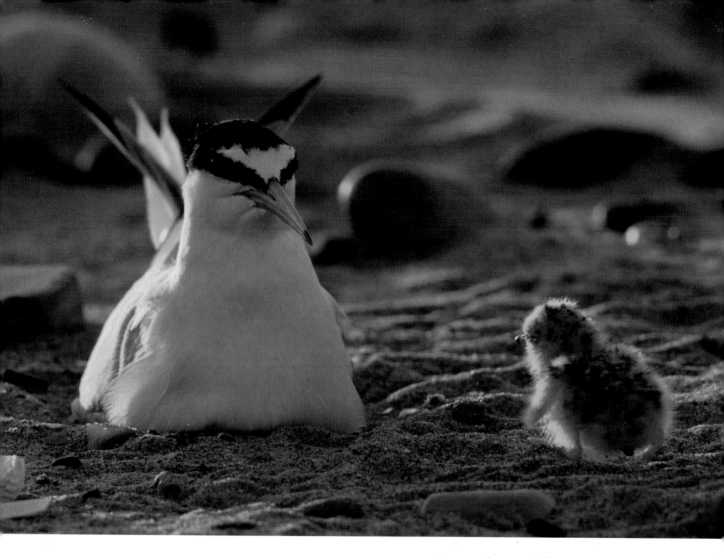

spend the winter, returning in late April every
year to begin their breeding cycle once again.
While their future as a breeding species in
Britain and Ireland is uncertain, a great deal
has been learned about the breeding biology,

Little tern chick seeks its mother.

ways to help protect their breeding success, and
how the community can be involved to help
protect these resilient little birds.

Rewilding at the Coast: A Buffer Against Climate Change

Phil Dyke

During the twentieth century global sea levels rose by 19 cm, and all evidence suggests, with increasing certainty, that for our current century, this figure could be four times higher. This will have major implications for the shape of the coastline that millions of us visit every year and a coastline that is home to some of our most valued wildlife.

By default rather than design, the coastal fringes of the UK host some of our last remaining wild landscapes, as competing land-use pressures inland have squeezed nature to the margins. The conspiring forces of land-use change and climate change continue the squeeze on nature at the coast, and the concept of rewilding, while not a complete antidote, may provide something of a buffer against against these challenges.

Worm's Head in Rhossili, Gower.

The winter of 2013/14 saw a series of intense storms sweep across the UK and provided a real insight into what future change at the coast might look like. Images of the 'rope-bridge' mainline railway at Dawlish, tracks and sleepers swinging above a void with nothing but boiling seas beneath, provided a graphic illustration of how our reliance on defence against the sea as the only strategy, looks less plausible in the light of a changing climate.

There is of course an instinctive inclination to want to defend the coastline with concrete, but our coastline is dynamic, and the forces of nature that shape it are both part of its beauty and a fantastic opportunity for a range of habitats and species to thrive. In addition, there is a very real sense emerging that some of our key infrastructure, the railway at Dawlish being an example, is simply in the wrong place. A realisation may

Coast guard walking along sea wall, Rhyl, Denbighshire.

be dawning, albeit slowly, that we will need to adapt to rising sea levels and increased storminess by rolling back, out of harm's way – in the case of Dawlish, perhaps by developing an alternative rail route inland.

If a societal appetite emerges to move vulnerable infrastructure out of harm's way at the coast, rewilding comes into play as a valid land use for coastal land that is no longer required to be held *in situ* for railways or roads. This land could be given back to nature and help create not only great new habitats at a landscape scale, but function also as a natural buffer against climate change. Wherever we can, we need to give the natural processes that shape our coast the space to work, and create

areas where the coastline can realign as sea levels rise. Natural habitats and features such as sand dunes, soft cliffs and saltmarsh can act as buffers against the impact of storms and sea level rise.

A few hundred kilometres to the east of Dawlish on the southwest corner of the Isle of Wight, at Compton Bay and Downs, the National Trust is seeking to put this thinking into practice as part of its Shifting Shores approach. Compton Bay and Downs is a beautiful coastal landscape with significant nature conservation interest and is much loved by the people who come to enjoy it. Recent acquisition of land by the National Trust, of extensive areas of farmland adjoining existing Trust land and both sides of the coastal road, have enabled a deepening and broadening of the Trust's holding, which now extends to a block of nearly 500 ha, roughly 0.6% of the land surface of the Isle of Wight.

In light of rapid coastal change and the predicted loss of the A3055 coastal road in the coming decades, the Trust is planning to create a landscape rich in wildlife, but which can still be enjoyed by people. The A3055 currently bisects the landscape and the future involves planning for the loss or truncation of the road – encouraging the Isle of Wight Council to pursue an new approach, based on working with natural processes. In the short term there will be a shift on Trust land towards extensive agriculture across the whole site aimed at delivering maximum conservation gain – a measured form of rewilding. In the longer term – and after the loss of the road – natural coastal processes will assert themselves along this whole frontage and this landscape has great potential to be both rich in wildlife and act as a coastal buffer.

The need to adapt all aspects of the way we manage land, in the face of climate change and extreme weather, applies inland as well as at the coast. The notion of giving over large tracts of land to nature through rewilding, in whatever form, may be anathema to many but whether for climate-change buffering reasons, or simply to allow nature to thrive in our warming world, it is something that we are going to have to come to terms with and the coast is a good place to start

If we begin thinking now about the different ways we manage land at the coast or inland in the face of broad-scale environmental change, then we can start to find adaptive solutions. If we shun the opportunities that rewilding presents and carry on in business-as-usual mode, we will simply be compounding the problems that future generations will have to face.

Machair

Derek Robertson

Wild places replenish the soul. As I sit painting among the wild flowers of the machair, on the island of Berneray, terns and waders fly around me calling and displaying. The sun shines and I can smell the island scents of seaweed and peat. This feels like a wild place in a remote and untouched corner of the world, but it is a rare and precious habitat that is maintained by human management.

Machair is the Scottish Gaelic word for a specific sand and grassland systems that exist only on the west coast of Ireland, the north and west of Scotland and, most abundantly, in the Outer Hebrides. They are characterised by sandy ground with low fertility and they are maintained by low-intensity grazing and arable farming, which is usually managed by crofters. The low fertility of the soil means that ground

Harebells on machair, Berneray, North Uist.

is only cultivated in small patches, then left to lie fallow for a year or two, before another crop is planted. The sandy soil rapidly leaches away chemical fertilisers, so their use is impractical, but the use of seaweed harvested to spread on the fields increases the fertility of the soil and the richness of the wild flora that grows there. In a world where agriculture is becoming more and more intensive, this landscape leaves plenty of space for wildlife to flourish. Likewise, grazing has to be carefully managed. Too much and the soil quickly erodes, but too little and the sward becomes thick and rank and reduces the rich diversity of wildflowers. The presence of livestock increases the diverse mosaic of habitats and creates networks of tussocks and wet hollows that are favoured by many nesting waders. It is this sympathetic, human management that is essential to maintain the rich, natural heritage of this fragile habitat.

I have often spent weeks at a time living out on the machair, using my van as a hide, as a base to eat and sleep and as a mobile studio. I have happy memories of huddling for days in my rain-lashed refuge as I worked up paintings and looked out at the iridescent-green pasture beneath a sulking, grey sky – or awoken to glittering sunshine and the jubilant calls of terns, dunlin and redshank all around me. Stepping out onto the grassland, it can be difficult to describe just how much the land and skies bustle with life and energy. Everywhere you look is brimming with wildflowers, humming with insects, alive with birds. This is a habitat that is rich in wildlife, but also rich in culture. It is the outer land of the cultivated

ground – familiar and known intimately by those who manage it and yet apart from the township and the croft. It is both tame and wild but acknowledged in story and song as having a claim upon the soul and the sense of belonging of those who live there. Deep in the memory of the people who tend the machair there is the history of kelp gathering when

Croft strips of black oats, the Borve, Berneray, North Uist.

seaweed was a valuable, even essential, resource for fertilising the fields. Crofts and townships each had their own territories for gathering. There is a rock off one of the islands that is only visible at low tide and is known as the 'rock of dispute' after a violent fight between two

groups of men over who had rights to harvest the seaweed there. During the Napoleonic wars, the resource became a blessing and a curse. At a time when huge areas were cleared of people to make way for sheep, the wars made it impossible to import chemicals from overseas. Kelp harvested and burned in the Hebrides to produce valuable chemicals rocketed in value and the population actually grew to service this manufacture. However, the work was terribly hard and involved living rough in damp and squalid turf huts for weeks on end; landlords imposed onerous leases on their tenants, who had to process the seaweed without pay. When the war ended the prices crashed and the whole economy collapsed. You can still see the ruins of some of the tiny turf houses out on the machair where people had to live and work.

I sat in the living-room of Duncan MacKinnon on the island of Berneray as he told me of his father, Eachainn, the great bard of the island, and sang me one of his father's songs in haunting Gaelic that lovingly described the rich machair – the birds, the flowers and the bees, together with the people who used to live there and how the plots were ploughed and the oats harvested. Time and place dissolved and were rekindled in song. Scottish Gaelic has a word – *dùthchas* – which can't be easily translated but, like the machair, brings together a rich mosaic

of elements. It is a way in which people inhabit the land by their management of it and, in their turn, are claimed by that land. It draws together an identity that links place, language and culture through a sense of interconnectedness. It focuses on relationships and continuity rather than rights of ownership and monetary value. This is what I think of when I consider the concept of rewilding in relation to the machair, because the habitat is managed and yet it is allowed space and time to continually renew itself. Space is left for the wildflowers to flourish and for the birds to nest, but this non-intensive system already exists and, as long as these traditions of light-touch management are maintained, they will continue to thrive there.

It was a collaborative art project with David Woodfall that brought me back to the machair on Berneray most recently, to study and sketch the little terns that breed there. There is something about these birds that distils the importance of marginal habitats. Throughout the UK they breed on the tidelines and edges, and their breeding grounds have been put under intense pressure by increased disturbance and by the mounting threat of rising sea levels. In the Outer Hebrides they nest in scattered colonies but are intensely vulnerable to disturbance from the increasing number of holidaymakers who now

visit. Their dependence on the continued, sensitive management of the machair throws conservation challenges into sharp relief. Continuing population changes mean that there are fewer young crofters to manage the land and this can lead to less appropriate management – to a reduction in the careful tending of the ground and an increase in indiscriminate grazing pressure. The growing surge in tourism leads to more people – and their dogs – disturbing the nesting birds and continually camping and parking their campervans on the fragile grasslands, which causes further disturbance and erosion. Increasing numbers of geese have led to a difficult conflict between the interests of conservation and farming in the croft-lands. Dealing with these challenges touches on some sensitive issues because the ecosystem of the islands needs both good conservation science and the engagement of the crofters who live and work here. Balancing those issues will take patience and understanding but, with the goodwill of those involved, should maintain a machair that continues to have a thriving heritage of wildlife and culture.

Little tern at the nest, Berneray, North Uist.

Rewilding Whales

Simon Berrow

Imagine the scene: *'They're here!'*, shouts young Conor O'Shea to his father. '*The whales are back!*' Three, maybe four, distinct bushy blows can be seen about five miles offshore. It's late April and the first humpback whales of the season have returned to the rich feeding grounds off the west coast of Ireland. For the next five months these whales will be part of the local community, familiar friends who return year after year to this same area. Fiction or a vision of the near future?

Humpback whale numbers are increasing throughout the North Atlantic – population recovery after decades of protection against commercial whaling. Whaling was by far their greatest threat and, once removed, some populations could recover. Humpbacks whales have now been recorded in every month in Ireland, typically within 10 km of the shore

Minke whale feeding.

and the same whales are returning each year, to spend months foraging our inshore waters. Were humpbacks historically abundant in the inshore waters of Ireland? It's hard to know – they have been hunted since the fifteenth century, so it's not possible to reconstruct their pre-whaling distribution. It is easy to imagine, though – inshore waters full of humpbacks, bubble-netting, breaching, slapping their long pectoral fins and singing. Certainly, their current preferred prey in Ireland of young sprat and herring and sand eels would have been very abundant, able to sustain large populations of whales and dolphins as well as sharks, seabirds and predatory fish.

Populations of fin whales are also recovering and are abundant inshore off the south coast of Ireland, often feeding alongside humpback whales, as well as offshore along the shelf edge. Will blue whales recover in offshore waters? Will the most endangered large whale in

the northeast Atlantic, the right whale, ever recover? Or, is it too late. Gray whales have been extinct in the Atlantic since the 1700s but recent sightings of Pacific grey whales in the Mediterranean may signal the potential re-colonisation by this species through the now ice-free Northwest Passage. Exciting times.

Rewilding in the marine environment in my mind is more concerned with restoring marine ecosystems and populations. Without doubt the greatest human impact, especially inshore, is over-fishing; the removal of millions of tonnes of potential prey and predators to a point where populations crashed and in many cases have been replaced, ecologically, by competing species.

So how can we encourage rewilding of our inshore waters? Although the recovery of large whales is primarily due to the cessation of whaling, the local ecosystem must be able to sustain an increasing whale population. Critically important is to maintain healthy fish stocks, especially those small pelagic species with high lipid content which, through their schooling behaviour, concentrate energy into highly desirable whale meals. Here we have much in common with our coastal communities, especially the inshore fishing fleet, which itself has felt close to extinction in recent decades. Initiatives which seek to manage inshore fish stocks to heathy levels,

such as local, weekly quotas for small vessels, vessel restrictions based on length or power, management zones, marine protected areas or no-take zones around spawning beds, can all contribute to locally managed small-scale fisheries which maintains stocks at high levels, sufficient for all predators be they human, marine mammal, seabird or shark.

There is no doubt a rapid expansion of marine conservation zones displaying a range of management options relevant to local objectives and the environment, with coastal communities from fishing to marine tourism and angling interests playing key roles, is the cornerstone of a long-term vision. This must happen! This will happen! This is happening from the bottom up, with local coastal communities taking back ownership of their local marine resources. And ensuring that there are enough of these resources for all constituents including an increasing whale population is essential.

Marine wildlife tourism, including whalewatching, is expanding. Carried out in an appropriate manner, it can provide a fantastic experience and create a real local connection with whales and their important habitats. The world is changing rapidly. The impact of climate change is huge and profound and all notions about distribution, chronology or what is 'normal' are history. We need flexibility

of thought and management practices to reflect this rapidly changing and dynamic environment.

Whales and other cetacean species at the top of complex food chains and can act as a barometer of the health of marine ecosystems, at a local or ocean-basin scale. A sea full of whales and other large sea creatures is a good thing and will demonstrate we are creating a better balance with the world in which we

Atlantic white-sided dolphin, County Cork.

live. Look after the whales and dolphins and large parts of the marine environment will be taken care of. Let's share our excitement and enthusiasm for rewilding with everybody. Let's learn more about whales and dolphins and share this knowledge so our ambition to rehabilitate vibrant coastal ecosystems is owned by everybody.

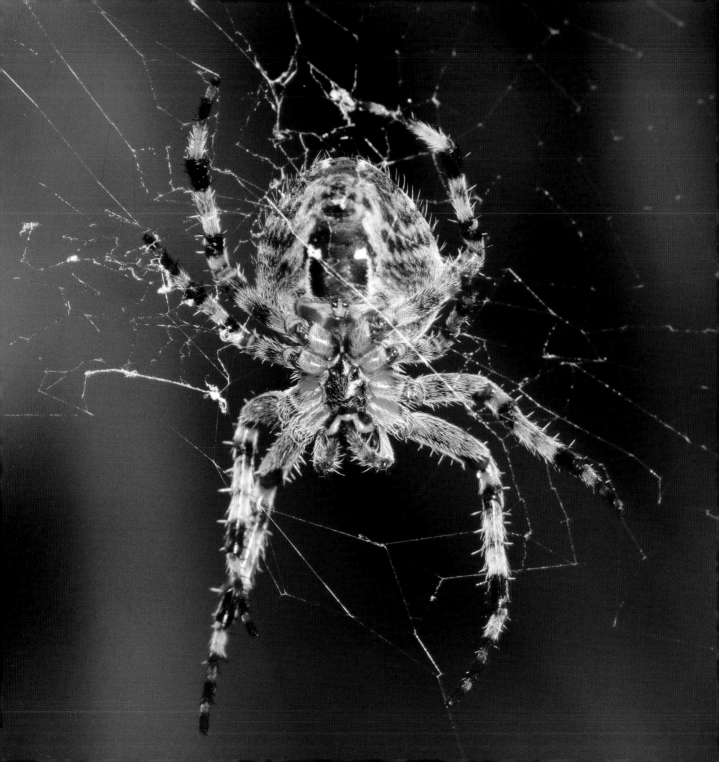

Rewilding Notes on Forest Gardens

Mike Pope

What does rewilding mean to me? Several things really. I suppose the subject has been drip-feeding into my consciousness for a few years without me really thinking about it as a standalone subject. From my early interest in wildlife gardening, which progressed into learning about permaculture, forest gardening and foraging, to concern about flooding, climate change and other environmental issues, I've increasingly seen rewilding as an important subject. Not just for environmental reasons but to reconnect people (especially children) with the natural world.

From a very young age I've felt most at home in woodland. I was lucky as a child to have Heaton Park (North Manchester) on my doorstep and I would wander through the woods, often alone, watching the birds and creatures doing their thing. My parents didn't

Garden spider.

seem to worry about me, but maybe they did and just didn't tell me! I also remember, from childhood, not particularly liking the moorland surrounding Manchester. It was bleak, boggy and just didn't feel right – I didn't realise, at the time, that most of it was once forested. After completing my permaculture design course, my wife and I designed and started a forest garden project on some unused council land with volunteers from our local Incredible Edible group. Over several years the garden has become a diverse, young edible woodland for people to make use of. There is food for anyone to pick, volunteering opportunities and a chance to make new friends – a place to go for a picnic, or just to sit and be. And there is lots of wildlife using the space and sharing the produce. Part of the garden has been left truly wild and untouched. The garden is four miles from Manchester city centre, but feels a million miles away and is a really therapeutic space.

During this period we've become interested in foraging and hedgerow medicine and are lucky to have a friend who leads walks throughout the year. We've also been on mushroom walks and I've realised how detached we've become from nature in a relatively short time – a couple of generations. A Polish friend is an expert on mushrooms; he's been brought up picking them from a very young age. Some of our not-so-far-away neighbours have not lost their connection with nature to the extent that we have.

Ripening apples and fruiting bushes, Prestwich Clough Forest Garden, Manchester.

We've now started a second forest garden project and our aim for the future is to get as many people as possible reconnected with the natural world, including establishing a forest school. I see rewilding as one of the best things we can do for both the environment and our physical and mental well-being.

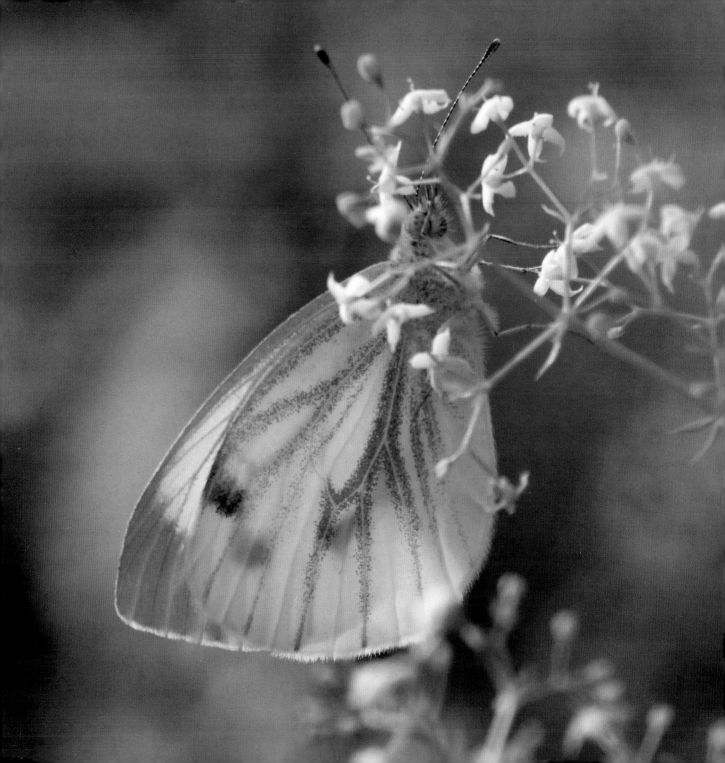

The 'Wilding' of Gardens: How We Will Transform Gardens into a Resource for Wildlife

Marc Carlton & Nigel Lees

A History of Control

The dramatic introduction to the BBC's coverage of the 2012 Sochi Winter Olympics ended with the question: 'Nature – who will conquer it?' The answer can be found in most gardens: it is the everyday activity we call gardening. The garden, like most of the landscape in the UK, is a totally human-made creation. Gardens were originally developed over 3,000 years ago in the Middle East, not only as enclosures to grow crops and keep some animals, but also to separate the homestead from the real and perceived dangers of the wild. Gardens became places of order, sanctuary, control and status where people could exclude the wildness and disorder of nature. From the late nineteenth century onwards, we have been increasingly seeking the chemical control of gardens as well.

Green-veined white in garden, Chepstow.

Gardens have Great Potential

The wildlife of these islands continues to decline, but recent research confirms that gardens and allotments sites in the UK can act as oases of insect diversity and as refuges for small creatures, such as hedgehogs, slow worms and amphibians, that were once so common. So how do we create spaces of beauty and tranquillity – artificial creations of the gardener's hands – where wildlife will positively thrive? If we leave gardens to their own devices, they will eventually succeed to secondary woodland, neither necessarily very diverse, nor a great resource for pollinators. They would cease to be gardens. We have a proud heritage of gardens and gardening, which we should aim to retain – but transformed. So gardens require human intervention. Hence we don't talk about rewilding the garden, as gardens have rarely,

if ever, been wild places. Instead we need to discuss the wilding of the garden, perhaps as a brand-new garden paradigm. We propose a kinder, more relaxed approach to gardening that puts wildlife first, but still creates an enticing outdoor space for people to be in: aesthetic spaces that are recognisably gardens, but use building blocks (i.e. the plants) that have maximum benefit to wild creatures. Many pieces of recent research across the world suggest that people's health and well-being are improved by regular contact with green spaces and by some form of interaction with nature. Gardens should be places on everyone's doorstep where this interaction can happen.

Planting Choice

Many of our wild species are creatures of woodland glades, hedgerows, scrub or woodland edge, and many of these take very happily to gardens as a substitute for these habitats. Native wild flowers planted in gardens can be augmented with close relatives from the rest of Europe – to good effect. The wild flora of Western Europe, which, based on recent scientific evidence, should be the first choice for wildlife-friendly planting, is massive and gives enormous scope from which the gardener can choose. The drought-resistant flora of the Mediterranean area gives us many plant

choices that will help our gardens cope with future climate change, while still supporting our invertebrate fauna.

Habitat Features

Creating gardens that focus on habitat development is the new garden paradigm. This means providing low- and high-level 'cover' through choice of shrubs and trees, food plants for invertebrates, pollen- and nectar-bearing flowers, home-made compost, piles of branches, a pond ... and not digging too much (in order to maintain mycorrhizae). This will create a natural, sustaining environment for many species in your garden – you are providing a home for them. Both the traditional 'cottage garden' and modern 'prairie' planting styles can accommodate these features perfectly.

A Living Tapestry

Humans and the rest of nature often appear out of balance in the garden, with so many front gardens reappearing as car-parking spaces and back gardens used as extensions of the home: patios, paved areas, gazebos, lawns, pretty and colourful borders with hardly any insects or birdlife. These 'Chelsea effect' gardens may contain some pollinator-friendly plants but the overall purpose of the garden is to impress. We are rarely impressed by such gardens, as

they are too often silent 'green deserts', lacking conspicuous wildlife. A garden should be alive with the constant movement of pollinating insects of all kinds as they visit a tapestry of flowers – a gardening 'coral reef'.

Changing the Definition of 'Good Gardening'

We are not talking 'weeds and wilderness'. Gardens should be places of beauty where we can experience wildlife close to home. With climate change starting to bite, gardeners need

A variety of native and introduced plants, Chepstow.

to feel empowered to help support our biome by creating the sustaining habitat in our gardens (and allotments, orchards, and public spaces). We propose a new gardening paradigm that puts wildlife-support first and leisure activities second. It is now time to repurpose gardens as a national resource for biodiversity to help mend our damaged environment.

Being wildlife-friendly needs to become the defining ethos of 'good gardening'.

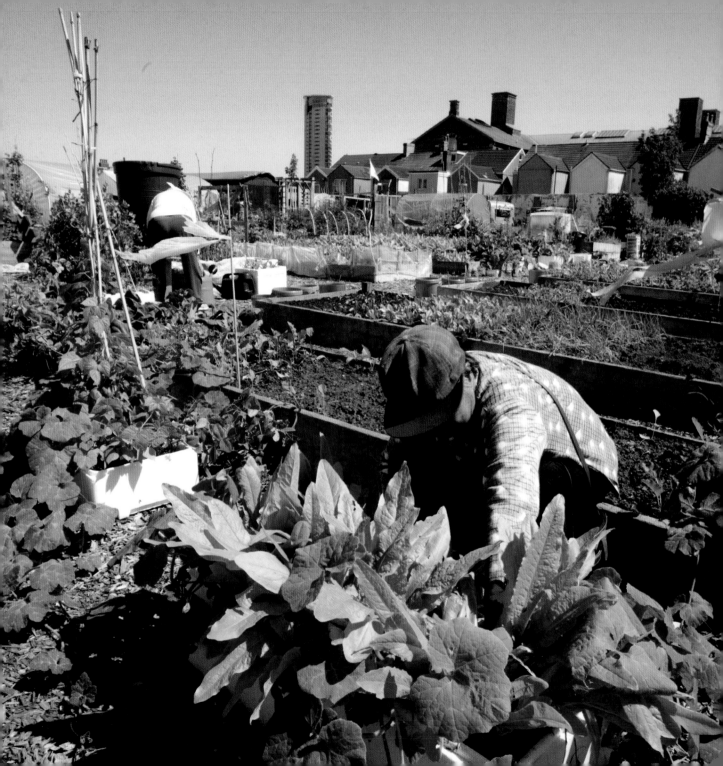

Vetch Community Garden

Susan Bayliss

In the heart of Swansea city lies a small green area which was once the home of the Swansea City football team known colloquially as The Swans. The Swans had used the Vetch as their home from 1912, when they were called Swansea Town, until 2005, when they moved into their new stadium, the Liberty, on the other side of the city. The Vetch lay fallow for several years, but now has become a park and community garden for the local residents and rewilding is carried out here on a small, but successful scale.

The community garden was started in 2011 as a specific short-term art project, which over the years, has re-formed into a well-organised space for growing produce of all kinds with special areas of rewilding. The original project was commissioned for the Cultural Olympiad in 2012 and was intended to transform a section of the old stadium into a temporary garden leading to the grand finale of a 'Flower and Produce Show'. However, in early 2012, it became evident that strong local support for the garden merited a more permanent outdoor community space.

From the very start, the residents of Sandfields – the area where the Vetch is situated – were eager to learn new skills, such as building raised beds and constructing polytunnels, building a cob oven and keeping chickens and beekeeping. Along the borders of the garden various indigenous shrubs and hedge trees were planted and now flourish and provide shelter for many birds and other wildlife. An abundance of hawthorn, hazel, crab apple, goat and crack willow and also honeysuckle and dog rose can be seen in these borders.

The diversity of the local community has meant that many species of plants not indigenous to Wales or even the UK

Mrs Peng, Vetch veg, Swansea.

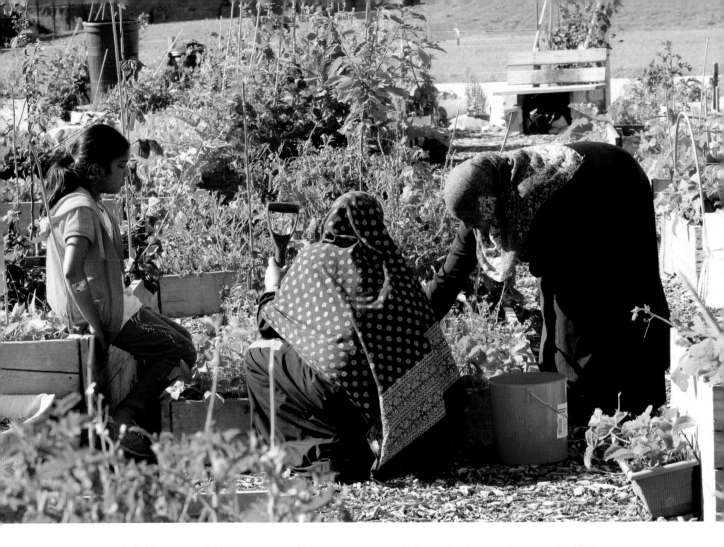

Bangladeshi women and child harvest vegetables.

have blended in with the local species and through the natural way of gardening have also enhanced and encouraged the growth of original species. The gardeners come from very different backgrounds as Sandfields is a cosmopolitan area with two primary schools, a mosque, a home for the Chinese elderly, four churches and businesses that include Chinese and Asian supermarkets. There are now over 50 gardeners, with many having several plots

to maintain. The committee liaise with several volunteer groups in the area, including the college and university students, who call each week and help with planting, painting and repairing beds. The inmates of the local prison, HMP Swansea, have even contributed their skills by building and painting boxes and fences for the garden. The local community becomes involved in open days held at the Vetch, with competitions for children, carol singing at Christmas, Eid celebrations, Easter egg hunts and, just recently, a crafting and sewing group set up.

The garden itself has been designed to promote interaction between all the plot holders by having at its centre a large meeting area used for many of the activities, with a shed and community sharing of water butts and standpipes. This has nurtured a sense of belonging and understanding between all the varied ethnic groups that live in the Sandfields area.

Members are able to grow anything that they want and each year sees a quantity of vegetables and flowers, some native to the UK and others originating from quite exotic places. Many growers have introduced flower species that have not been common in the area for years such as ragged robin with its beautiful pink flowers, evening primrose and poppies.

As a result of this isolated growing space in the centre of the city, we have also seen a return of some of our native birds – namely, sparrowhawk, grey wagtail, chiffchaff, goldfinch, dunnock and blackbird. Residents of the area have remarked on the fact that they see much more wildlife in their gardens since the Vetch garden has developed. The return of these birds has, of course, meant that seed distribution has also increased, and other areas of the city are now finding plants such as oxeye daisies and red and pink campion popping up.

Many important species have disappeared over the last century, including birds and mammals. The Vetch project certainly provides a healthier ecosystem and therefore helps to return areas to their previous status. The Vetch was so named because common vetch originally grew on the field and now, more than a hundred years later, it seems to have returned in abundance.

The future of the Vetch is uncertain but while it remains in the hands of the Vetch garden committee and users, it will continue to contribute in its small way to the rewilding of an important and very well-loved area of Swansea city.

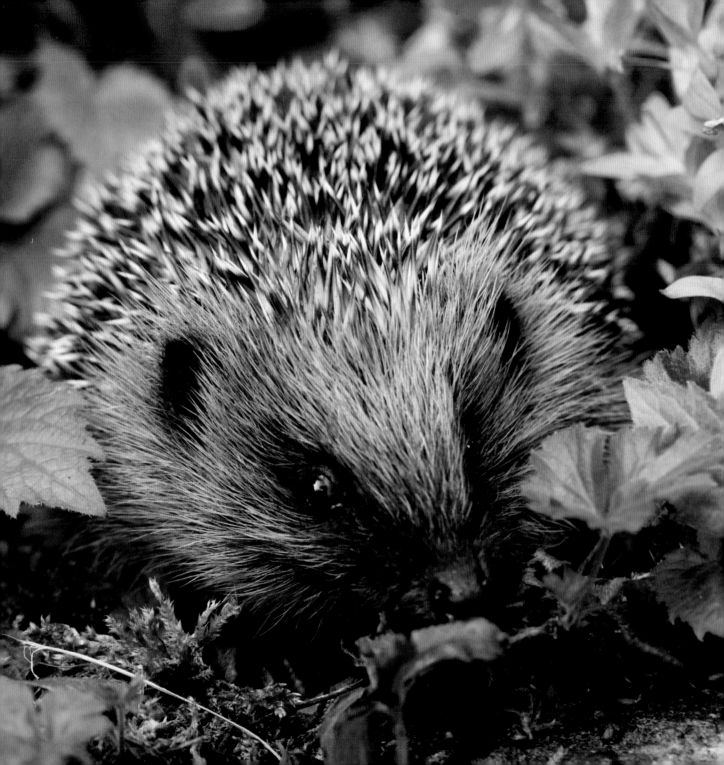

Rewilding: My Hedgehog Story

Tracy Pierce

My name is Tracy Pierce and I'm 53. I was brought up on a farm in Cilcain, North Wales, from the age of 7 – and at 19, I started my nursing training.

I married Mark in 1988 and we moved into our house in Prestatyn, where we still live 30 years later. It's a white Dutch-style detached house, one of the first properties to be built in the area nearly 80 years ago. We have a moderate garden, front and back, with fruit trees, hedges, shrubs, lawn ... and there was an orchard next door. Our boundary fencing was alternating horizontal wood planks with easy accessibility.

My first encounter with hedgehogs was very soon after we had moved in. We had some bags of garden rubbish that had been there a few weeks. I heard squeaking one afternoon and thought it could be mice or rats.

Young hedgehog in suburban garden.

On investigating, I discovered a nest of baby hedgehogs, with white bristles. I covered them over and hoped that Mum would return. Sadly, she did not and the hoglets were getting cold. I contacted the RSPCA, popped them in a box and kept them warm. They were collected and that was the last I saw of hedgehogs, until four years ago.

There have been lots of changes over the years –some good, some bad. Sadly, the neighbouring orchard has been reduced to a gravel car park and the fence was now an impenetrable six-foot wall. We made a small pond, we grow thornless blackberries and the ivy has taken over. The garden has always been nature-friendly with weeds, rough areas, open compost, mixed habitats. I have always fed the birds and one evening saw a hedgehog picking up the dropped food. The sighting reignited my interest in hedgehogs and I started to learn

how I could help. I put down food and water, provided nesting boxes and would spend the twilight hours sitting in the garden watching and listening for visitors.

Friends and neighbours learned of my love of the creatures and when they found poorly hedgehogs, they would bring them to me. With my background of farming and nursing, I was confident I could revive them, but sadly that was not the case. I would take them to the vets. He would give them an injection and I assumed they would recover with my care. They were dying, I was upset and frustrated. There was nowhere locally to take them or get advice and I knew I had to do better.

I joined the British Hedgehog Preservation Society and registered as a carer. I went to the Vale Wildlife Hospital in Gloucester and did a hedgehog carer course for a day, learning so much. I changed vets and the way I treated the hedgehogs.

My nursing career had come to an end due to arthritis, but my knowledge and skills were invaluable in caring for the hedgehogs. Sadly, as they are wild animals, they are usually quite poorly by the time they are found and rescued, and so survival rate can be low.

Hedgehog Help Prestatyn was started in October 2016. I wanted to spread the word that the hedgehogs are in trouble, what to look out for, how to help and who to contact for advice or care. With my pension I bought a shed and equipment. I developed a Facebook page, distributed business cards and information packs. That first winter I looked after ten hedgehogs, seven of which were Autumn juveniles, from a litter born in my garden, and too small to survive hibernation. I kept them in a heated shed and allowed them to gain weight. Once up to 700 g, they were moved to an unheated garage – allowing nature take its course and cause the hedgehogs to hibernate.

I continued to support-feed the visiting hedgehogs throughout the winter as with climate change and unseasonal weather the hedgehogs can wake up at intervals.

It was a steep learning curve and I made many mistakes along the way. I am eternally grateful for the support and advice of established rescuers and carers who have all been in my position and are happy to share their knowledge and advice.

Hedgehogs are in terrible trouble and the list of hazards is very long. The ones that I have dealt with include: dog attacks, trapped in netting, down drains, in building works, found out in the day 'sunbathing', orphans, autumn juveniles, gardening injuries, fractured limbs, dehydrated, starving and maggot infested. They are also poisoned, run over and displaced.

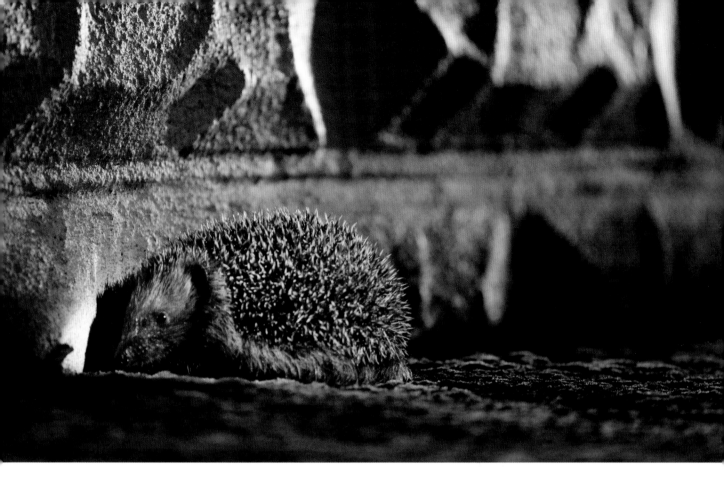

Many of the hedgehogs found out in the day are overcome with internal parasites, the main ones being roundworm, lung worm and fluke. These are diagnosed by microscopy – so a faecal sample is always eagerly awaited.

New admissions are weighed and examined before being placed on a heat pad if appropriate. Once warmed many have fluid injections. When they have passed urine, foods can be

Hedgehog blocked by urban garden wall.

commenced, of which there are many varieties, depending on the needs of the hedgehog. If a parasite burden is the problem, then it's on a course of worming injections and antibiotics. Injured animals need veterinary examination for anaesthetic and surgery. They are weighed daily to monitor progress or decline.

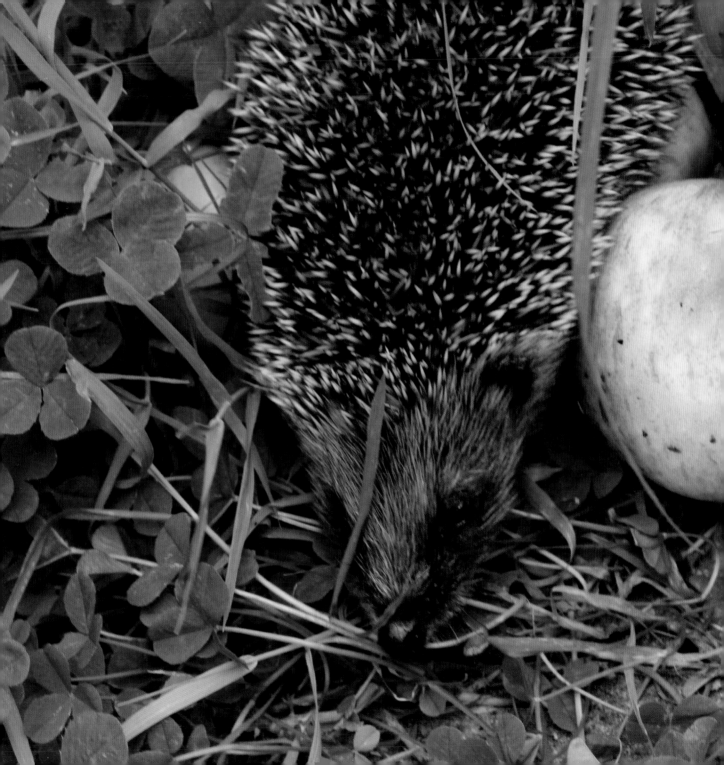

Hedgehogs should always be released where they were found but obviously not if they were attacked by a dog, or the area is dangerous, such as a building site. They will know where they can get food and water, shelter and mates. They are not territorial or sociable. Their bodies will also be accustomed to the parasites in that area.

Urban and suburban areas have higher populations than rural areas, according to latest studies. When releasing the hedgehogs, they are always started off with a nest-box and support feed. The site is checked and advice given. Access is vital, ponds need to have an escapes route and wild areas are promoted. These also provide habitat for the mini-beasts, which in turn provide food for the those further up the food chain.

Many times, I have heard of people finding a hedgehog in a dangerous place, maybe in the road, and they take it to the countryside or the woods. This has many negative consequences. The hedgehog will not know the area, where to find food, water, shelter, they are introduced to new parasites and there will probably be no other hedgehogs. There is also a chance that badgers in the area will predate the hedgehogs. Relocation can be a death sentence.

Educating people and sharing my knowledge, even though I am a novice, is a big part of my role in hedgehog care. Many people have never seen a hedgehog or know their normal behaviour, so when they do find one there can often be a delay before help is found. As they are wild animals, they do not show weakness until they are very ill and sadly any delay in getting help can be fatal. I talk to schools, groups, run information and awareness stalls.

I'm a member of the North Wales Wildlife Trust, Woodland Trust and RSPB, as well as local environment groups. I'm also a litter champion with Keep Wales Tidy. Our hedgehog group links up with all these other organisations to help plant hedges and trees, assist wildlife projects and litter pick. We are presently working on the Long Forest project to plant hedges to provide wildlife corridors. I have volunteers that help with the daily care of the hedgehogs in care – they consider it a real privilege to be helping with these wonderful mammals. I do fear for the future of hedgehogs and they need all the help they can get.

Hedgehog among apples.

Rewilding Cities

Scott Ferguson

The return of whooper swans to Hogganfield Loch after a 1,400 km flight from Iceland is a reminder that even our cities have a wild side. The first yellow beak among the ever-present orange of the resident mute swans is not just a sign of the changing season but demonstrates that we can create great places for nature in the heart of urban communities.

Hogganfield Park in Glasgow is just a minute from one of Scotland's busiest roads. While almost 75,000 vehicles a day thunder along the motorway corridor, Hogganfield Park is an opportunity to replace the hustle of urban life with the bustle of birdlife. Throughout the year a huge variety of wild birds come to the loch to rest, feed, and breed. From the familiar, such as coot, tufted duck and mallard, to more unlikely urban birds like the aforementioned

Whooper swan, Hogganfield Loch, Glasgow.

and charismatic whooper swans and elegant great crested grebe. The current species count stands at almost 150 birds.

The impressive species list is no accident. The park recently celebrated its twentieth anniversary as a local nature reserve, and before that many hundreds of Glaswegian schoolchildren visited the park to be taken round the nature trail on the island bird sanctuary. The island now truly is a bird sanctuary, and over the last 20 years Glasgow City Council has been proactive in transforming Hogganfield from a traditional park of boating pond and amenity grass to a nature reserve of loch, wetland, grassland and woodland. Re-naturalisation of the loch margins, creation of ponds and scrapes, and meadow management have all contributed to making space for nature. More recently Hogganfield Loch became the first in Scotland

to have 'biohaven' floating wetlands, a trial that was instantly rewarded with nesting great crested grebe in spring 2017.

Hogganfield Park is also a key part of a larger, more ambitious rewilding project. In 2016, the Seven Lochs Partnership was formed to lead a five-year, National Lottery Heritage Fund project to create the Seven Lochs Wetland Park – Scotland's largest urban nature park. The park, which straddles the Glasgow City/North Lanarkshire Council boundary, brings together two sites of special scientific interest, five local nature reserves and a country park across an area of almost 17 km². The vision for the Seven Lochs is of a new heritage and nature park of national significance that protects biodiversity, improves people's health and well-being, and supports social and economic regeneration in the surrounding communities.

The Seven Lochs vision reflects the need for urban rewilding to be about more than just changing how we manage land; we need to change the way we think about people and place. It involves rethinking urban areas to look at where nature can work for people, people can work with nature and where wilder is better. At Seven Lochs this means creating wetland areas in green spaces to reduce flood risk, prescribing time in green space to improve people's health and well-being, and restoring peatlands to absorb and store carbon. One of the concepts at the core of urban rewilding should be 'multi-functional'. Spaces that benefit both people and nature.

Another key element of rewilding is connectivity. This thread of 'joining things up' runs through the Seven Lochs Project – whether it's physically connecting habitats that have been fragmented by past land management, reconnecting people to the wild places on their doorstep, or building new partnerships between institutions and communities. A critical connection is between children and nature. The greatest predictor of time spent in nature as an adult is time spent in nature as a child, and research shows that time in green spaces has well-being benefits from cradle to grave. If making space and time for wildness in childhood has a lifelong benefit, then wilder cities will be healthier cities.

But there is also a paradox for 'wilder is better' in urban areas. All cities include spaces that are forgotten, overlooked and undervalued, and the Seven Lochs area has more than its fair share of vacant and derelict land. In these unmanaged spaces nature can put down its roots, find a foothold, spread its wings and thrive. Where places like this exist in the countryside – albeit usually on a larger scale – they often become places that we recognise

and protect as nature reserves. Where they are found in urban areas, they can become spaces that are wasted and abused – hot spots for fly-tipping and antisocial behaviour that mean they are blight on, rather than a benefit to, surrounding communities.

This is well illustrated in the Seven Lochs area thanks to a unique, nationally significant population of water voles that have found a way to survive and thrive in unmanaged grassland on areas of vacant and derelict land. Across the UK water voles in their more familiar wetland habitats have declined by over 80% in the last 50 years. In Easterhouse, Glasgow, they have found a way to adapt to life in areas of forgotten and neglected land – and at densities significantly higher than in pristine wetland habitat. But while conservationists might celebrate this story of survival, some people living with these sites on their doorstep view them as wasted spaces, and water voles as a barrier to more beneficial use of the land. In world of increasing pressure on land and resources, we must pay attention to these wasted spaces. Rewilding cannot be an excuse for neglecting land – it must be positive, proactive, and bring people and nature together.

An emerging concept that might help to make that connection is the idea of a National Park City. London is on the way to becoming the world's first National Park City in 2019, and active campaigns are under way in Glasgow and elsewhere. There's no official definition of a 'National Park City', but the idea is broadly based on applying the principles and benefits of traditional National Parks to the urban environment. This focuses on thinking about cities, where there are a multitude of ways in which people can access, enjoy, understand and care for wild spaces, where natural and cultural heritage is protected and enhanced, and where individuals, groups and organisations are helped to work together towards these aims.

Cities face a multitude of challenges – not least the need to move rapidly towards a low-carbon, sustainable future against the backdrop of a rapidly changing environment. Rewilding is an opportunity to work with, rather than against, nature to help us meet these challenges. And a big part of the beauty of urban rewilding is that because it needs to be done at a range of scales – from greening gardens and local green space, to working collaboratively on big ideal like National Park Cities – it creates opportunities for everyone to take part.

Colliery Spoil Biodiversity
Liam Olds

Well before the concept of rewilding was established in the UK, its practice had been happening for decades in the South Wales coalfields. Although entirely unintentional and unforeseen, the actions of the coal mining industry would, many years later, be viewed by some as rewilding at a regional scale. For more than a century, the environment of the South Wales Valleys and the fortunes of the people who lived here were shaped by coal mining. The scars of heavy industry were everywhere and black tips of coal waste brooded ominously over the Valleys, but that was the past. Mining and heavy industry have gone, nature has acted and the landscape has been transformed.

Centuries of intensive mining activity ultimately generated excessive quantities of waste. Coal was hauled from the ground by

Dare Valley Country Park, Aberdare, South Wales.

generations of fathers and sons, and the spoil heaped and mounded on the valley sides. Such spoil tips have become an iconic feature in the landscape of the South Wales Valleys. After decades of weathering, these once barren wastelands gradually developed thin soils and slowly vegetated. Today, these tips form diverse and intricate habitats. Heathland, flower-rich grasslands, species-rich lichen and moss communities, scrub and secondary woodland, wet flushes and seasonal pools have clothed the once bare ground. Ironically, spoil tips that were once a symbol of unprecedented habitat destruction are now an oasis for wildlife. Once black eyesores in the landscape, many now support habitats and wildlife of considerable biodiversity value. To me, these spoil tips are the essence of rewilding. Starting from nothing more than waste rock, these tips have been transformed by the powers of nature

into fantastic places for both people and wildlife. They confirm the intuitive belief that nature does best when left to its own devices.

Regardless of how well nature has recovered these sites, there is still often a desire to do something 'useful' with them. That 'doing something' can not only involve commercial opencast schemes looking to rework coal and untapped seams, but more recent proposals to plant biofuels on 'derelict' colliery spoil. It also includes pressure from environmental 'enhancement' projects looking to plant trees on colliery spoil habitats, or sow wildflower seeds on already wildflower-rich habitats. What should be seen as an ecological asset is still often viewed as a problem needing to be transformed. Long-established prejudice exists, which stems back to the era in which spoil tips were dangerous and eyesores in the landscape. Many old tips were indeed dangerous and their belated removal after the terrible Aberfan disaster essential. However, these tips have long gone and nature has acted. Only those tips deemed stable have remained, left undisturbed to naturally revegetate over time. Though the landscape has been transformed, perceptions of dereliction and despoliation stubbornly persist. Developing public support and wider interest in these sites is key to their conservation. That process has begun through the Colliery Spoil Biodiversity Initiative, a project I founded in 2015 to raise awareness of the important biodiversity value of these overlooked and under-appreciated habitats.

My fascination for spoil tips began in childhood. Living opposite a former colliery site, I spent many a day exploring the site, seeing what wildlife I could discover. Many memorable wildlife encounters followed and a lifelong passion for natural history began to flourish. Although seemingly unrealistic, I dreamt of one day working to conserve colliery spoil, the habitats that first introduced me to wildlife and have shaped my life ever since. Some years later I achieved this seemingly unrealistic dream and founded the Colliery Spoil Biodiversity Initiative. Investment from a small number of local authorities has allowed me to conduct research into these habitats, addressing gaps in our existing knowledge. Particular focus has been placed on invertebrates, prior to which very little was known beyond a few more 'charismatic' groups such as butterflies and dragonflies. To date, 15 sites across two local authority areas have been surveyed – contributing to an increased understanding of the importance of colliery spoil to invertebrate conservation. Through training courses, guided walks, talks for

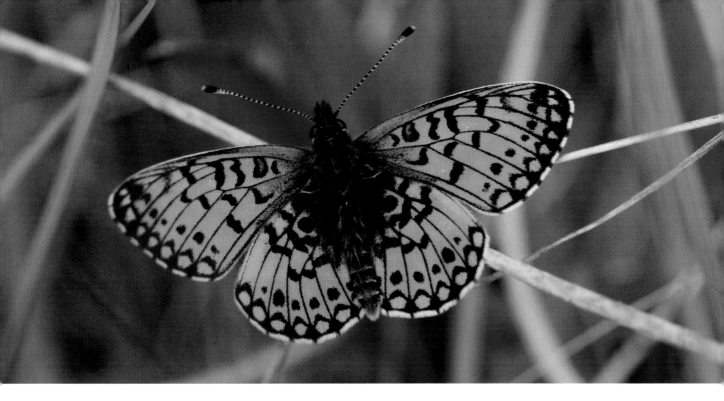

Small Pearl-bordered Fritillary.

local interest groups, social media, magazine articles, and coverage on TV, radio and in newspapers, I continue my efforts to raise the public profile and conservation status of colliery spoil in South Wales.

Colliery spoil is a regional resource that needs conservation and further investigation. Also, at a time of uncertainty for nature conservation, it is an inspirational habitat which gives us hope for the future. Colliery spoil has shown us that, given a chance, natural processes are dynamic and strong. If we are to rewild areas of lowland and upland Wales, the conservation of spoil tips and other brownfield land is essential – after all, these sites are often the source of our remaining wildlife. Unique landscape features and sites of high biodiversity significance, colliery spoil deserves to be conserved, protected and admired. Join me and others in championing the cause for colliery spoil and other brownfield sites. Wherever you may be, brownfield could hold the answer to a wilder Britain.

The Place of Rewilding in the Wider Context of Sustainability

Richard Moles

Of late, there have been seismic shifts in the popular view of sustainability. Television programmes and newspaper articles, for example, until recently were 'balanced' by having both a scientist set out the evidence for, and the dangers of, climate change, and a climate-change denier who, on the basis of contrived evidence, furiously argued that nothing was certain and we should not modify our ways until certainty was clearly established. Recently, however, extreme weather events have had enormous consequences in terms of, for example, food production, forestry, health and well-being, which, furthermore, have been monetised, so that people can see more clearly how climate change might affect their lives. Doubtless there are future battles to be won, but

Wind turbines and oilseed rape biofuels, Cambridgeshire.

there is a dawning realisation of the scale of the changes required to avoid what some have called an existential threat to human life. We have made some small progress – renewable energy generation is cheaper than using fossil fuels; houses are well insulated; electric-powered public transport and cars are now accepted as the new reality; our use of plastics identified as wasteful and polluting. These are symptoms of our ability to change, but not anywhere near the scale of what is required if we are to avoid very widespread disruption and hardship. While EU and national government reports and policy statements point up the need for a radical change in the way we live, few to date have explained a plan for how we are going to convince people to make the necessary adjustments. Such changes require us to enter into novel, creative and imaginative relationships with each other and with our planet.

We have to forge a coalition of ecology and economy, so that what happens in the economy supports a sustainable society. This in turn requires a fundamental shift in mind-set. We cannot reasonably expect people who are not sure where their next meal is coming from to be much concerned with events likely to occur in coming decades. We cannot reasonably expect people to work cooperatively if they are divided between a small number of the very rich and a much larger number of the very poor. We cannot arrange to live sustainably if we use our planet's resources at twice the rate that they are being replenished by natural processes, and if we disable these processes through pollution and the accumulation of our wastes.

So we need to live in ways that do not interfere with the fundamental planetary processes which create and maintain our life support system. But if we are not going to struggle to give meaning to our lives by, to take a few examples, becoming richer than our neighbours, eating food from around the world, travelling by air in search of exotic 'experiences' and living in enormous houses, then what *are* we going to do with the money we earn? There is no generally agreed answer to this question. But there are clear guides to how we might go about achieving this. People in our society, acting as individual consumers, tend to be motivated by financial concerns, to gain the most from expenditure. Conversely, people who are active members of purposeful communities are more concerned about what is good for community members, the common good, and the social interaction which community membership brings, and making the world a better place. These communities are crucially important demonstrations of how we might live in the future: Cloughjordan village and Westport town are examples in Ireland, Findhorn in Scotland. In Cloughjordan village, land is divided equally among housing, food growing and forest. Houses are energy efficient and the community, among many other things, organise on-site organic food growing and distribution, generate electricity from wood and sun, come together for decision making but also organic feasts and music, and host talented and informed organisations which work to promote sustainability. A surprisingly large number of residents in Westport actively volunteer to enhance their town. Over time, a spectrum of committees of volunteers came together to focus on interests such as attractiveness, tourism and transport. But then, recognising the need to address more fundamental issues, they formed

Fisherman in dry reservoir, Llyn Brianne, Carmarthenshire, Wales.

Cattle, Cliffs of Moher, County Clare.

another committee with the goal of working towards sustainability. Now each specialist committee includes a member representing the sustainability committee. In this way they have developed and implemented a wide variety of far-sighted actions, going far beyond what has been achieved by other small towns. Shared motivation is key to ensuring voluntary communities keep going long enough to see

positive benefits from their actions. Findhorn attracts many thousands of people every year, finding a mixture of practical help, but also a more spiritual guide to exploring and supporting the underlying reasons why increasing numbers of people seek out communities as a way of building into their lives something more meaningful than individualistic consumerism. Even the most world-weary come away more enlightened about themselves and their lives. In summary, using a variety of organisational

and at the same time have little opportunity to ponder more fully the extraordinary opportunities available to sentient beings. Some suggest we use time to focus on the wonder of this planet, as far as we know unique in our galaxy, and its ability to support life. We have learned a huge amount about how this planet functions, the processes which shape it and our actions which damage these processes. Building on this understanding, we need to find ways of living which translate this wonderment into a lifestyle. Thus, the indicator of a successful life will be the extent of our creativity and imagination in minimising any negative impacts which we might have on the planet, and the extent to which we act to be a powerful but thoughtfully benign agent in restoring and encouraging the complexity of the natural world, as well as community-building to provide the sense of belonging that every person needs. One strand to achieving this is to start giving back some of what we have taken from nature. Already we have made the first few strides in this, as this book demonstrates so clearly. For a growing number of us this is an important manifestation of a desire to live more sustainably. In future it will not be the only one, but it is crucial in the mix if this existential threat is to be avoided.

strategies – some planned, others spontaneous – these communities unite and energise members in an effort to make their own lives both more satisfying and sustainable, but also magnify their impact by seeding ideas of what is possible well beyond their boundaries. There are many other examples all around the world: the lessons they teach us urgently need to be learned by most of us.

We have allowed a society to evolve in which we compete with one another for scarce jobs,

Rewilding the Law
Mumta Ito

There are universal laws that govern all of life. When we align with them we create a cycle of peace, harmony and prosperity for all of life. When we are out of alignment we create a spiral of destruction, as we can see in the world today. All societies that ignored this truth have perished.

In the last 40 years – the time from which the first environmental laws were enacted – we have extinguished over 50% of the populations of all species on Earth, climate change is upon us and the world's ecosystems are collapsing. A key reason for this is because our laws – designed around an economic paradigm that is coupled with the destruction of Nature – legitimises it.

As a lawyer, I've advised multinationals, investment banks and governments as well as grassroots communities and NGOs working to

Blanket bog, Denbigh Moor, Denbighshire.

protect Nature. One thing I learned was that our current structure of law cannot meet the challenges of our time. At best, these laws can slow the rate of destruction, but they cannot stop or reverse it. This is why in 2015, I set up a charity – Nature's Rights – to pioneer the movement in Europe to secure legal personality and rights for ecosystems and species within a holistic framework of law, based on earth jurisprudence. Our aim is to catalyse a paradigm shift in law – and consciousness.

At the heart of the ecological crisis is a dominant economic system based on infinite growth. Other key systems integrate with this, creating a powerful destructive force. But there is something that underpins all of this – a legal system that is out of alignment with the laws of Nature.

There is a deep flaw in our system of law that treats living beings as objects or property,

while treating corporations, which are a form of property, as subjects of the law with legal personality and rights. At the core of this is valuing Nature for its utility to human beings – as resources, property or natural capital – rather than valuing it intrinsically as the source of life. This legal construct of Nature as an object is at the root of the ecological crisis. It is the reason why it is legal to have an economic system based on infinite growth; an agricultural system that poisons the Earth; and an energy system that destroys Nature faster than she can replenish. Furthermore, the law doesn't recognise a relationship between us and the rest of Nature, so there is no legal duty of care or obligations towards Nature. Environmental law operates to manage the externalities of the system, without challenging the root cause of the problem. This is why, despite hundreds of environmental laws, Nature is still in decline.

But we can change that. Legal personality and rights for Nature provides a powerful opportunity to fundamentally reshape our uncritical models of economic development, address our unmet moral obligations to future generations, and challenge our concept of what it means to live a flourishing life. It counterbalances corporate and property rights, values Nature intrinsically and creates a legal relationship between humanity and the rest of Nature, healing the disconnection, bringing in a legal duty of care and protecting our collective right to life.

Nature's rights strengthen all other environmental causes by creating an overarching legal framework that empowers and unites existing initiatives to protect Nature, giving them a much stronger basis in law. It ensures that the laws and subsidies scale up solutions – such as rewilding – to create massive systemic change through creativity and innovation, increased health, well-being and jobs, creating living economies that serve life. We've talked about sustainability for decades, but there is actually no legal framework to achieve it. Nature's rights, integrated across all key policy areas, create this. They also catalyse a cultural shift in attitude towards a society based on love and compassion for all beings and proactive community ecological governance.

One of our local pioneering UK projects is securing legal personality and rights for the River Frome and Rodden Meadow. Although Nature's rights have been recognised in over 36 municipalities in the USA, once approved by the Ministry of Housing, Communities and Local Government, this will be the first in the UK. This move is aligned with the recent trend for courts to recognise the inherent rights of ecosystems around the world. The application process includes preparing a draft bye-law, a regulatory assessment and local consultation.

Local authorities can also create policies that recognise Nature's rights through the Well-being Powers under the Local Government Act 2000. By declaring their municipality a Nature's Rights Zone and proposing an action plan, they can empower locals to act as if Nature had legal rights at a local level, creating 'living law'. Additionally, any landowner, school or project can sign up as a Nature's Rights Zone by adopting a declaration. It is a powerful way to align all rewilding and other positive initiatives to protect

Brown hairstreak.

Nature with the paradigm shift that we seek to achieve in law, demonstrating to the decision-makers examples of earth jurisprudence in action. This also ties in with Agenda 2030 and the UK's commitment to deliver the 17 UN Sustainable Development Goals. To find out more about how to start a local initiative, sign up to be a Nature's Rights Zone or otherwise get involved, visit www.natures-rights.org.

Homeless

Siobhan Davies

His cardboard bed curls at the corners
With the damp of rain
His sleeping bag cannot shelter him from.
Dog at his feet, tied to him
With more than just the tattered rope
Around it's neck.
Doorway man,
His backdrop a holiday in the Maldives,
Sunshine wallpaper
To his concrete pillow.
Glass eyes heel-click him by,
Thinking that copper will make a difference.
Once he was suited, booted, tied
Perhaps to a desk, perhaps
Just to a wage.
But not for him a middle age
Of gastric ulcers and palpitations
And monthly mortgage repayments.
Instead a fight against the drizzle,
Against the frost,

Against the cold not just in the air
But in your faces as you pass him by.
His belly empty as pockets,
But his dog fed.
Do not judge this man.
For he is a man.
He has a name.

His name is not Mike, or John,
Or Steve. His name is uncle,
Dad, son. His name is Austerity.

And he is ours. We own him.
We own the tin whistle he plays
With fingerless gloves,
We own the ragged newspapers
That scream headlines from his bedding,
We own his loneliness, his raggedness,
His wretchedness, his pride.
He has a story to tell,

Homeless camp, Brighton, East Sussex.

If only you had the time to listen
Between lunch dates and meetings,
Rushing to catch the tube home.
And his loneliness speaks itself,
In the way his dog curls at his stomach,
In the notes that rise from that tin whistle,
In the pity of coins at his feet.

His dreams begin and end with graffiti,
Shattered glass,
The sharpened remains
Of a society done with him.
His history lost amongst the rubbish,
The litter, his future
Part of a pavement stage
Upon which no spotlight picks him out.

REWILDING

Just pause; and imagine a bed
Of paving stones,
The loneliness of a moonless night,
The growl of hunger ever-present in your belly.
Imagine the warmth
Of a scraggy collie
Your only warmth,
The bright light of a soup kitchen
The only glow.

As you stretch in front of satellite TV
And wireless broadband
Imagine the only conversation
Is muttered amongst passers-by
And think.
Just think.

We can change.
Austerity only has power
If we give it power,
Austerity, the name of that man
Sleeping under the bridge,
In the doorway, right now,
While you turn on your night light
And snuggle under duvet
Safe under four walls and a roof.

Imagine that your only roof is endless sky
And a moon not bright enough to light your
doorway
And change.

Short change. Enough
To feed him, clothe him,
Shave that endlessly ageing face
And give him shelter.

He is the forgotten,
The unseen,
Unknown as quickly as he was known
To judgements that pass him daily, hourly,
Every cold waking moment.

Sleep comes harder than the pavement
And waking brings it's own nightmares
So give him his dreams,
Give him the rooms lying empty,
Give him a space
That doesn't open onto stardust and car tyres,
Give him warmth.

We all deserve warmth.

Rewilding Reborn

Em Mackie

*When we try to pick out anything by itself,
we find it hitched to everything else in the
universe.*

<div align="right">John Muir</div>

It becomes about the little things. The smell of a struck match. The light of the flickering candle. The whistle of the kettle on the gas cooker, its steam clouding the air. The sound her feet make padding on the bare floorboards of the shack she calls home. Today she will plant more trees on the hillside of Glenlude. She will plant them with these hands that had once piloted the air and now warm themselves on a mug of hot tea in this *nowhere* she is in the middle of. A wildness entirely her own. She will carry the saplings, dig the earth, press home the tap root hidden within its cell of compost. She will allow the beginnings above ground to wrestle and be shaped by the elements of this upland. For is that not what it means to *live*?

It becomes about the little things. The way she lifts her feet moving through the heather. The sound of the wind threading through spruce and larch. The 'pilyay' of a buzzard's cry overhead. The soil that will collect beneath her fingernails. When she looks at the veins on her hands she does not see evidence of the passing years, but sees instead something not unlike those delicate young hairlike roots that nourish and strengthen, let grow, her saplings into trees.

* * *

Sheila Bell was a real inspiration with regards to rewilding. She is a testimony to how just one individual *can* make a difference. In 2000, at the age of 57, she purchased Glenlude, 150 ha of hillside farm and conifer plantation in the remote Scottish Borders, with the vision to re-establish it as a native woodland. There is something beautifully poetic about this remarkable woman who in her lifetime

had mastered the skies as a pilot in Uganda and in later years worked so closely with the earth. She passed away in 2010 and left Glenlude in the hands of the John Muir Trust, the conservation charity that is dedicated to protecting and enhancing wild places in the UK. Her elemental spirit, her mission and her ambitious energy and focus has now combined with that of John Muir, the Scottish environmentalist, who was instrumental in creating the world's first national park and who is the inspiration behind the continued work of the John Muir Trust today.

Glenlude is now a hub of volunteering, community engagement and rewilding conservation days. People of all ages and abilities are welcome. Young people engage with the project through school groups and youth charities. Nature lovers join in on surveying wildlife and the changing landscape. Participants of the John Muir Award visit on their journey exploring what wild spaces mean to them. Those who are pursuing work in conservation and woodland establishment find stepping stones at Glenlude, invaluable experience that can lead to future employment. And for those who enjoy their experience and want to return time and time again, there is always room amidst the stalwart core of regular volunteers that form Glenlude's ground-force

team, without whom the bulk of work required to make this rewilding project possible simply wouldn't get done.

In its commitment to 'therapy through nature', Glenlude further seeks to work with charities, focussing on well-being, mental health support, drug and alcohol rehabilitation, homelessness and unemployment, with a focus on confidence-building and gaining new skills. In 2012, an area of Glenlude was set aside to establish a native woodland that would symbolise recovery from addiction. It was named Phoenix Forest after Phoenix Futures Scotland, a Glasgow-based recovery charity which regularly brings teams of volunteers from some of Scotland's poorest urban communities to plant trees and carry out other rewilding activity. For every individual who successfully completes a Phoenix Futures drug or alcohol rehabilitation programme in Scotland, a new tree is planted. This part of the landscape is now being revitalised, with over a thousand new native broadleaf trees, each representing a life that has been transformed. 'In every walk with nature,' John Muir writes, 'one receives far more than he seeks.'

Gradually over the years, this 150-ha former sheep farm and conifer plantation will be transformed into a haven of wildness. Natural regeneration has already begun,

with species such as birch, alder, willow and rowan all finding ground to take root. There is blaeberry on the hill where there was none before and the first sightings of species new to Glenlude, like the northern brown argus and the small pearl-bordered fritillary.

But this rewilding project is not only about re-establishing a native woodland for environmental benefit, but about re-establishing human engagement and connection with nature. Being a part of something bigger, something lasting, makes a very real positive impact on not just the environment, but on people's lives. As one visitor wrote in the guestbook, 'In the confusion

Work party from Phoenix Futures.

of life, what simple serenity to be wild and free in the beauty of earth's natural surroundings.'

Planting trees, building brash hedges, potting on in the polytunnel are all tasks that might be assigned on a conservation day, but it is often those unplanned moments that bring the most joy. Sighting an adder basking on a rock in the midday sun. Hearing the warbling, whistle and trill of the curlew. Watching damselflies darting over the ponds. It becomes about the little things. At Glenlude it is acknowledged that those little things can make a big difference.

Rewilding of the Heart

Bruce Parry

What is it to rewild? It's a term that is becoming increasingly hard to define and use. When I'm asked, my mind goes to the people I've visited on my travels who live much closer to nature than most of us do. And what's more, I've been lucky enough to have spent time with people who, I believe, truly live in the wilderness. And I don't say this lightly, for it's no easy thing to live in a way that the 'wilderness' remains 'wild'. I might even go further and say that these people are a fundamental part of the wilderness, as we all once were. So I guess you could say that these people, themselves, are wild. But what do I mean by that? In contemporary parlance, this could be taken as an insult. To be wild, according to Wikipedia, is 'to be uncontrolled or unrestrained, especially in pursuit of pleasure' (well that is true for them too – in a delightful way), but it also commonly means 'to be rowdy and riotous'.

Young cyclists under sculpted badger head, Welsh Wildlife Centre, Cardigan.

The reality, however, is that the Penan people of Borneo were quite probably the most civilised people I've ever met. But how, you may ask, can a group of people be 'wild' and 'civilised' at the same time? Confused? Bewildered even? I guess it goes to show just how much we've changed – and how our language has changed with us.

The Penan were the last tribal group I ever visited when I was making the BBC TV series, *Tribe*, and visiting them challenged everything I thought I had learned about human nature and society. The Penan's physical impact on their ancestral home is so light that they leave no discernible trace on their environment at all. And it is this, their invisibility, which also renders them defenceless against the state-sanctioned destruction of the forests and the encroachment of the palm oil plantations – the result of 'our' globalised 'civilisation'.

The Penan, and a tiny handful of others like them, are nomadic hunter gatherers, the last remnant peoples still living without

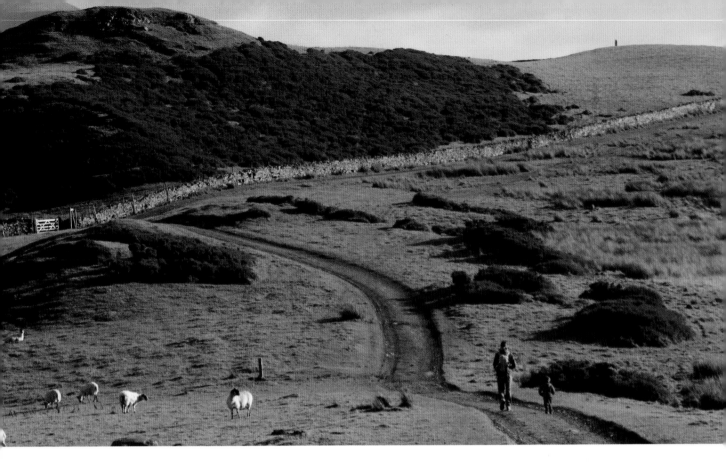

Father and son, near Loweswater.

influence from the Neolithic revolution and the domestication of plants and animals for food. They live for the day, with no hierarchy and no sense of ownership as we know it. They are anarchists and yet, with no leaders of any kind, they are also thought to be the most peaceful people on the planet. Peaceful anarchists who are wildly civil. Yes! Their way of being is to avoid and they practise almost no coercion in their community at all. As soon as you can walk, you are a free, autonomous member of society, with as much voice in the group as anyone else. Even the coercion or domestication of nature, especially animals for food, is an anathema to them. My friend Arau once said to me, 'Someone who could kill an animal that they had lived alongside could kill a human – how could someone do that?'

Everything is fastidiously shared among the group and being with them is to live in a world with no discernible competition, which is a truly remarkable experience to be immersed in. And, even more remarkably, this way of being isn't confined to the inner workings of small separate groups who are outwardly in competition with each other, but it extends out, intermingling and overlapping with all the other egalitarian groups throughout the tropical belt, as can still be seen in the Congo today. This, I believe, is our true ancestral past.

I am aware of how romantic this sounds and I agree, it is romantic – but romantic doesn't need to mean untrue, does it? For a long time I was afraid to express these thoughts for fear of being ridiculed, and despite these ideas becoming widely accepted in academic circles now, somehow they don't seem to have entered the wider public discourse yet. They need to.

After years of meeting with tribal peoples around the world, it was only when I met with the Penan that I discovered this insight. Had I visited them first I don't think I would have noticed. It was only because I visited so many groups that I truly noticed the real difference. They live without competition! Without hierarchy! Everyone else in the world exists with chiefs, shamans, leaders, priests, politburos, etc. And yet for the vast majority of our time on the planet, the evidence is increasingly clear that we did not – we lived in fully decentralised egalitarian anarchies. But, somehow, this story has been lost.

Our existing cultural narrative is so strong, and continues to be peddled by the plethora of pop-science books telling us that we've always been aggressive, warlike and competitive – perhaps to assuage our feelings and help us forgive ourselves for how we behave today, by acknowledging that nothing can be done about our destructive ways and 'it's ever been thus'.

But I won't have it. As a society, even a global society, we can create any way of being together that we want. I've experienced what's possible and I know we could achieve a more harmonious way of being together if we wanted it. This is a vital part of our cultural narrative that is missing and it needs to come back. The narrative is key.

We need to know what we are capable of to bring back some hope for a different kind of future. It doesn't mean we have to turn back the clock and be hunter gatherers again, but it does mean we need to re-evaluate where we are at today in light of a different understanding of both our past and our potential? Maybe this is simply something to be known for those who will be restarting out of the ashes of what may come. Either way, we need to know it.

One interesting thing I discovered in the course of investigating these ideas (which are the subjects of my film, *Tawai: A Voice from the Forest*) is that hunting and gathering requires a very different kind of attention to be brought to the world than that of farming. The act of hunting is an intense experience of being alert and embodied in your senses in the present moment in order to catch your quarry. Likewise, foraging for wild food requires a type of attention to the natural surroundings which gets you out of the endless abstractions of the mind and into a deep concentration of what is immediately around (as I am slowly discovering myself). This is to some degree why nature-based therapies work so well – they bring us into the present. But this type of attention is clearly not the same for agriculture. Of course you can be attentive, present and connected as a gardener, horticulturist and farmer, but you don't need to be. This is the difference.

Ask anyone who has been on a week-long meditation retreat how they differed between going in and coming out and it's pretty much guaranteed that they will say something about feeling more 'connected'. And experiments show us that this type of attention increases our sense of empathy.

Family on boardwalk, Dyfi wetland.

So one has to ask the question, what has this shift in the way we use our minds and bodies meant in our relationship to each other and to nature since we stopped meditating every day and began to domesticate and manipulate our natural surroundings? Is it any surprise that we feel so superior and apart from each other and the natural world – with devastating consequences only getting worse.

Imagine, living with a deep sense of empathy for all that surrounds you would almost necessitate that you act ethically, that you care for each other deeply, for your pain is my own pain, your pleasure mine too. And what if that feeling extended to the wider world? To intimately know that your actions have deep repercussions and that if you abuse the natural world, you will absolutely be abusing yourself too. Might it be that, although the same person as you and me, and not perfect by any stretch, our distant ancestors felt this and knew this and created their world accordingly? I think perhaps this will have helped.

For me, to rewild is to connect with this part of myself again; I want to be wild and to feel bewilderment again – the letting go of certainty and analysis and experiencing the awe of all that is around. I want to feel connected to the unknowable and untameable rather than believing that I can know and

Resting in alders, Strathdearn, Scotland.

control everything. This other way of being is available to us all if we choose it, and the type of society which can emanate from this way of being might be available too. The first step is to believe it's possible, and this is a whole lot easier when you realise that it was how we all once lived.

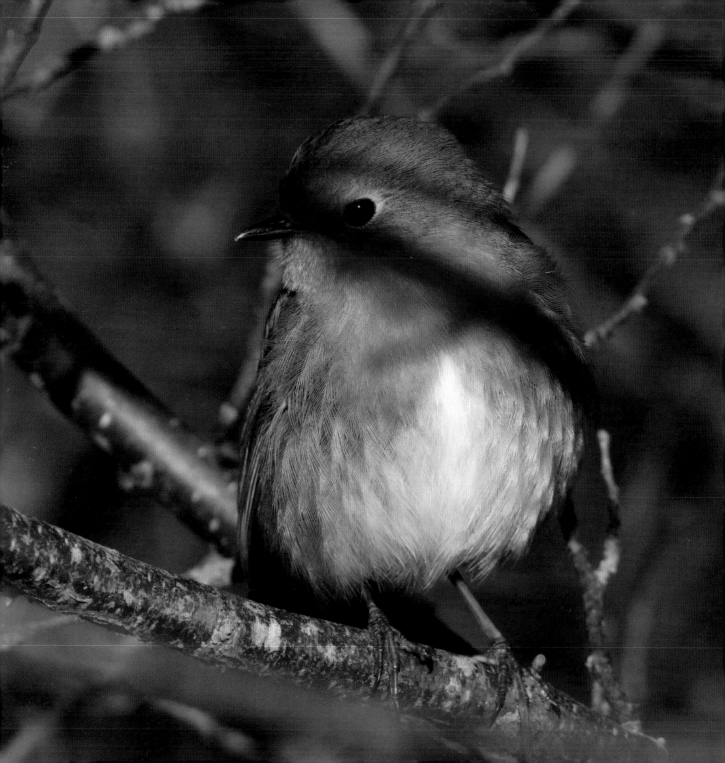

Conclusion
David Woodfall

When I was five, my uncle took me fishing for the first time. Unbeknown to me, he had bought two sea trout from Swansea market the day before and, when I wasn't looking, put them on my hook! This simple act of kindness led me to believe I had caught my first fish – but, more significantly, likely changed my life. Subsequently, I went fishing in our local valley at every opportunity. I soon realised that I had to be patient, quiet, still – and use my eyes and ears – if I wanted to experience that wonderful taste of fresh fish. An unforeseen result of this was that, by the age of six, I had inadvertently learned to meditate. This is turn led to me becoming an ecologist, which lead me to work in conservation – and, finally, as a photographer, utilising the skills I learned at this tender age. Today, very few children get the chance to experience the natural world in such a first-hand way. There are

Robin under brambles.

good education projects run by conservation organisations, but, in the main, the lack of funding and support are testament to the low priority such organisations place on conservation education. To me, this ought to be the primary aim of conservation organisations and conservationists. The success of David Attenborough's stunning series of films clearly illustrates the kind of impact that good education about the natural world can have.

Rewilding, as the unique set of accounts demonstrate, has many roles – ecological restoration through both natural processes and human intervention – but, as Bruce Parry has so eloquently written, it is our hearts that we need to rewild. Rewilding is principally about people and how they engage with their environment through the natural world. The sense of peace and connectedness I first experienced sitting quietly by a small stream, has stood me in good stead. Our minds can lie – to ourselves and others – but our hearts

do not. Each of the projects has required many interlocking elements – collective planning, practical work and finance – but, primarily, they have required passion, which comes from the heart. What was clear visiting all of these projects, was that passion, determination, knowledge, and dedication – often over a long period of time – are the key elements in the establishment and management of every rewilding project. It would be easy for government to fund such projects, but the fact is, that many of them depend upon the voluntary involvement and passionate vision of participants alone.

Many of us who work in nature conservation, myself included, have suffered disillusion in the face of increasing bureaucracy and a lack of vision and imagination in the central funding of conservation projects. And the establishment of these project requires huge vision and imagination. They – and countless other rewilding projects not included here – stand in stark contrast to the government conservation organisations' lack of engagement with rewilding in England and Wales. In Scotland, Scottish Natural Heritage has shown considerable commitment and to support such projects. In Ireland, there is hardly any government conservation work taking place (apart from a few badly funded National Park's). And so, much of the effort

has been left up to a small number of inspired individuals, community groups and NGOs.

Essentially, rewilding allows us all to have a stake in our futures by direct involvement. To help shape our landscapes, start ecological restoration and allow the long process of healing. The timing of this is very important and it gives rewilding a real and pressing relevance today, with many people feeling isolated, alienated and uninvolved in their own futures. This is a dangerous situation, in a heavily populated overcrowded series of islands where the pressure of modern life creates many problems, including homelessness. Rewilding, with its emphasis on grassroots involvement and requiring volunteers to establish and run projects, offers a sustainable way for communities to become more engaged with the natural world. Importantly, through this involvement communities and individuals can then 'fix' themselves. This is equally true for both urban and rural communities.

Already, government conservation organisations are sending employees to experience how these projects have been set up and are starting to act as a focus for their communities' sense of pride and wonder. Many of us have long forgotten that we originally came from the earth and believe that we no

Amroth Beach, Pembrokeshire.

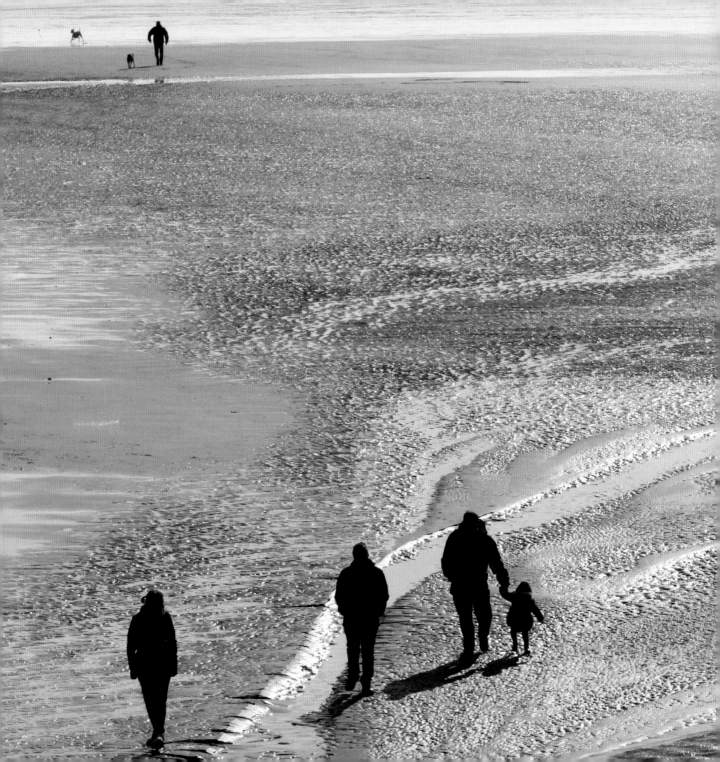

longer need it. It is not uncommon to meet people who believe that they don't need the earth. It is my belief that our future well-being and mental health are increasingly linked to the health of the natural world – every one of the people involved with this book is testament to this truth. I well remember working with patients from St George's Hospital, near Morpeth, and how, after three weeks spent outdoors taking part taking part in sand dune conservation projects, their drug intake had halved – the improvement in their self-esteem was visible. These projects have also shown themselves to be wonderful ways for different organisations to work together, as demonstrated by the John Muir Trust project at Glenlude. Rewilding is a positive force for both the natural world and ourselves.

During my first job in conservation, I became bored. So I undertook a research MSc looking at the beetle communities of a sand dune system. Through this I learned that a number of species were restricted to within only a few feet of the dune – so without a damp slack (within the dunes) with colonising scrub, many species wouldn't find a niche and would simply disappear. At the same time a British Trust for Ornithology (BTO) volunteer was ringing birds in the nearby reed marsh. As part of his research he discovered that reed warblers returning from Africa each spring, were nesting

to within a metre of where they had nested the previous year. Both of these discoveries were indicative of the ecological importance of every single stage of the vegetation succession. From the beach to oak woodland, a small number of species are easy to recognise and identify. However, the vast majority of species are never seen and, in many cases, we are unaware of their importance in the ecological processes that shape our landscape.

Historically the government had four research stations – at Banchory in Scotland, and Merlewood, Monks Wood and Moorhouse in England – which investigated the natural world and informed conservation organisations, providing a scientific basis for conservation management. A scientific basis upon which to inform conservation management. Currently (2019), there are none. If rewilding is to be successful as a movement, science-based research, monitoring the restored ecologies of these new places, is vital. So that we may learn. Without it, we have no proof that such restoration is truly benefiting our landscapes and its wildlife. It would make sense for our governments to restore such centres, developing long-term research which will provide a litmus test for our developing ecosystems, as well as utilising the original data which the four research stations created. Currently, almost all research is carried out by

ecological consultants, universities, and many inspired individuals and volunteers.

While talking with Dr Dave Goulson about his involvement in this book, I mentioned the research on bumblebees being carried out by his colleagues at Rothamsted Research Station. He was not aware of the paper and I expressed surprised. He explained that as a new paper on bee biology appears almost daily, it is not humanly possible to keep up – a startling admission considering that he is one of the most eloquent champions of bumblebee conservation. Research work on honey bees at the National Botanic Gardens of Wales suggests that the hedges around meadows are of more significance for bees than the meadows themselves. While working with Dr Steffan Wolf at Rothamsted, I learned how he and his colleagues had discovered how the queen bumblebees sent out the workers, which then chose the best flowers for the future health of their species' gene pool. They attached transponders to the bumblebees and mapped the areas that thy repeatedly returned to. This research, and the insights it has provided, has huge implications for our agricultural landscapes and wild places. Effectively, if we developed and implemented this research, we could change our landscapes, both in terms of food production and a restored ecological balance. Bees are central for the pollination of the majority of our flowers and crops, and their continued decline should be a cause for considerable concern.

We live on a series of islands – our marine ecosystems should also be subject to regular scientific monitoring. We know very little of the marine processes or conservation status of many of the species that inhabit our waters. We do know that several species of seabirds have declined rapidly over a short period of time. We don't know why – effectively, we have to make ill-informed guesses. This is of particular concern when we consider our dependence on the fish populations of the continental shelf around our islands. The real reason for the catastrophic decline of Atlantic salmon is still not known, although appears that there may be several different and often interrelated causes, including overfishing. Currently, the future prospects for individuals catching salmon in the rivers of England and Wales are at risk. If our marine populations are to be maintained, this ought to be based on applied research.

Britain and Ireland predominantly consist of agricultural landscapes that have been shaped and developed over the last 10,000 years, creating a huge diversity of environments on top of our physical landforms which have both shaped our ecosystems and wildlife. Today, and in the

past, huge and regrettable divisions exist between conservationists and the farming community. Farmers have been under huge pressure to produce food economically and need every support to do so. Maintaining our ecosystems while under such pressure, is very difficult, particularly as policies seem to change every five years. The change in our status within Europe and the likely end of the Common Agricultural Policy (CAP) will have huge significance for our future landscapes. This also offers us an opportunity for the agricultural industries and conservationists to forge new partnerships through innovative projects like the controlled reintroduction of animals such as beavers, which could bring in much-needed income for our rural communities. Such rewilding projects also have the potential to mitigate against flooding events – which, with the effect of climate change, are becoming much more frequent and seriously threaten the futures of a number of our communities. We can look to the success of the Pontren project in Montgomeryshire, where ten different farms have planted miles of new hedgerows, shelter belts and ponds to reduce flooding in the River Severn catchment. One of the commonest criticisms of conservation organisations

Kingfishers, Surrey.

in relation to agricultural practices is that their solutions are far too prescriptive, effectively imposing their will on farmers without involving them sufficiently. The example of Knepp Estate and its rewilding has demonstrated how wildlife and agricultural production can work effectively with common aims. Significantly, such projects attract large numbers of curious and sympathetic people, many of whom are themselves landowners. They want to see how a farmer can alter the cycle of debt and yet still produce food while maintaining and, in some cases, increasing wildlife communities. Without co-operation between the farming community and conservationists, there is scant prospect of carrying out ecological restoration on a large scale in Britain and Ireland.

It is only in the last few years that the value of our post-industrial landscapes has begun to be appreciated. Because of the relatively recent decline of regional industry, they offer a timeline of how quickly industrial land can be colonised by vegetation and develop important plant and invertebrate communities – at least on sites that have not been decimated with chemicals. The Colliery Spoil Biodiversity Initiative in Wales carries out invaluable work, surveying invertebrates and hopefully protecting the most important post-industrial sites. While some of these will be developed

for housing, it is heartening to read of a recent online petition signed by 300,000 people (in two weeks) requesting that Hedgehog Highways are created in all new housing projects. Rewilding could have a significant role to play in protecting these much-loved mammals, whose decline is closely linked to the spread of housing that prevents their natural movements, destroying their natural habitat. We need to consider incorporating new legislation into the planning process.

The dramatic decline in the peat bogs since 1947, when many of the sites were given licences for peat-winning, has at last been halted by the work of government organisations in the UK and Bord na Mona in Ireland. In Ireland 30, 000 ha are in the process of being rewilded. In both countries there is now the active blocking of old drains (created to drain the peatlands), often utilising the skills of those who originally drained the bogs, to raise the water table and kickstart their regeneration once again. Even in the last 30 years, on such sites, a number of peat bog species close to extinction have started to recolonise our peatlands. The opportunity to develop research programmes on the bogs that are being restored is exciting.

Many of the rewilding projects that have been established so far, are relatively small. However, there is now the opportunity to develop more landscape-scale projects, such as the Summit to Sea Project which is now being set up in mid-Wales by Rewilding Britain. In Scotland the Cairngorms National Park are undertaking significant large-scale projects, often with the cooperation of large estates. The culling of large numbers of red deer in Glenfeshie in the recent past by a visionary landowner, and the resultant regenerating pine and birch forests, is indicative of how quickly ecological restoration can take place once the key elements threatening this restoration are changed. Another large-scale ecological restoration project taking place in Scotland is being carried out by the NGO Trees for Life, at two large estates in the northern Highlands. It was set up by the visionary Alan Watson Featherstone, and now staff and volunteers are busy restoring the native pine forests. Paul Lister, a private landowner, and his staff have restored over 8,100 ha of glens and mountains, while managing it as a sporting estate – the landscape once again clothed in native woodlands. Recently, they have successfully captive-bred wild cats, which they hope in time to release into the estate. In the Southern Uplands the incredible success of the Carrifran Wildwood Trust in purchasing

Alder tree eaten by beavers, Bevis Trust, Carmarthenshire, Wales.

three large mountains and sheep walk, and planting over 600,000 trees, is testament to what well-trained professional staff, aided by a wonderful resource of volunteers, many of whom come from all over the UK, can achieve. The John Muir Trust is also restoring several large-scale estates in different parts of Scotland using similar techniques. These large-scale, landscape-shaped projects are proving to other landowners that rewilding is indeed a realistic prospect for them, and it is likely that they too will follow the example of these conservation organisations and individuals.

The maintenance of established and existing ancient woodland in Britain and Ireland presents a different challenge. While it might be appear easy to apply rewilding principles to their management, many organisations actively manage their woods exclusively for recreation, commercial, and sporting interests – whether they are in urban areas such as Epping Forest, or rural areas such as the New Forest. Such landowners might take longer to incorporate the principles of rewilding into their futures. However, the presence of such large woodland areas offers huge opportunities to allow nature to further

Ancient Scots pine, Glenfeshie, Cairngorms National Park, Scotland.

take its own course, rather than actively manage it.

Much of the land owned by landowners, such as the National Trust, is farmed by tenants. The Trust in the Yorkshire Dales is trialling a new form of agri-environmental support with some of their farmers; an 'output'-based system, this involves all the habitats found on uplands farms and is rated by the amount of wildlife which occurs on these farms. So, the richer the habitat and wildlife that they support, the better the payment the farmer receives. If successful, this is likely to have an extremely positive effect, particularly on blanket bog, upland pastures and hay meadows – many of which are severely degraded from an ecological perspective. The National Trust is a significant landowner in the UK, with a membership of over five million, which makes it is a vital player in the ecological restoration of the landscape.

More than any other part of Britain and Ireland, the coasts are our most dynamic landscapes. With the challenges of combating the effects of climate change, our coasts will offer the greatest opportunity for selective rewilding projects, as sea levels rise and modify our shores. Managed retreat has already been demonstrated to work at Old Hall Marshes in Essex and at Steart Marsh in Somerset, where the Department for Environment, Food and

Rural Affairs and the Wildfowl & Wetlands Trust have collaborated in changing 250 ha of former farmland into saltmarsh, by puncturing the banks of the River Parrett. Fish are already starting to breed within the channels and many overwintering birds are being attracted to the new habitats. This project also has the added benefit of potentially preventing flooding – such as happened in 2014 on the Somerset Levels.

However, some species, such as little terns, are likely to be affected negatively as rising sea levels threatens their breeding habitat of beaches and shingle spits. This, in addition to other related climate-change issues, may threaten the future of this species. The historic management and creation of machair by crofters and the communities off the west coast of Scotland shows how important such community-based management over a long period can be in benefiting the unique assemblages of wildlife which are so characteristic of this part of Scotland and the west coast of Ireland.

The most important factor in the success of rewilding in Britain and Ireland is public support. Historically, conservation bodies have enjoyed a mixed public response. It is my belief that until recently they have not fully engaged with the public. However, rewilding provides a new opportunity for re-engagement, and in a much more socially relevant way. Such projects are often genuinely wild and offer the public the chance to become involved in practical, spiritual and nurturing projects – leaving them feeling much more engaged with themselves, the place and the their futures. Such projects can have an important role in securing people's own identity. The ground-breaking collaborative project between the John Muir Trust in Glenlude and drug and alcohol programmes from urban areas demonstrates the healing power that nature, allied with careful nurturing, can provide. Currently, over 400 homeless people a year die on our streets. Surely the involvement and inclusion of marginalised people in conservation can illustrate the wider power of rewilding projects? It could provide opportunities for conservation organisations to approach social services and develop specific programmes for homeless people that could aid enormously in restoring their dignity and identity.

Rewilding is a positive opportunity to re-engage with nature, to rewild our hearts, continue ecological restoration and involve the public in an unprecedented way. However, at an early stage in its development, different interpretations of what the concept actually involves have led to considerable conflict

Black grouse with open wings, Ruabon Moor.

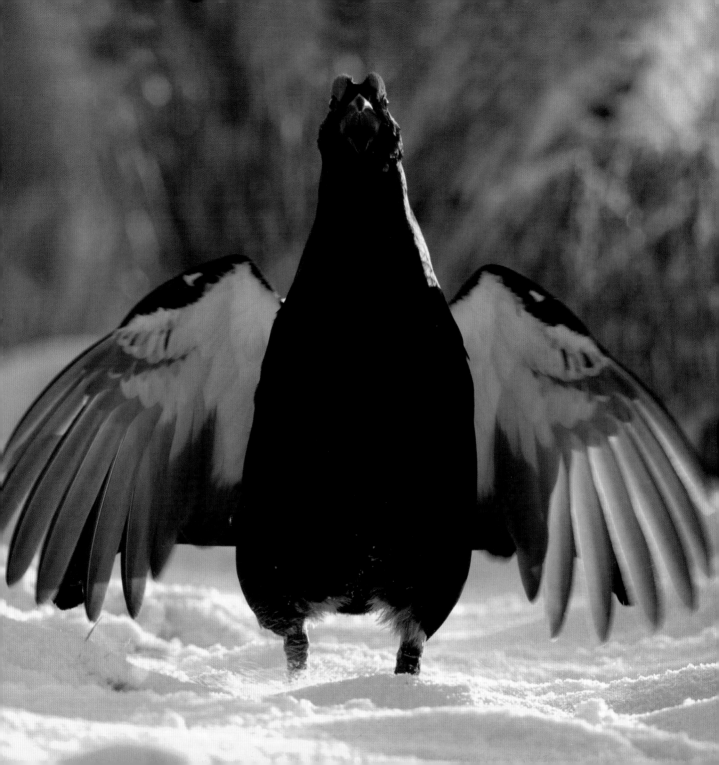

among groups of people with strongly divergent views. In some ways this has alienated sections of the community, particularly farmers. It is both the weakness and strength of the concept that it has few limiting factors and can be used by some as a means to their own ends. The main aim of this book is demonstrate the huge diversity of landscapes and wildlife communities which exist in a relatively small area. These initiatives provide a fantastic opportunity to enhance our islands and to help secure our well-being at a time when pressures on people in many sectors of the community are reaching breaking point. It offers us the opportunity to re-engage with society in a meaningful way.

Encompassing such a variety of landscapes I hope the book will demonstrate that to restore such places requires many different approaches towards ecological restoration. People learn by their mistakes – by attempting different solutions to overcome problems and challenges. Clearly, rewilding is an attractive option for people of all classes and backgrounds throughout our islands. More than anything, I hope this book, with its emphasis on positive successfully run projects, will demonstrate that practical projects have a successful future in our society – helping to restore ecological areas of significance. I'd like it to become a practical template of what is possible: from a corner of

an urban park with the highest density of water voles in the UK in Glasgow; to Ireland where the Irish Whale and Dolphin Society runs affordable trips, giving people the opportunity to watch large number of large cetaceans in close proximity along the Wild Atlantic Way.

All this, can only happen with your involvement.

* * *

For many years conservationists have argued, pontificated and theorised about nature conservation. All the projects in this book are different, in that they have just 'done it'. They have planned, been practical and used their passion to inspire other people to become involved in their projects. Many of these projects have been running for up to 20 years and have attracted considerable interest and support from their respective communities. Rewilding is an exciting concept because it is hopeful about changing landscapes in a way which benefits our lives. It gives people the opportunity to become involved in their own landscapes and help shape them.

All the projects in this book have been included because they offer a cross-section of landscapes in our islands and are representative of most of the regions in Britain and Ireland. There should be rewilding projects fairly close to your home that offer you

the opportunity to become involved yourself. You may not have the energy to buy a farm or buy a mountain and plant it with hundreds of thousands of trees – however, the sheer number of projects in existence means that it shouldn't be too difficult for you to find one that requires volunteers. Also, you should be able to match your varied skills to a project at a level that suits your needs. Becoming involved in managing land has a transformational effect on people. The effect is manyfold and often gradual. You will be become healthier, more grounded, learn about the land and science, develop many new practical skills. You will also learn about team-working, develop new friendships and become part of a community in a way which enriches your life. Not only will you transform yourself, you will transform the landscape in time. This transformation will enable you to be more connected to the earth and your community. It will give you a more of a vested part in the future, and will, in turn, give you greater positive energy.

There are so many organisations that offer opportunities to become involved in rewilding projects that the most important thing to ask is what do I want? What am I looking for and what are the skills I can offer? All of the organisations in this book would be a good place to start. Volunteers travel the length of the country to work in large spaces like the Carrifran project

or Trees for Life, attracted by the expansive Scottish landscapes. Conversely, every local authority and county council will have voluntary groups that carry out conservation work on your doorstep – so you'll be able to find a similarly minded group of people close to where you live and work. Similarly the Wildlife Trusts will organise work parties and host interesting talks close to where you live. Every county Wildlife Trust has contact details online as have all the organisations included in the book, so in no time you can be involved. For children, there also Watch groups – enabling young people to learn about nature and start getting involved in practical work groups.

Some of the most exciting rewilding projects to become involved with are species protection projects – these allow you to directly benefit wildlife. I am still benefiting greatly from my own experiences: with little tern protection schemes (nesting on the coast) and osprey nest protection projects (there are now over 300 pairs of ospreys nesting in Britain). The people involved in such projects are invariably interesting and you can learn a great deal about wildlife behaviour in a very short time. You will invariably be working with other like-minded people, united in maintaining populations of threatened wildlife. For those of you who know birdsong, or are prepared to learn, the BTO monitors

populations of breeding birds by mapping territories of singing birds at dawn each spring, providing important baseline data on the health of our bird populations. Butterflies, are one of the easiest groups to identify and learn about. Butterfly Conservation are one of the most dynamic organisations in the UK and it is possible to help monitor populations of these insects by carrying out regular transects between April and October. By becoming involved in something like this you can help gather important scientific information about issues such as climate change.

Some of the best places to see wildlife in the UK and Ireland are National Nature Reserves and these always need volunteers. Please check Natural England, Natural Resources Wales and Scottish Natural Heritage websites to find nature reserves near you that require work parties and volunteers for survey work. You could be waist-deep in a marsh or helping a warden untangle their computer programs. The Conservation Volunteers (TCV) is a good place to find practical work and operates throughout the British Isles. The National Trust runs conservation holidays for young people all over England and Wales, called Acorn camps; and in Scotland, the National Trust for Scotland runs a similar service. Organisations like the Marine Conservation Society work closely with volunteers, regularly collecting plastic washed up on our coasts.

If you are too busy to join in, but are fortunate to have your own garden, simply leaving a corner to develop naturally is a wonderful experiment – literally to see what happens there. The The Royal Society for the Protection of Birds (RSPB) runs a yearly survey called the Big Garden Bird Count, which surveys birdlife in the UK's gardens – a brilliant way to contribute to 'Citizen Science'. Allotment and orchard groups also offer many opportunities, often right on your doorstep.

Being able to give free range to your passions, enabling both nature and yourself to grow, has to be one of the most empowering actions available to us. As Stuart Adair of the Carrifran project told me while planting a silver birch – 'every tree is planted with love'.

Acknowledgements

This project was born out of tragedy, but the following people have enabled me to transform it into a celebration of the landscape, people and wildlife of our incredible islands. I'd like to thank everybody who has contributed to this project and have given their time and enthusiasm so freely – helping to draw people's attention to these important issues. The following three people, in particular, have helped me find deeper meaning for the book than I otherwise would: namely, Robbie Bridson, Richard Moles and Geoff Morries. In addition to writing wonderful contributions, they have provided critical feedback and invaluable background information. It is rare to see such candid professional views on land management, particularly focusing on such a contentious area. This book is testament to their practicality and vision – but also, the power of rewilding to restore the ecology of our islands.

I like to thank Tom Cabot for his beautiful design and assistance with the text. I would also like to thank Myles Archibald for his guidance, but particularly at the beginning of the process – his input has had a profound effect on the final book.

The following people have helped me locate specific wildlife or places: Mike and Eileen Worsfold with the lesser horseshoe bats; Neil Hulme and Mathew Oates, with the purple emperor butterflies; Dr Kieran Hickey, for pointing me towards Cabragh wetlands; Glynn and Ade Jones, Kevin Dupe, David Carrington, Innes MacNeill and Ryan Monroe at Alladale; Mike Daniels and Karen Purvis at the John Muir Trust; Paul Trees and Rod Everett, who wrote lovely pieces, but whose essays couldn't be included in the book for lack of space; Tom Wood, for his inspiration; Lenny Antonelli and Lynda Huxley, for help with locations in Ireland; Cliff Reddick, Lorne Gill, Jamie and Marie Boyle in North Uist; Peter Williams at the Welsh Mountain Zoo, for his help with the pine marten; also to Peter Adams, who sadly passed away before he could complete the text on Epping Forest – he contributed much to the spirit of the book .

All the photographs are my own, apart from the turtle dove (p. 141) by Ben Andrew, and the curlew (p. 49) by Stephen Barlow. The pine marten (p. 75) and golden eagle (p. 22) were photographed under controlled conditions.

William Collins
An imprint of HarperCollins*Publishers*
1 London Bridge Street
London SE1 9GF

WilliamCollinsBooks.com

First published in Great Britain by
William Collins in 2019

2022 2021 2020 2019
10 9 8 7 6 5 4 3 2 1

Copyright in this compilation
© David Woodfall 2019
Individual essays © Respective authors
All photography © David Woodfall 2019, with the
exceptions of pages 49 (© Stephen Barlow) and 141
(© Ben Andrew).
Front cover image: European Beaver, Bevis Trust,
Carmarthenshire, Wales
Back cover image: Little Terns, North Uist

David Woodfall asserts the moral right to be
identified as the author of this work in accordance
with the Copyright, Designs and Patents Act 1988

A catalogue record for this book is available from the
British Library

ISBN 978-0-00-830047-0

Printed in China by RRD Asia Print Solutions

MIX
Paper from
responsible sources
FSC™ C007454

FSC
www.fsc.org

This book is produced from independently certified FSC™
paper to ensure responsible forest management.

For more information visit: www.harpercollins.co.uk/green